THE
FIELD GUIDE
TO
WITCHES

AN ARTIST'S GRIMOIRE OF
20 WITCHES AND THEIR WORLDS

3dtotalPublishing

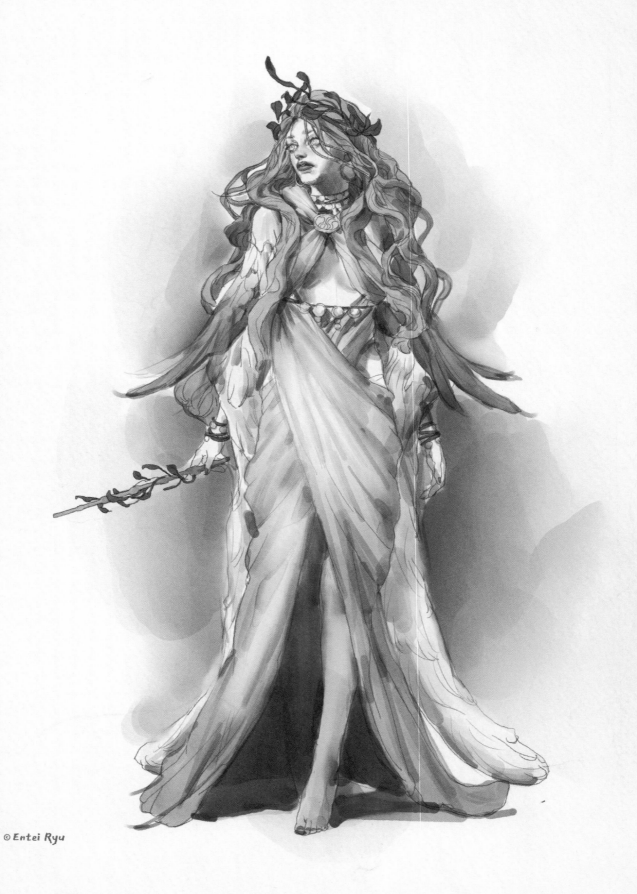

© Entei Ryu

THE
FIELD GUIDE
TO
WITCHES

AN ARTIST'S GRIMOIRE OF
20 WITCHES AND THEIR WORLDS

3dtotalPublishing

ONE TREE PLANTED FOR EVERY BOOK SOLD

We at 3dtotal Publishing donate 50% of our profits to charity. For every book sold, we give to reforesting charities to plant new trees. This is just one part of our annual donation to a large number of the most effective charities, covering causes such as humanitarian work, animal welfare, and the protection of existing rainforests. We also aim to be a carbon-neutral publisher with carbon-neutral products, which means that by buying from 3dtotal Publishing, you are helping to balance the environmental damage caused by the publishing, shipping, and retail industries, as well as supporting many other causes.

See 3dtotal.com/charity for full details.

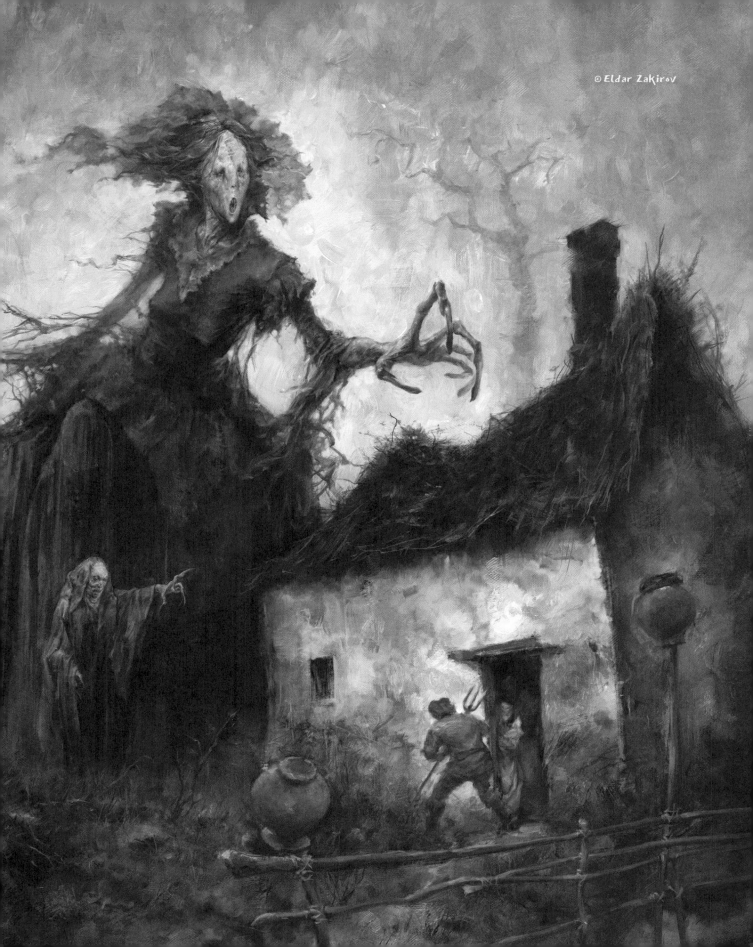

© Eldar Zakirov

3dtotalPublishing

Correspondence: publishing@3dtotal.com
Website: www.3dtotal.com

Every effort has been made to ensure the credits and contact information listed are present and correct. In the case of any errors that have occurred, the publisher respectfully directs readers to the www.3dtotalpublishing.com website for any updated information and/or corrections.

First published in the United Kingdom, 2022, by 3dtotal Publishing.

Address: 3dtotal.com Ltd,
29 Foregate Street, Worcester
WR1 1DS, United Kingdom.

Hard cover ISBN:
978-1-912843-57-2

Printing and binding:
Gutenberg Press Ltd (Malta)
www.gutenberg.com.mt

Visit www.3dtotalpublishing.com for a complete list of available book titles.

Managing Director: Tom Greenway
Studio Manager: Simon Morse
Lead Editor: Samantha Rigby
Lead Designer: Joseph Cartwright
Designer: Fiona Tarbet
Editor: Marisa Lewis
Cover artwork: Abigail Larson

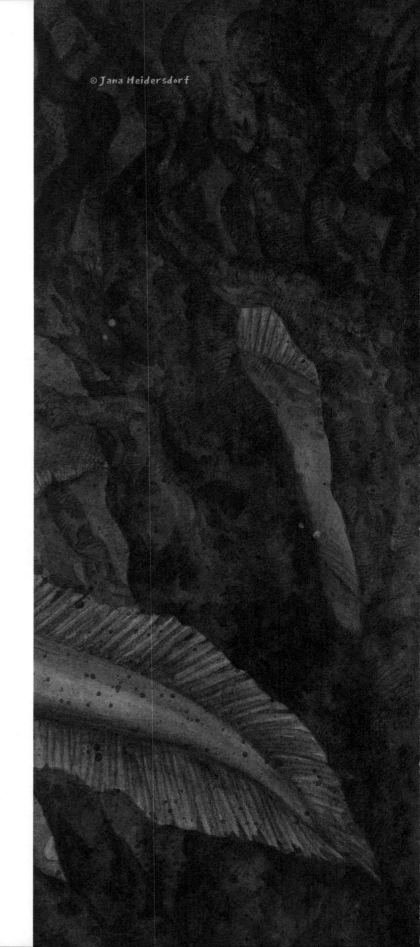

© Jana Heidersdorf

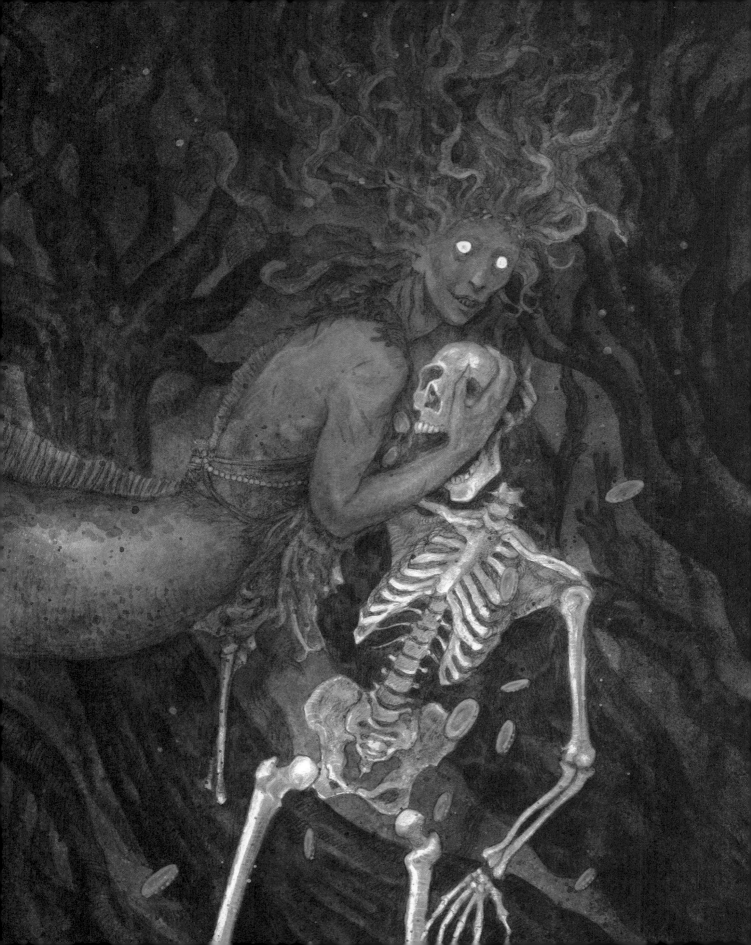

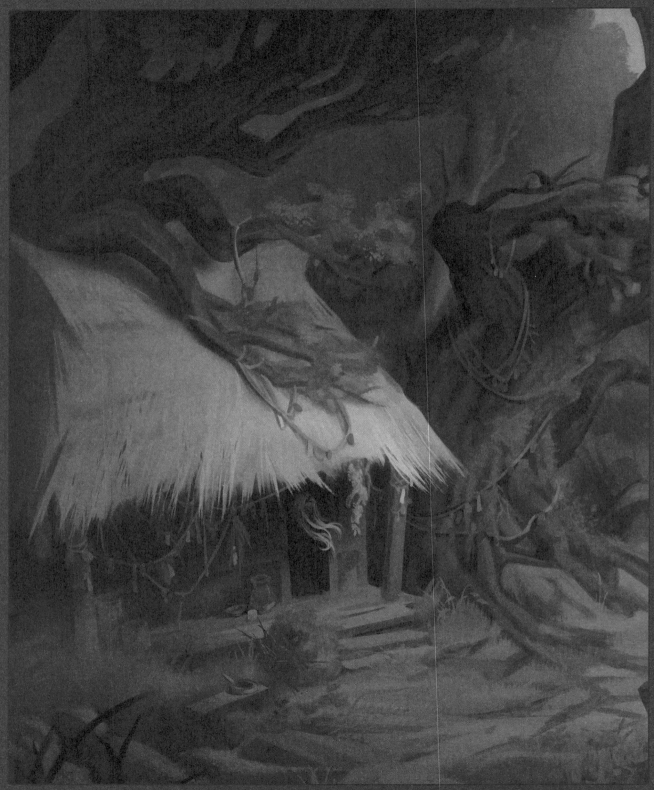

Contents

Introduction

The witch has been a staple figure in folklore and legend for thousands of years. She wears countless guises: the wicked witch with her cauldron; the beautiful, seductive enchantress; the magic-wielding mother goddess; the wise, cryptic soothsayer; the shapeshifting trickster; the child-eating hag of cautionary tales. She is found in cottages in the woods, in afterlifes and underworlds, in untamed mountains and forests, and in dark caves and pools.

In stories around the world, witches can be found as forces for good, ill, or their own mysterious whims. Some witches are celebrated in the divine halls of the gods while some are exiled to the outskirts of society. Some witches are guardians, helpers, and mother figures, while some are monstrous, cruel, and violent. Sometimes a witch can be all these things, depending on who is telling the story.

In this book, you'll be joining twenty intrepid artists as they dive into the magical domains of twenty witches, enchantresses, hags, and goddesses. Using their skills with sketching, concept development, and character design, they will research and create their own unique depictions of witches from fairy tales, fiction, folklore, and mythology, ranging from the familiar and well known to the strange and obscure. We hope that you enjoy looking inside the worlds of these fascinating witches, as well as inside the creative minds and sketchbooks of the artists portraying them on these pages.

Marisa Lewis | Editor

© Abigail Larson

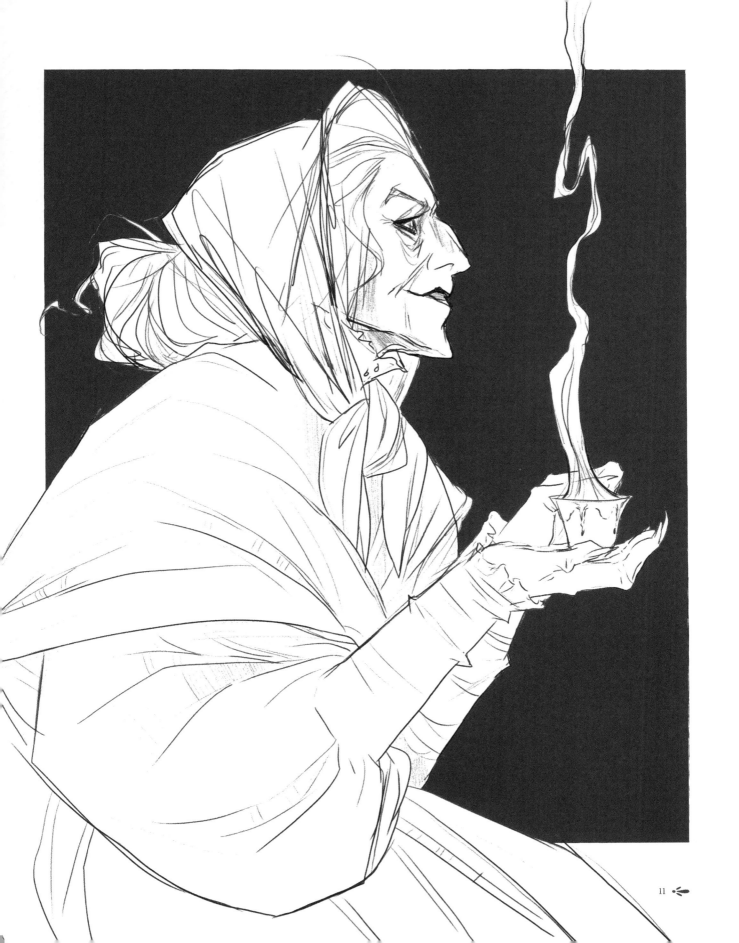

How to Use This Book

You will find twenty chapters in this book, each authored by a different artist, drawing a different witch. Each person in this roster of illustrators, concept artists, and character designers has their own style and interpretation of their subject, but their accounts of each witch will follow the same path...

Research & rumors

These interesting whispers, fragments of tales, and nuggets of research are an artist's springboard into imagining a witch. A witch may be little known and hard to find, but these are the pieces of lore and initial leads that will help us begin to visualize her.

Location

Where is this witch likely to be found? Some witches are from a specific country or region, while others come from unknown or impossible realms that few living explorers will ever see (in those cases, our artists must use their imaginations)!

Important notes

As the artist becomes more familiar with a witch's story, they note down and sketch particular features, qualities, or objects of interest. Whether it's a special artefact, garment, or anatomical detail, these elements will really help to capture the witch's personality, world, or story.

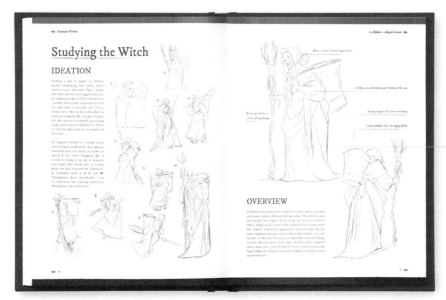

Studying the witch

This is where the artist's most creative decisions are made, exploring various options for what the witch might look like, from different angles and in different poses or scenarios, based on all their research and observations so far. Throughout, you will find annotations and labels highlighting the witch's key features and traits.

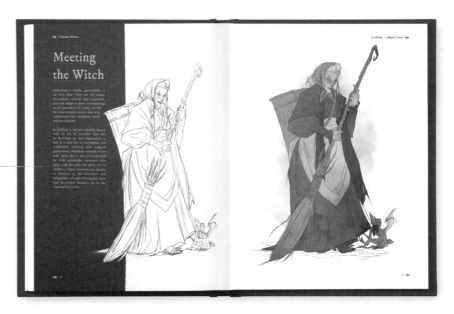

Meeting the witch

Next we see the artist's final sketch of the witch, showing both a line drawing and a shaded design. Finally, turn to the artist's last page and you will find a painting of the witch in her world: a scene of the character at home in her environment, whether that is a forest, swamp, heath, or cottage.

As you follow along with each chapter, imagine how you would depict your own witch. Would you choose the same features as this artist, or would you branch off some other way? What elements of the witch's story or personality really pique your curiosity? You could try to research sources and inspirations of your own, to see how your interpretation may differ – perhaps you'll discover some new witches altogether.

Witch Locations

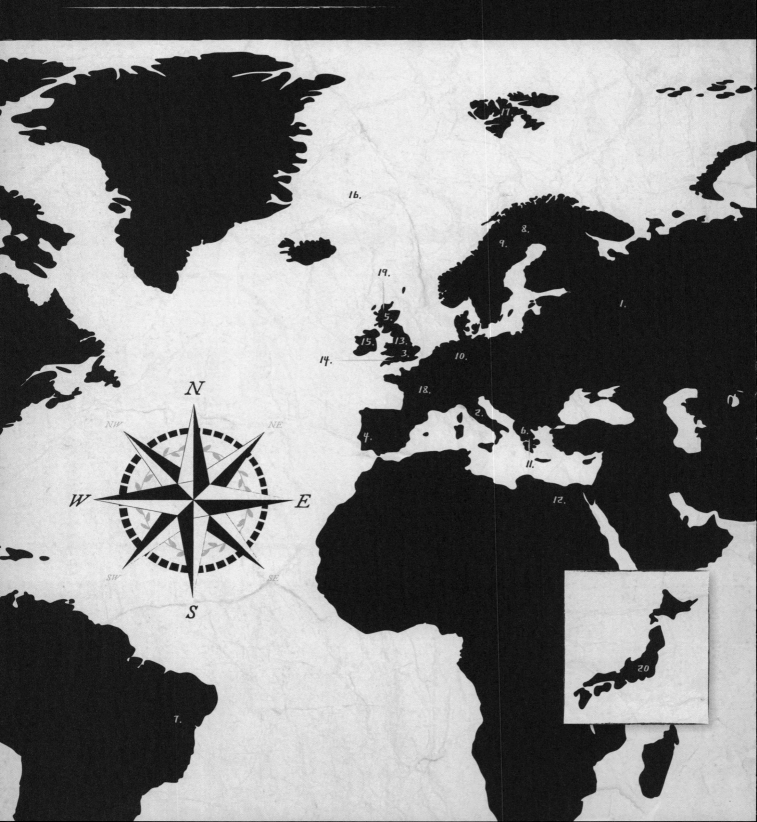

 1. Baba Yaga

 11. Hecate

 2. La Befana

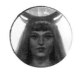 12. Isis

 3. Black Annis

 13. Jenny Greenteeth

 4. The Bruxa

 14. Morgan Le Fay

 5. The Cailleach

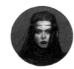 15. The Morrigan

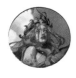 6. Circe

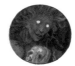 16. The Sea Witch

 7. The Cuca

 17. The Snow Queen

 8. Elli

 18. The Spinning Witch

 9. Freyja

 19. The Weird Sisters

 10. The Gingerbread Witch

 20. Yama-uba

Baba Yaga
page 18

La Befana
page 32

*The Gingerbread
Witch*
page 46

The Sea Witch
page 60

The Snow Queen
page 74

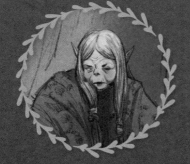

The Spinning Witch
page 88

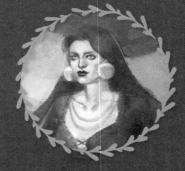

Morgan Le Fay
page 102

Fairy-Tale Witches

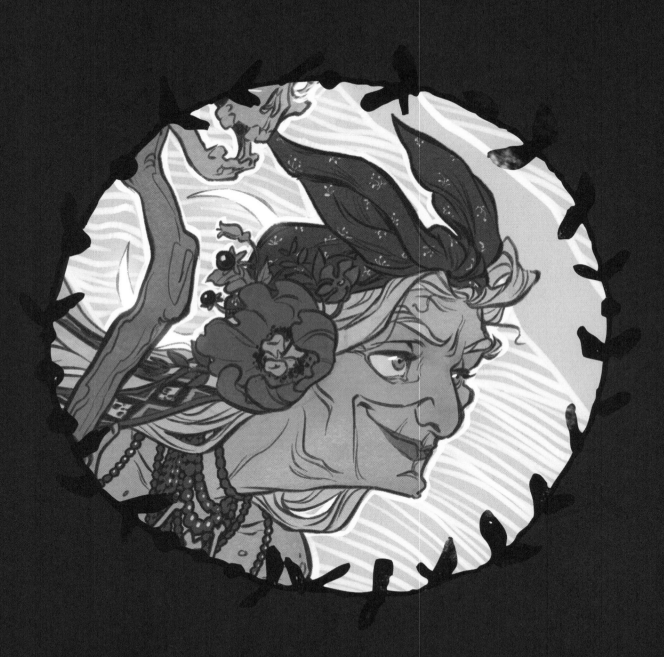

Baba Yaga

Baba Yaga is a supernatural figure renowned in Slavic folklore.
She is commonly described as a fearsome, forest-dwelling woman who flies
around in a giant mortar and pestle and lives in a spinning hut that stands
on chicken legs. She is sometimes characterized as a cannibalistic villain,
and sometimes as a powerful, neutral force of nature. In this chapter,
illustrator and artistic witch Olga "AsuRocks" Andriyenko draws on these
many traditional sources for her interpretation of Baba Yaga.

Olga "AsuRocks" Andriyenko | asurocks.art

Research & Rumors

Friend or foe?

Children are told scary stories of this dangerous witch, who is said to hunt, steal, and cook them. As much as she is deadly, she can also be a wise guardian to those in need – but only if they prove to be worthy of her advice and magical gifts. She gives those who seek her out difficult tasks and riddles, and only a few have solved them and lived to tell the tale.

Forest guardian

A wild woman living alone in the woods, she can communicate with animals and plants, and is even rumored to be able to control the weather and conjure up tempests and winter. Some call her the mother of the forest. She is as old as the forest itself, if not even older.

Growth & decay

Some legends mention that Baba Yaga is the guardian of the fountains of the water of life. Like the constant cycle of decay and new growth in her forest, Baba Yaga is connected to both life and death. Her house on chicken legs stands as a doorway between the world of the living and the other side.

LOCATION

Enter the dense forests of Eastern Europe. Somewhere deeper than even the bravest heroes dare to go, under the cover of the ancient trees, it is almost as dark as night. The air smells of rot and decay, but also of fresh, moist soil. Old wood is slowly decomposing and giving life to new growth. Mushrooms and fresh blooms sprout from the dense, mossy ground. Is that a human bone hiding between spring flowers? You don't want to know.

Important Notes

Skeletal leg

Baba Yaga is also known as "the bone-legged." With one leg she stands in the world of the living and with the other, the skeletal one, she stands in the world of the dead.

Mortar & pestle

She prefers to travel in a flying mortar. She uses the pestle to steer it, but she also carries a broom, which she sometimes uses to conceal her tracks or to stir up tempests as she goes.

Animal companions

Her most trusted familiar is a wise cat, who sometimes gives out useful advice in Baba Yaga's stead when she is busy. She is also known to enjoy the company of ravens, owls, and other animals.

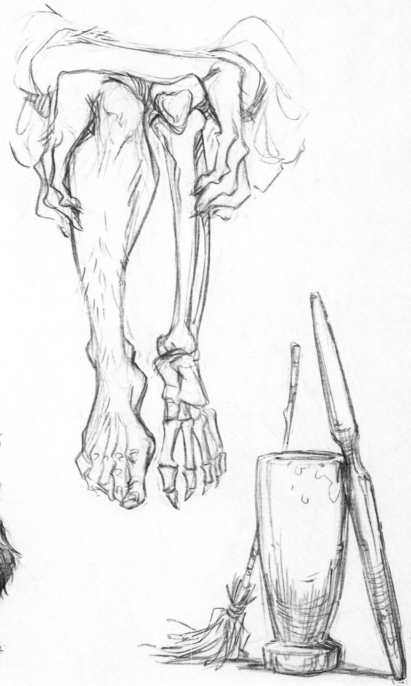

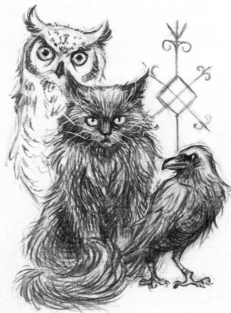

*"Baba Yaga wears traditional
Eastern European clothing,
rich in patterns and embroidery
full of symbolism"*

Bone decoration

Skulls and bones are some of her favorite accessories to decorate herself and her home. Many of them belonged to self-proclaimed heroes who did not show Baba Yaga enough respect, or just to those who failed at their tasks.

Traditional clothing

Baba Yaga wears traditional Eastern European clothing, rich in patterns and embroidery full of symbolism. Maybe some of the intricate ornaments have been embroidered by the mortals working to earn her advice and help.

Chicken-legged hut

Even if one manages to find Baba Yaga's hut on chicken legs, it appears to have no doors or windows. Only if you say the right words will it turn around and reveal an entrance.

Studying the Witch

1.

2.

3.

4.

5.

6.

7.

8.

9.

IDEATION

This witch has lived for an eternity and there are many stories giving different impressions of her, so when drawing her, many different directions can be explored. Quirkier and funnier variants work well with a shorter, rounder shape, or even a square shape, as in sketches **6** and **9**. But while exploring those I find them almost too ridiculous. I end up gravitating toward taller and more slender body shapes, as in sketch **2**, which remind me of tall, old trees. Despite being very old, Baba Yaga is incredibly strong, so she stands upright without too much of a hunch. For my final design, I decide to go with a mix of **2**, **4**, and **10**.

10.

11.

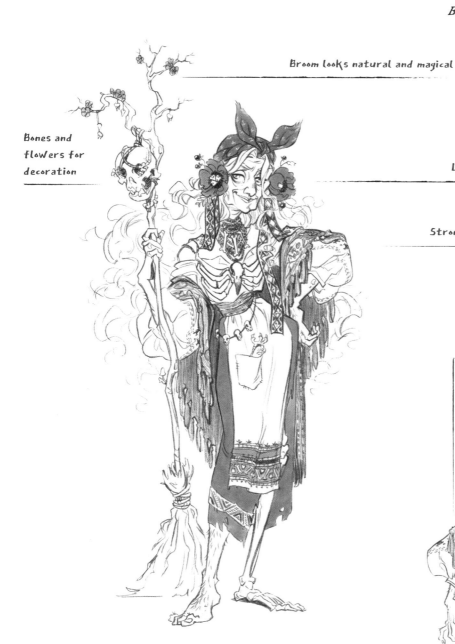

Broom looks natural and magical

Bones and flowers for decoration

Long, wild, white hair

Strong, confident posture

Traditional embroidered clothing

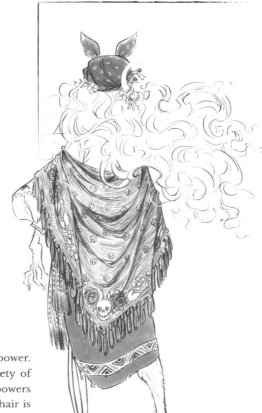

OVERVIEW

The final design shows a magical old woman who knows her immense power. Wearing layers of beautifully designed embroidery, decorated with a variety of bones, she looks confident and even playful. She is a witch who enjoys her powers and toying with mortals from time to time. Her head of long, wild, white hair is adorned with flowers, some spiky or extremely poisonous. She is barefoot, so her feet are always able to touch the raw soil, grounding her in the forest. Her broom has a life of its own, with some spring blooms and mushrooms growing out of the wood.

EXPLORATIONS

These sketches continue exploring Baba Yaga's multifaceted roles: a wise witch, a fearsome foe, and a kindly friend to animals and nature.

◄ Baba Yaga can also be gentle, but very rarely toward humans. She's just not a "people person!" Her cat, her companion and wise advisor, is one of the few that gets to witness her soft and caring side.

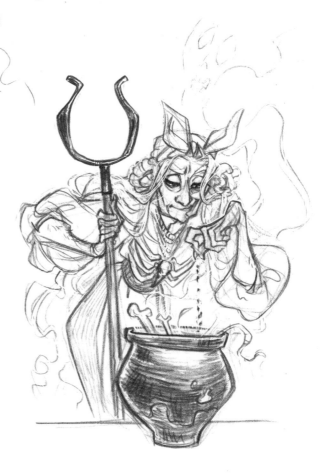

▲ What is she cooking? You probably shouldn't ask. Rumors say she enjoys human flesh from time to time. In her kitchen she is playful, experimenting with different spices, herbs, and mushrooms.

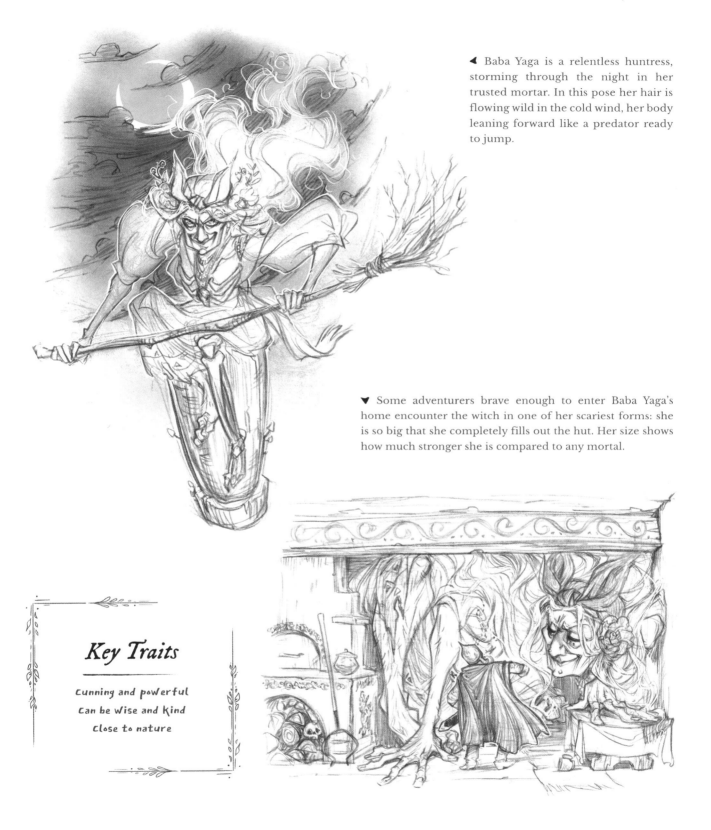

◄ Baba Yaga is a relentless huntress, storming through the night in her trusted mortar. In this pose her hair is flowing wild in the cold wind, her body leaning forward like a predator ready to jump.

▼ Some adventurers brave enough to enter Baba Yaga's home encounter the witch in one of her scariest forms: she is so big that she completely fills out the hut. Her size shows how much stronger she is compared to any mortal.

Key Traits

Cunning and powerful
Can be wise and kind
Close to nature

Meeting the Witch

For the final design, I have combined all the essential Baba Yaga symbols discovered in my research with her fierce yet playful personality. She is dashing through the forest, hinted in the background, on her iconic mortar, lighting her way with a skull lantern. Her clothing is ornate with traditional motifs and needlework, but also well worn. Her white hair flows like clouds in the wind. Her expression is strong and confident, but also scheming. You wouldn't want to stand in her way. Toadstools grow in her path, symbolizing death and new life, picking up the bright reds of the character design.

"Her expression is strong and confident, but also scheming. You wouldn't want to stand in her way"

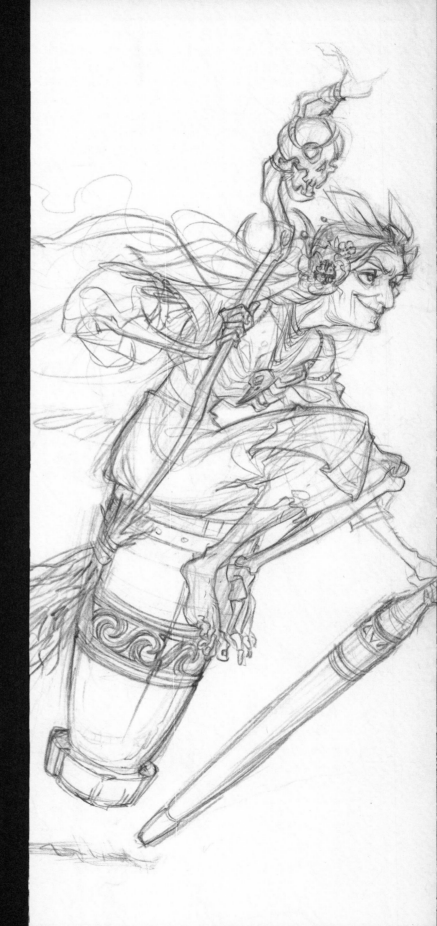

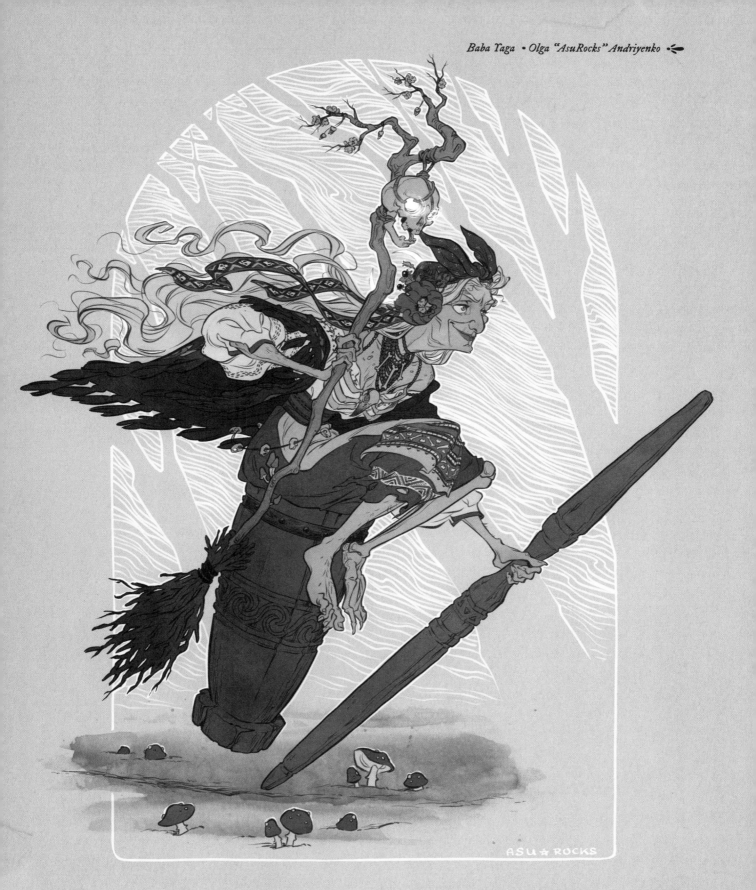

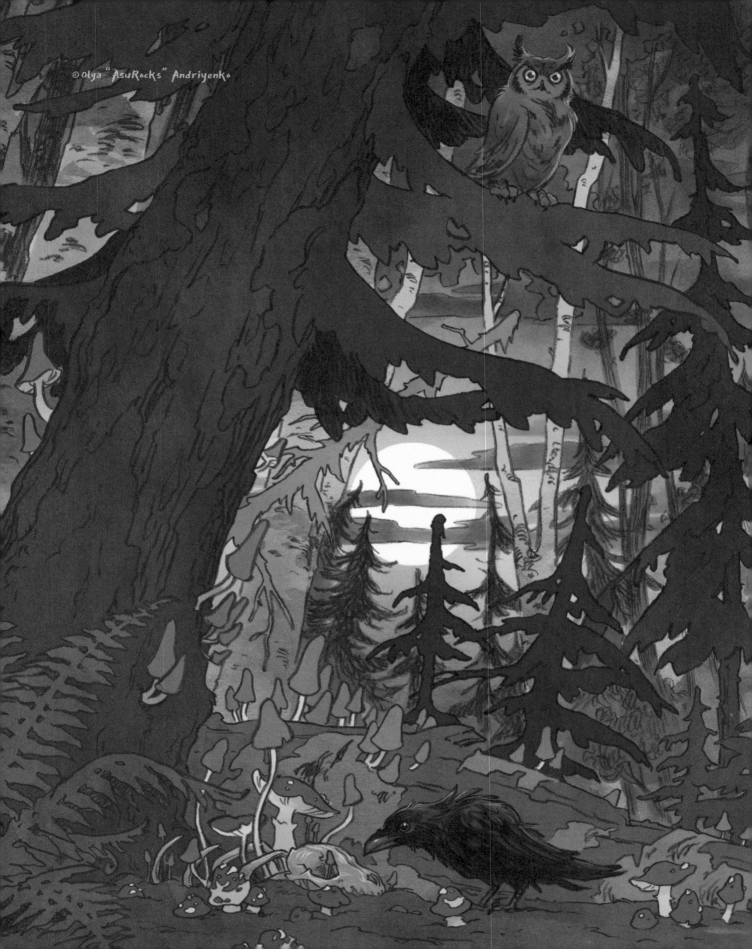

© Olga "AsuRocks" Andriyenko

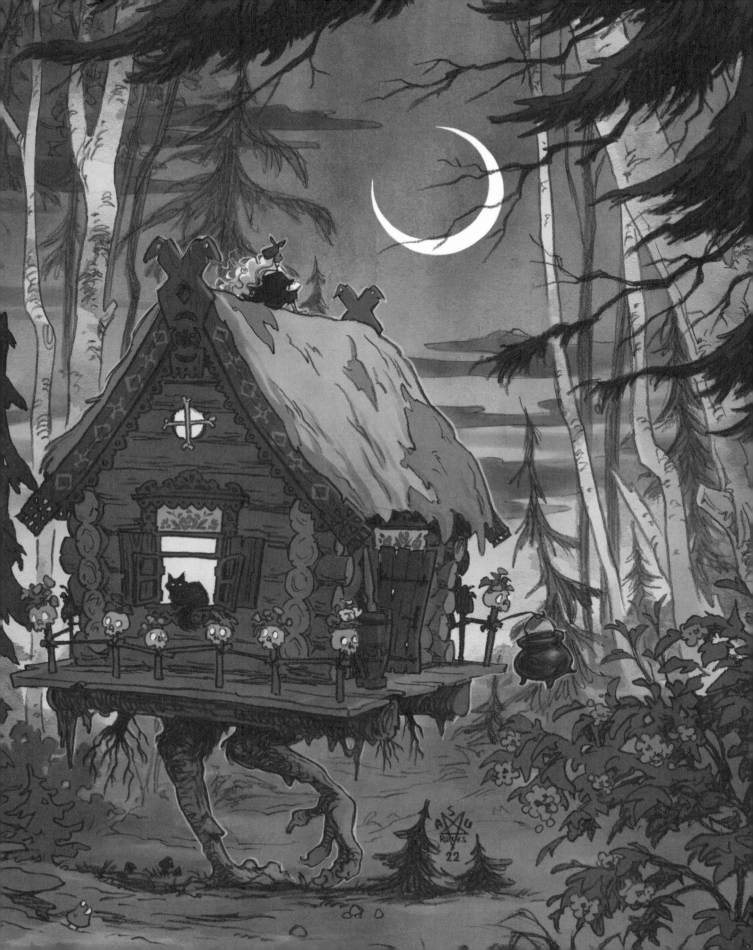

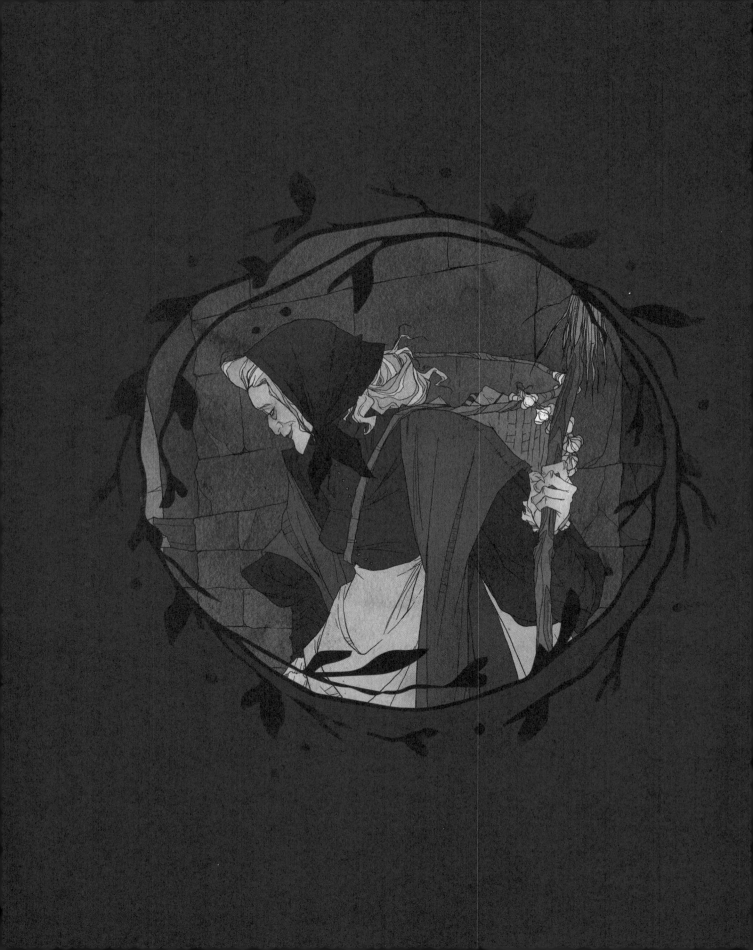

La Befana

La Befana is a fabled figure from Italian folklore, celebrated in the New Year as part of ancient tradition. She is a kindly but mysterious elderly woman, with a broom and a tattered shawl, who visits homes in the night to leave gifts for children as a reward for good behavior. In this chapter, illustrator Abigail Larson — who lives in La Befana's homeland herself — investigates this fascinating witch and her origins.

Abigail Larson | abigaillarson.com

Research & Rumors

Viene la Befana!

References to La Befana can be found in old Italian poetry. One text, by the poet Giovanni Pascoli, begins like this:

Viene, viene la Befana
Vien dai monti a notte fonda
Come è stanca! La circonda
Neve e gelo e tramontana!
Viene, viene la Befana!

This translates in English to:

Here comes, here comes the Befana
She comes from the mountains in the deep of the night
Look how tired she is! All wrapped up
In snow and frost and the north wind!
Here comes, here comes the Befana!

Winter gifts

La Befana as a gift-giving wintertime figure long predates Santa Claus, who has taken on many of her qualities in our modern storytelling. Befana flies through the night sky on her broom and delivers gifts. While she is seen as a symbol of the New Year, in some traditional folklore the image of this benevolent, wise old woman can be seen as a symbol of honoring ancestors who continue to look out for the new generation.

Roman origins

Ancient Roman worship of the sun meant that winter months were an important time for reflection and renewal, as the sun was less prominent. The sixth day of the New Year is a pagan holiday, when a magical woman might come to visit a household with a broom to sweep away the old year. This ancient tradition is thought to be Befana's early origins.

LOCATION

Beyond the frigid Alps and across the valleys and mountains of Italy, one can find villages where elders whisper tales of La Befana when autumn gives way to winter. Children look forward to the holidays, but are told to be mindful of their manners, as La Befana is ever-vigilant at this time of year. She arrives on her broom with gifts for well-behaved children and garlic, onions, or coal for naughty ones. Some families set aside a little glass of wine and a piece of pandoro (a sweet, festive bread) as an offering to her.

Important Notes

Flying

According to the stories, Befana travels throughout the land on the fifth night of January on a magical broomstick to visit every child's home, either down the chimney or through a keyhole if no chimney is present. Her broom is interpreted as a symbol of trees and nature. In some older tales, she is said to ride a goat as well; goats are a symbol of magic, fertility, and strength.

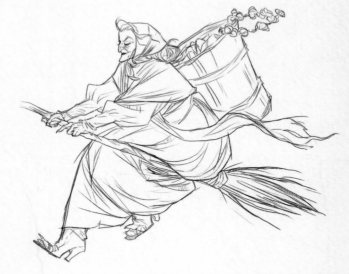

Strega dolls

Throughout Italy, wooden effigies of Befana are burned in town centers to symbolize the end of the year and welcome in a new time of prosperity. Such traditions have been observed in many parts of the world as a way to honor the old gods, but today it is simply seen as a sign of renewal and cleansing for the New Year. Some provinces still practice this tradition, but it's more common to see shop windows full of little wooden Befana dolls and puppets on display in honor of the ritual.

Broken shoes

La Befana is described as an old crone, bent with age, wearing tattered dark robes, broken shoes, and old, worn-out stockings. She carries a basket or sack full of gifts, and a broom. Interestingly, she is rarely referred to as a "strega" ("witch") in Italian folklore, though this could be an effort to overwrite her pagan origins. She is considered her own spiritual entity, with her own magic that goes back many centuries.

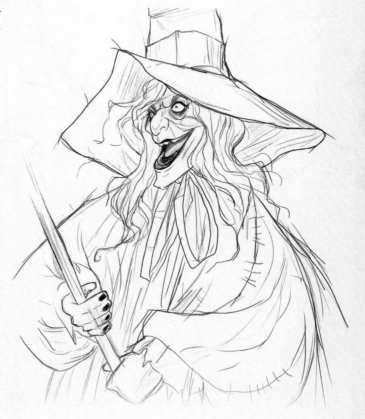

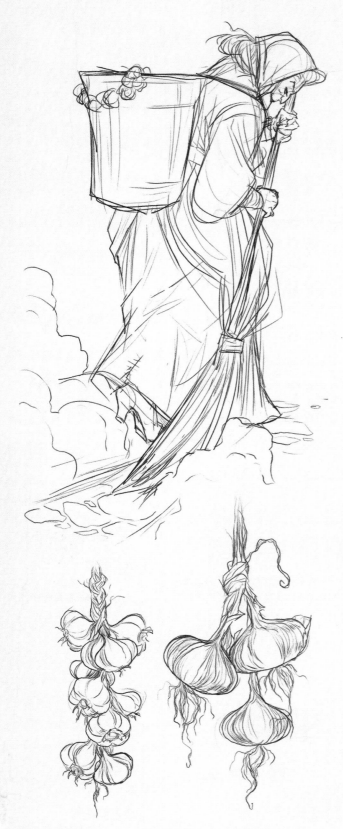

Sweeping ashes

La Befana's dark dress and shawl might not be dark-colored cloth, but colored by soot from all the chimneys she climbs down while delivering gifts. Traditionally, after she fills the stockings at the hearth, she carefully sweeps up all the fallen ashes. This is an act of sweeping away the previous year to make way for a clean, fresh start to the new one.

Stocking gifts

As the tradition still goes today, children leave stockings hanging by their hearths for La Befana to fill. While it's most common for her to leave candy, gifts, or coal in a stocking, she is also known to leave a candle in some households. Candles can be powerful magical items themselves, but one left by La Befana is a symbol of hope for the year to come, a way to shine light in the darkness, and a reminder that the warmth of spring will soon come again.

Onions & garlic

Because she is thoughtful in her judgment, knowing that all children are at least a little naughty sometimes, she often leaves both coal (in the form of rock candy, or "carbone dolce della Befana") as well as a little gift for each child. Sometimes she's known to leave a clove of garlic or an old onion at the bottom of a particularly naughty child's stocking to serve as a reminder to behave in the coming year!

Studying the Witch

IDEATION

Finding a way to depict La Befana means embracing her most noted characteristics. Her bent figure, shawl and robes, broom, and ragged shoes are all important aspects of her character to consider, but it's also important to find the right pose to describe her. I focus on that here. She has been described as bent and haggard, but she is also very powerful, possessing magic and wisdom and kindness. I have to find the right pose to encompass all her traits.

To disguise herself as a village crone would require a silhouette that appears hunched over and tired, as shown in sketch **1**, her robes dragging. But if I want to bring in an air of mystery and magic, her broom acts as a great prop that also balances the silhouette, in examples such as **3**, **4**, and **10**. Throughout these thumbnails, I try to emphasize her cunning expression through her face and hands.

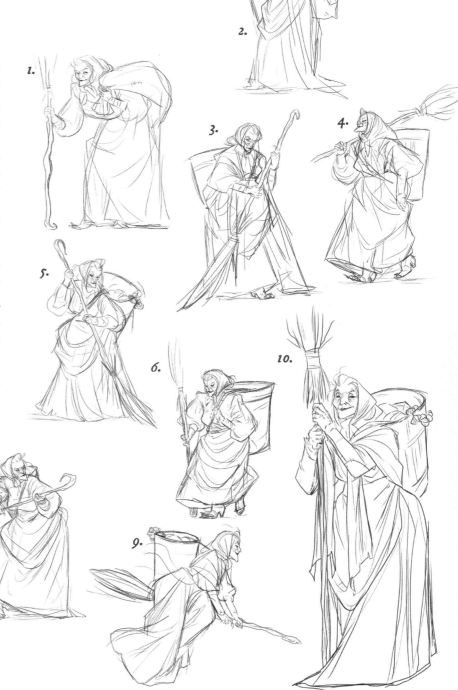

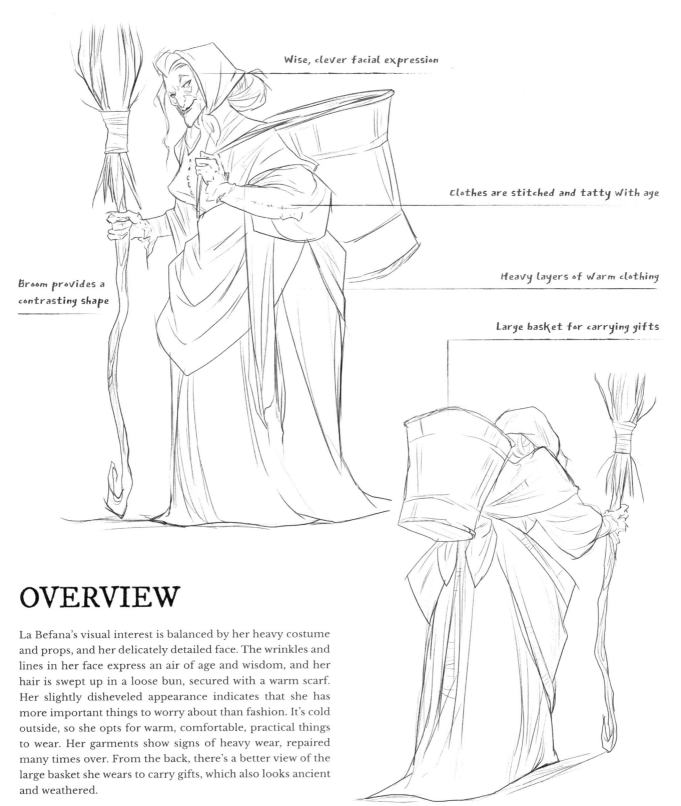

Wise, clever facial expression

Clothes are stitched and tatty with age

Heavy layers of warm clothing

Broom provides a contrasting shape

Large basket for carrying gifts

OVERVIEW

La Befana's visual interest is balanced by her heavy costume and props, and her delicately detailed face. The wrinkles and lines in her face express an air of age and wisdom, and her hair is swept up in a loose bun, secured with a warm scarf. Her slightly disheveled appearance indicates that she has more important things to worry about than fashion. It's cold outside, so she opts for warm, comfortable, practical things to wear. Her garments show signs of heavy wear, repaired many times over. From the back, there's a better view of the large basket she wears to carry gifts, which also looks ancient and weathered.

EXPLORATIONS

Now that we have established La Befana's costume elements and an overall shape that suits her character, we can explore how she might behave and carry herself in her everyday life.

▶ Here, Befana walks confidently without using her broom as a walking stick. Instead, she carries it over her shoulder, head held high as she strolls down a piazza unnoticed by passersby.

◀ In the same way that many people leave a gift of cookies and milk out for Santa Claus, it's common for Italian households to leave a slice of pandoro (or panettone) and a small glass of wine for La Befana – a very welcome offering on cold winter nights.

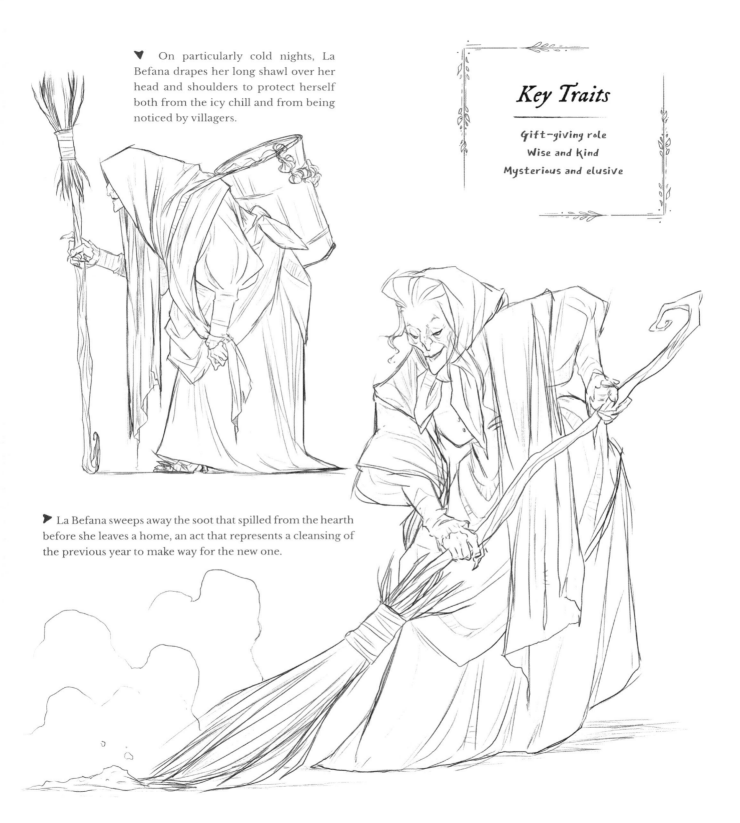

♥ On particularly cold nights, La Befana drapes her long shawl over her head and shoulders to protect herself both from the icy chill and from being noticed by villagers.

Key Traits

Gift-giving role
Wise and kind
Mysterious and elusive

▶ La Befana sweeps away the soot that spilled from the hearth before she leaves a home, an act that represents a cleansing of the previous year to make way for the new one.

Meeting the Witch

Capturing a witch's personality is no easy feat! They are by nature mysterious, surreal, and enigmatic, and can adapt to their surroundings to go unnoticed by many. So the best way to try to depict one is to understand her strongest traits and personality.

La Befana is overall a kindly figure with an air of mischief and wit, so focusing on her expression is key. It is also essential to encompass her traditional clothing and magical possessions, which are crucial to her role. Here she is also accompanied by little goblin-like creatures who help craft the gifts she gives out to children. These creatures are similar in folklore to the brownies and hobgoblins of other European tales, and symbolize La Befana's tie to the mystical fae realm.

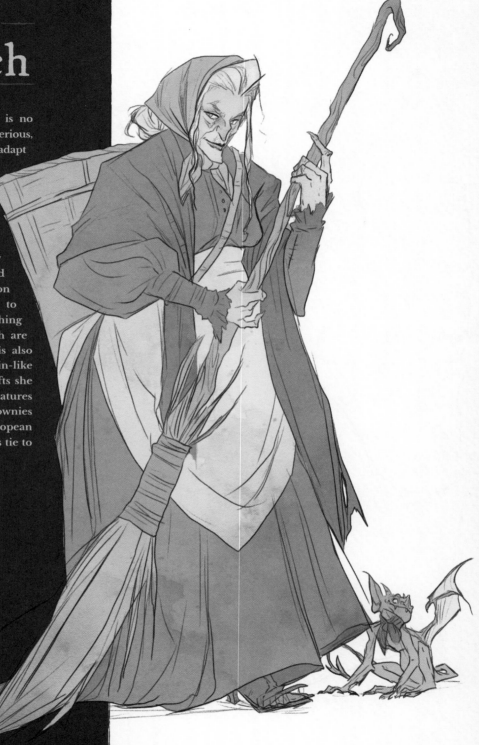

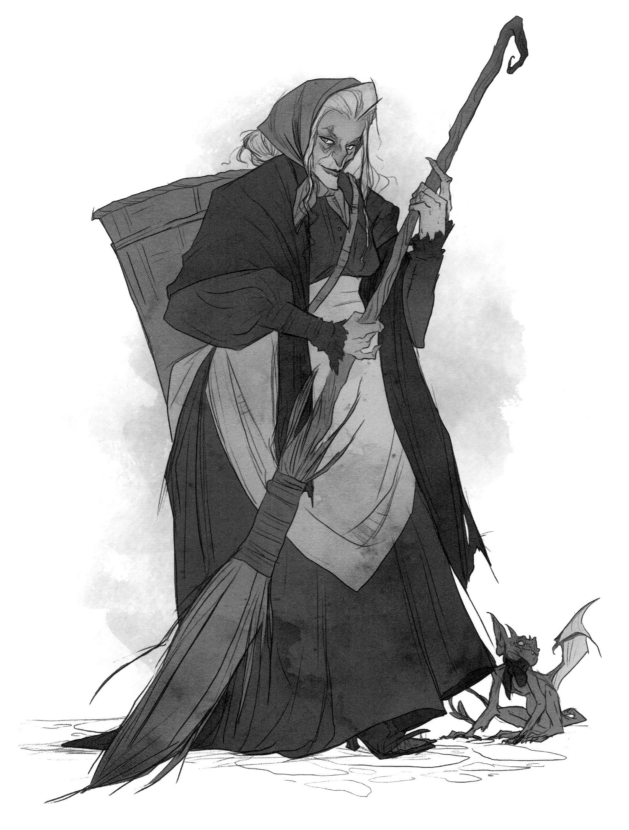

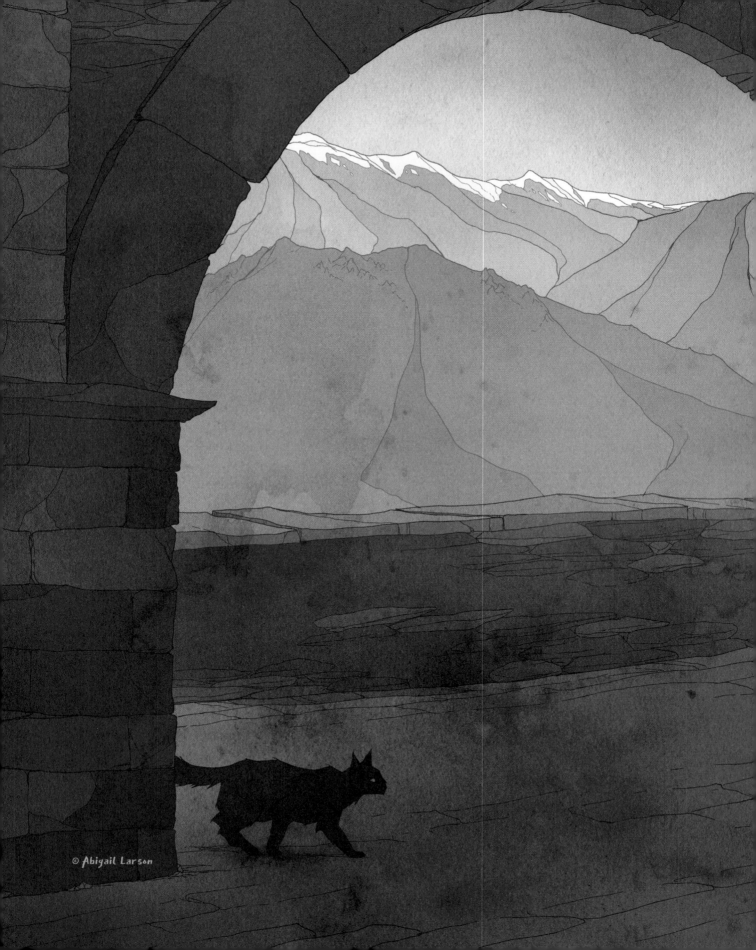

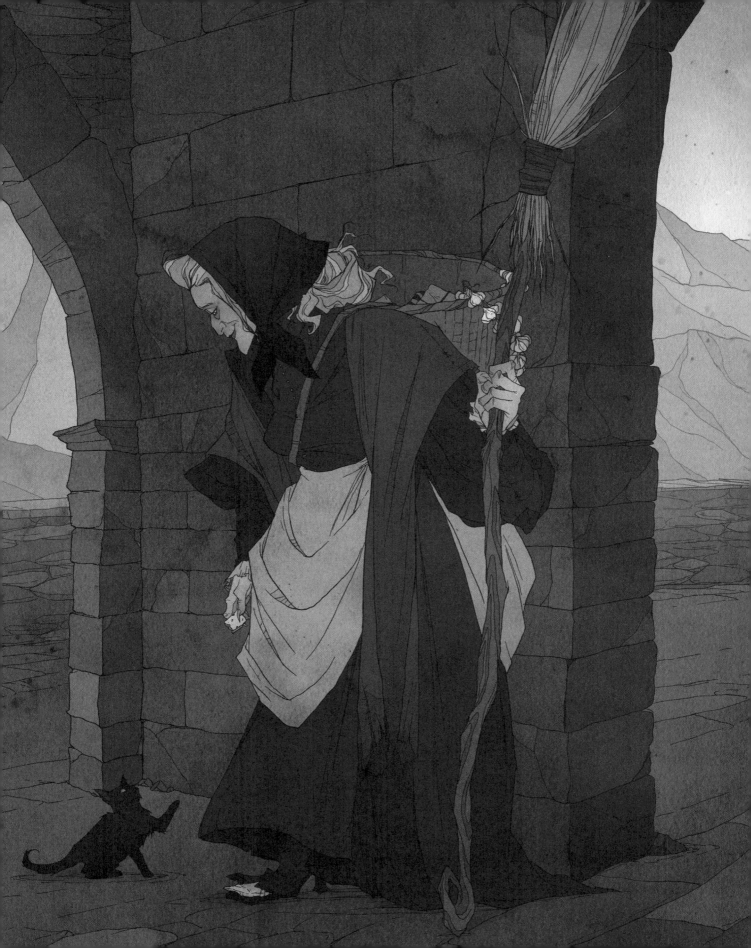

The Gingerbread Witch

One of the most iconic witches in the world of fairy tales is from Hansel and Gretel, made famous by the Brothers Grimm. This mysterious, unnamed old woman lives in a gingerbread house in the woods, built as a temptation to lure in passersby. A young brother and sister, Hansel and Gretel, are captured by this child-eating hag, but manage to push her into her own oven and escape. In this chapter, artist Leroy Steinmann shares his interpretation of this classic witch.

Leroy Steinmann | leroysteinmann.com

Research & Rumors

Gingerbread house

There have been many mentions of candy houses in different countries throughout Europe, but it was the Brothers Grimm, two German authors and academics, who first popularized the concept of a witch with a house made of gingerbread. This sweet, aromatic biscuit, made with ginger and spices, has been a popular confection in Europe for many centuries.

A magical baker

A gingerbread house, fit for a person to live in, could not be made by a typical baker. The sizes and quantities of candy and gingerbread required would be immense! As the house's owner is a witch, we can assume that there is some sort of magic involved in creating and maintaining it.

A Grimm warning

The Brothers Grimm version of *Hansel and Gretel* was written around 1800, likely based on traditional German stories that had been passed down orally. It would have been used as a cautionary tale to scare children, warning them to keep away from strangers' houses.

LOCATION

Deep in the woods in Germany, near Schwarzwald, you may stumble upon a house made of gingerbread and candy. Its roof and walls are made of crisp ginger biscuit, its walls are delicious cake, and its window panes are clear sugar. Many lost wanderers have been lured in by its sweet smell, never to be seen again.

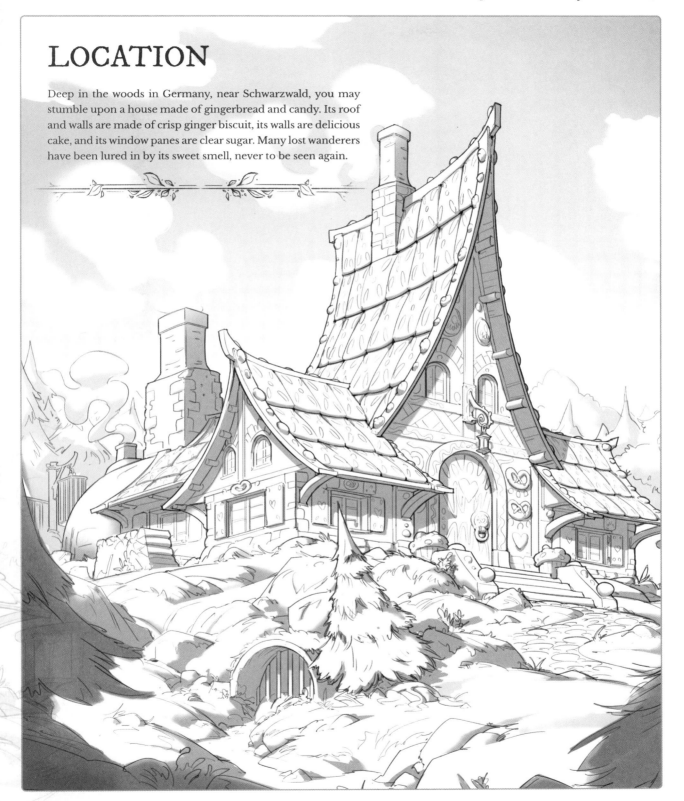

Important Notes

Weak eyesight

This witch is very short-sighted, almost blind. When she attempts to fatten up Hansel for eating, he manages to delay her by holding out a thin bone and pretending it is his finger. The witch compensates for her weak vision with a sharp sense of smell, like an animal's.

A child-eater

This witch's most frightening aspect is her cannibalistic appetite for children. She lures lost children into her delicious home, fattens them to her liking, and eventually eats them. Hansel and Gretel are especially resourceful and are lucky to outwit her.

Baking powers

I imagine this witch uses her magic to bake great quantities of uncommonly strong, delicious gingerbread, having to frequently repair the pieces that visitors have taken from her home. Perhaps she can even bring her gingerbread creations to life to do her bidding.

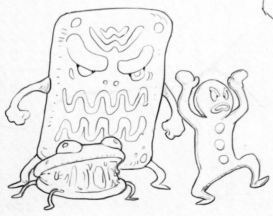

"This witch's most frightening aspect is her cannibalistic appetite for children"

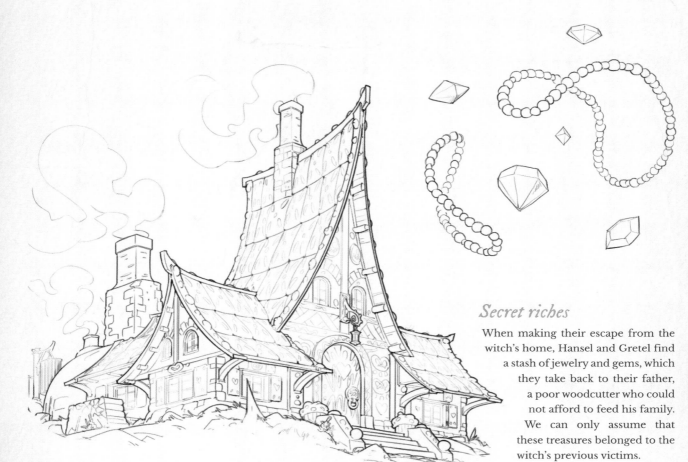

Secret riches

When making their escape from the witch's home, Hansel and Gretel find a stash of jewelry and gems, which they take back to their father, a poor woodcutter who could not afford to feed his family. We can only assume that these treasures belonged to the witch's previous victims.

Gingerbread house

The witch's gingerbread house is perhaps the most iconic feature of this story. I imagine it being grander than a small, rustic cottage, as it's constructed with magic. Tall gables and chimneys would help it stand out among the trees and attract the attention of lost travelers.

Captured children

Though the witch's gingerbread house is enchanting from the outside, the inside tells a very different story. Once a child is captured, they are locked in a cage for fattening, or made to carry out the witch's chores while they await their unfortunate end.

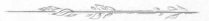

Studying the Witch

IDEATION

When researching for this design, I look at some clothing references from Germany in the 1800s, and also at how the witch has been depicted in old illustrations. I combine these elements while trying to find ways to show her character attributes in her outfit. For example, she is a cannibal, so might wear a necklace of bones or carry a cleaver on her back. The latter could even be a play on her hiding her violent intentions behind a false, friendly front!

She would obviously be incomplete without her baking gear and an apron over her dress. The keys to her victims' cages are carried in a ring on her belt. She has been described as bent and walking with a crutch, so I incorporate those elements too. More than trying to find the perfect sketch, I am trying to get a feel for the character and the attributes that best tell her story.

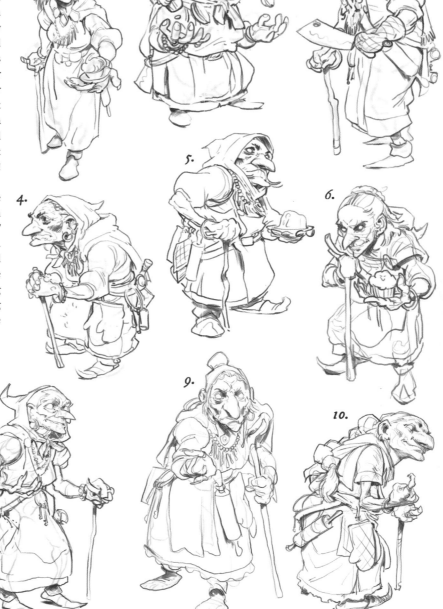

Apron and Kitchen
utensils for baking

Deceptive grandmotherly appearance

Bone necklace hints at her past victims

Comfortable,
cozy slippers!

Cleaver and shackles
behind her back

OVERVIEW

The gingerbread hag is essentially an evil character, so I try
to capture that in her posture and design. She entices victims
into her house with the promise of food and candy, with the
intention of trapping, killing, and feasting on them, so I try
to represent all of those elements in her outfit: her baking
utensils, the bone necklace and keys, and the cleaver and
shackles on her belt. I also want her to still feel somewhat like
a friendly granny, capable of deceiving travelers by putting
on a warm, cheerful act. I also imagine she mostly stays near
her home, so I've given her a pair of comfortable house shoes!

EXPLORATIONS

This witch's typical activities consist of baking – as her impressive gingerbread house is a constant challenge to maintain – and enjoying the occasional meal of an unlucky visitor. We can explore those ideas in these sketches.

▶ In this sketch, the witch sits down for her favorite part of the day: enjoying a hard-earned meal. She looks blissfully content and at ease, almost endearing, but a closer look at her plate of mysterious bones reminds us that she is a dangerous character.

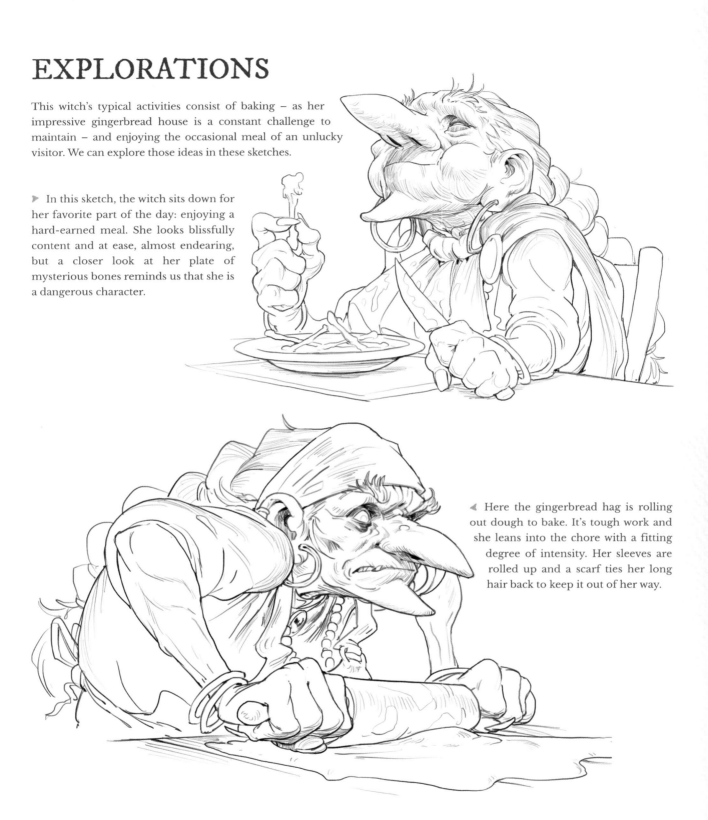

◀ Here the gingerbread hag is rolling out dough to bake. It's tough work and she leans into the chore with a fitting degree of intensity. Her sleeves are rolled up and a scarf ties her long hair back to keep it out of her way.

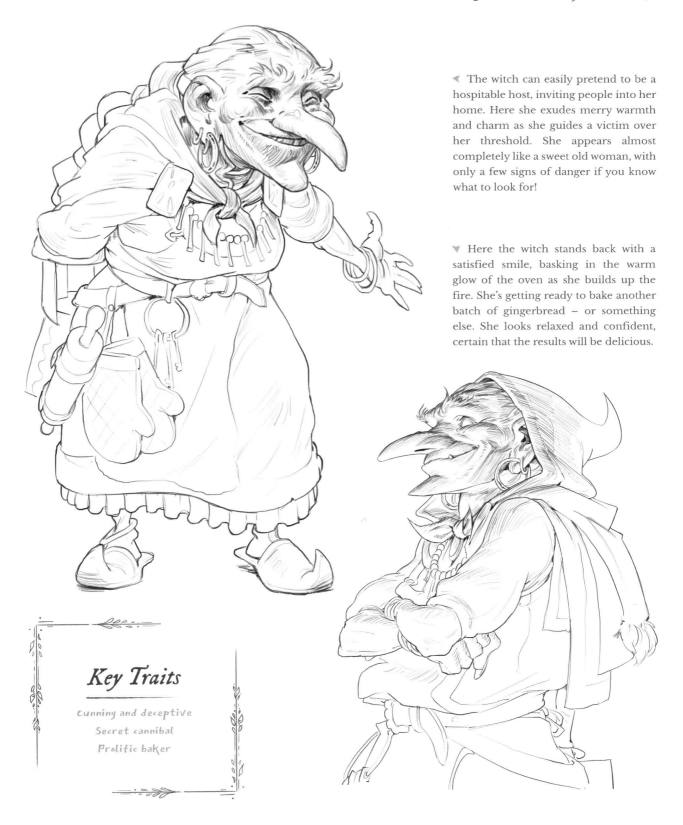

◄ The witch can easily pretend to be a hospitable host, inviting people into her home. Here she exudes merry warmth and charm as she guides a victim over her threshold. She appears almost completely like a sweet old woman, with only a few signs of danger if you know what to look for!

▼ Here the witch stands back with a satisfied smile, basking in the warm glow of the oven as she builds up the fire. She's getting ready to bake another batch of gingerbread – or something else. She looks relaxed and confident, certain that the results will be delicious.

Key Traits

Cunning and deceptive
Secret cannibal
Prolific baker

Meeting the Witch

The gingerbread witch is a thoroughly evil, frightening character: a malevolent, child-eating hag who is more of a creepy monster than a human. I have made sure to emphasize her villainous nature in my design. Her smile reveals a hint of sharp teeth as she offers some tempting biscuits in her clawed hand.

Despite her hunched posture and walking stick, her arms look tough and wiry from her baking exertions – an unexpected strength, all the better for wrangling surprised captives into their cages.

Her skill as a baker is evident throughout her design, from the utensils and oven mitts to the more subtle details, such as the piping-like pattern on the hem of her dress and the clasps of her cape matching the iced biscuits in her hand. But it is the necklace of bones, the half-hidden cleaver, and the ring of suspicious keys that tell the true story of this witch's wicked intentions.

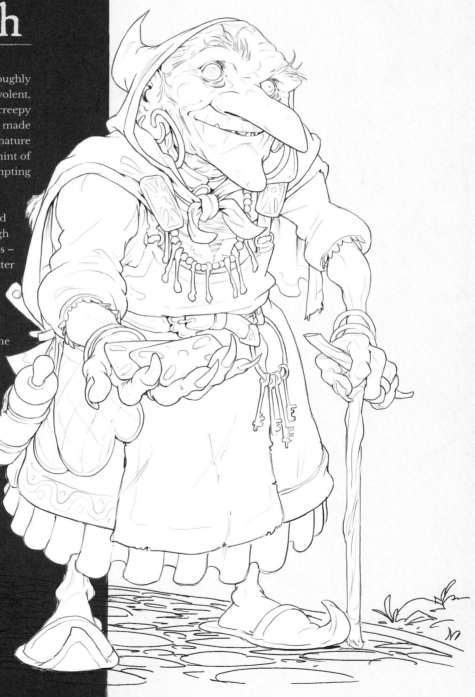

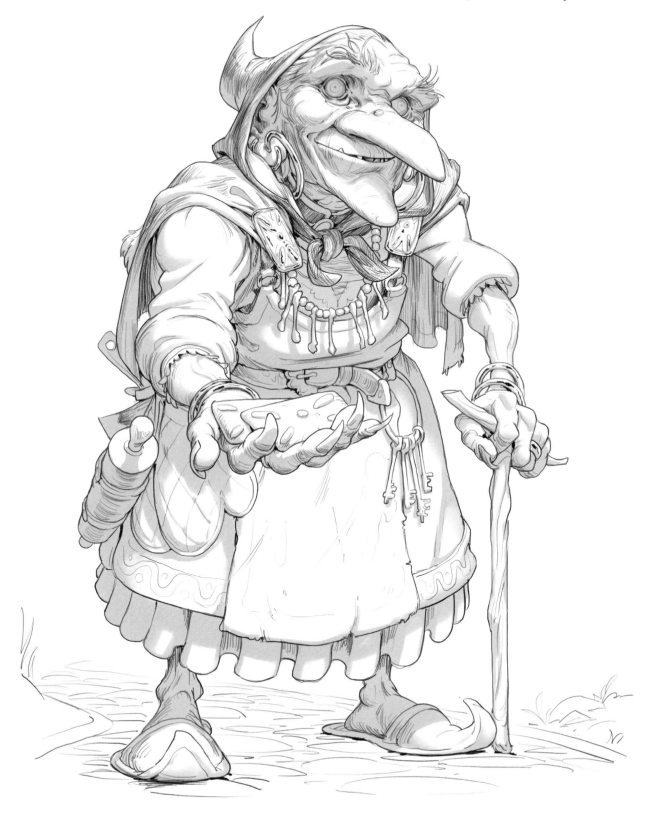

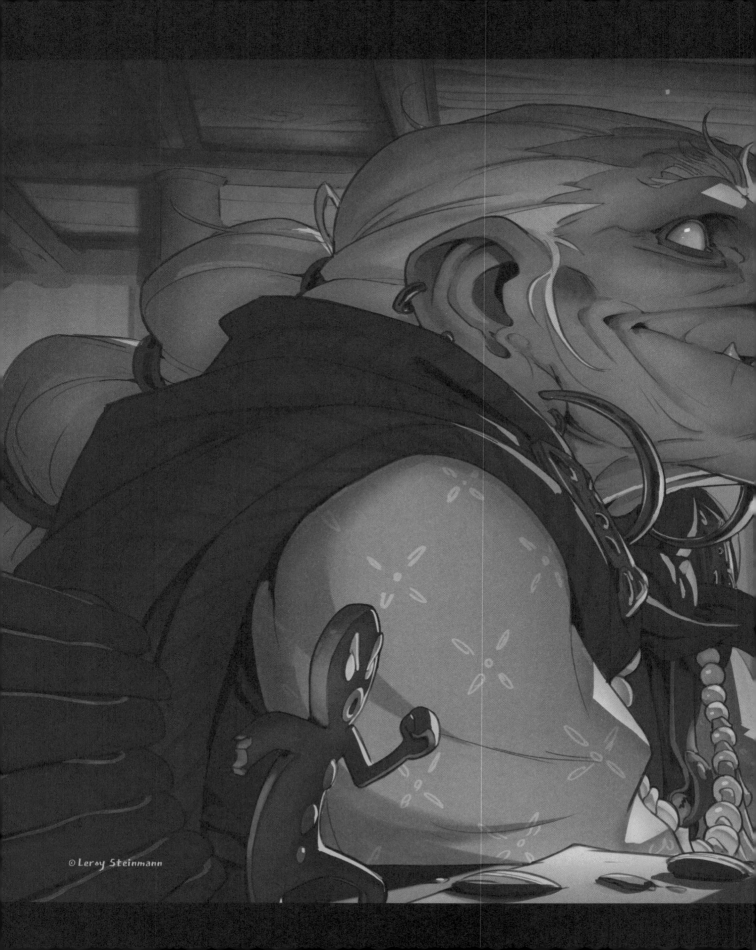

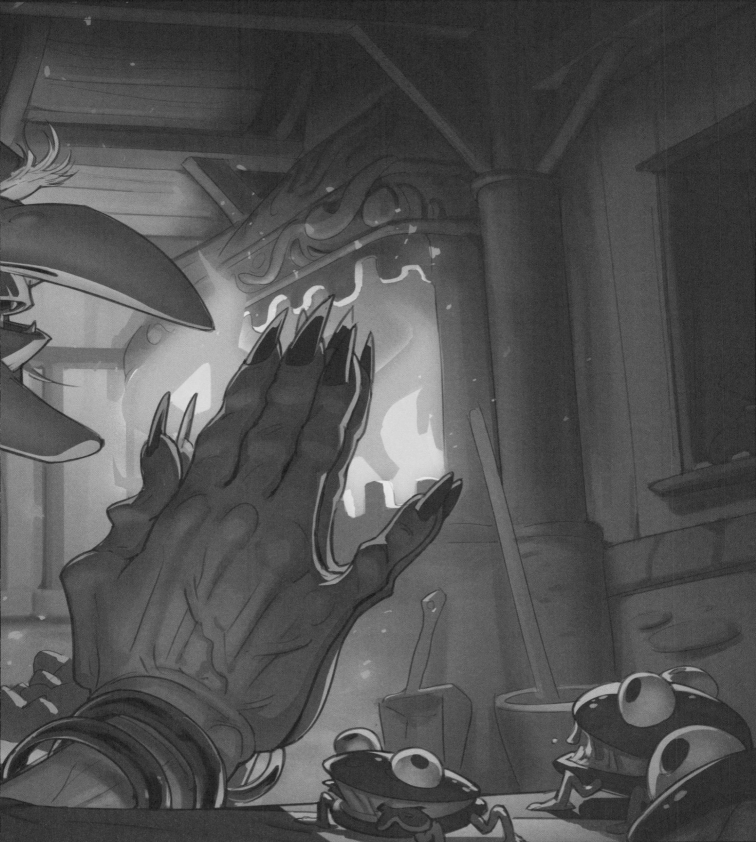

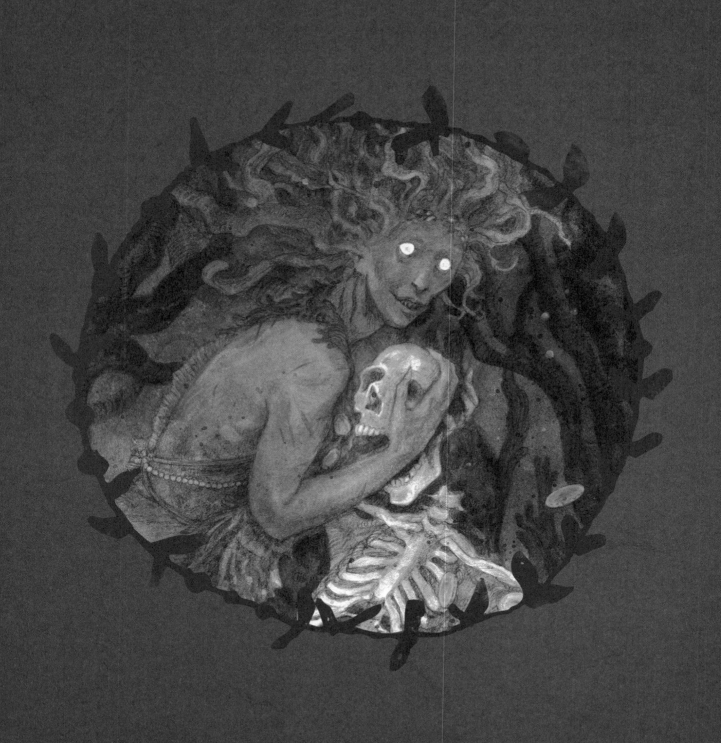

The Sea Witch

Sea witches and ocean-dwelling hags are found throughout stories
and legends the world over, but one of the best known is the Sea Witch
found in Hans Christian Andersen's tale, The Little Mermaid. *This
frightening witch grants the Little Mermaid human legs for a terrible
price — taking her beautiful voice and cursing her to never return to
the sea. Fantasy and horror illustrator Jana Heidersdorf dives
into the Sea Witch's underwater kingdom in this chapter.*

Jana Heidersdorf | janaheidersdorf.com

Research & Rumors

Sea witches' power

According to mythology, sea witches hold great power. They control the tides, can knot the wind into ropes or fabrics, and even see into the future. This particular witch even wields the power of transformation. When the Little Mermaid begs for her boon, the witch already knows the heartbreak to follow, but she has the wisdom to know that no power can change a young heart's desire.

The drowned dead

The Norse sea goddess Rán keeps the drowned at the sea floor, just as the Inuit goddess Sedna, Mother of the Sea, rules over the underworld. It is only natural for this Sea Witch to share her home with the dead. While mermaids who wish for the joyous company of the living are disappointed when their playmates arrive lifeless and limp at their underwater palace, the Sea Witch patiently stacks their bones.

A cruel price

The Sea Witch's price for her magic is steep, whether it costs a mermaid her tongue and gift of song, or her lush tresses of hair. No matter the witch's power – however comfortable she may be among the creatures of the deep, the snakes and toads – there must be some bitterness in her heart as she makes the mermaid kingdom pay for keeping her in the shadows.

LOCATION

When the Little Mermaid seeks out the Sea Witch, she travels a long road over barren ground, past swirling whirlpools, and through a bubbling mire. Even more terrifyingly, the witch's dwelling lies surrounded by a forest of polyps with bodies like snakes and branches like tentacles. These creatures hold all sorts of treasures in their strangling embrace: the bleached skeletons of the drowned, chests spilling gold and rubies, rudders and oars, and even the delicate body of a lost mermaid. In this kingdom of the dead, the Sea Witch's home can be found, built from human bones held together by slick kelp and old netting.

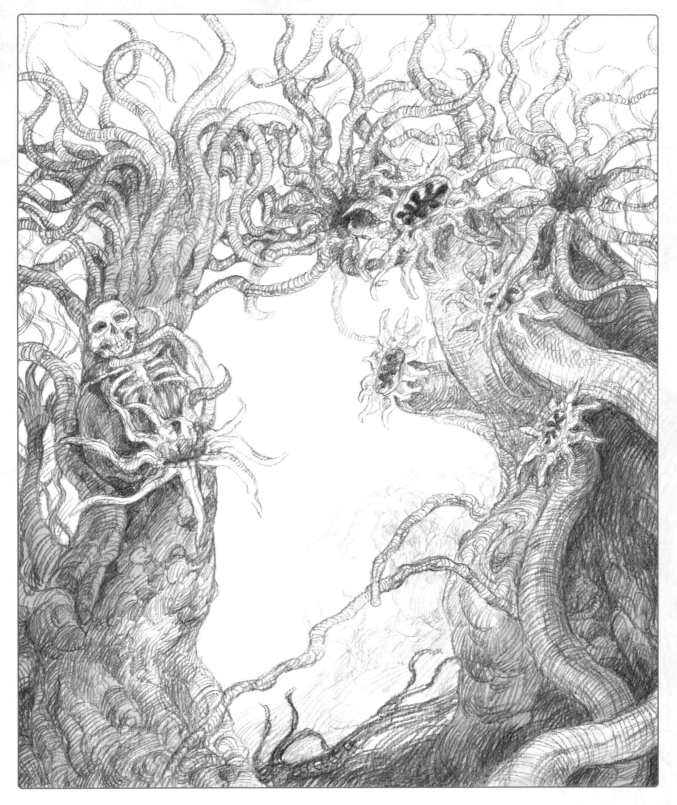

Important Notes

Moray tail

Sea witches can take many shapes, traditionally those of a selkie or a mermaid, while popular culture has come to the consensus of giving them the body of an octopus.
Yet I consider this Sea Witch essentially a mermaid, an outcast living on the periphery of the underwater kingdom. She is set apart by her power, strangeness, and lack of beauty, but is not an entirely different being. As a dangerous creature hiding in the cracks of her world, what fish tail would suit her better than that of the moray eel, with its sharp teeth and sleek body?

A precious potion

Despite the ugliness of its ingredients, including the Sea Witch's own blood, her potion is as clear as water and as bright as a sparkling star. What kind of vessel would hold such a precious draught? A perfume vial, scavenged from a shipwreck? An old, misshapen bottle, once containing a secret message, now lost at sea? Or perhaps a snail shell so fine it is translucent, with a stopper carved from bone and sealed with slug slime?

A witch's cauldron

In the days of Aristotle, people used cauldrons to retain air as they submerged themselves underwater. What early explorer dove deep enough to cross paths with the Sea Witch? She still uses their metal helmet to practice her dark magics. Unfortunately, from an artist's perspective, such an ancient diving device would look no different from a household item, while the iconic nineteenth-century diving helmets would be incongruent with the setting of this fairy tale. Yet even the invisible parts of her backstory make the character come more alive in my imagination!

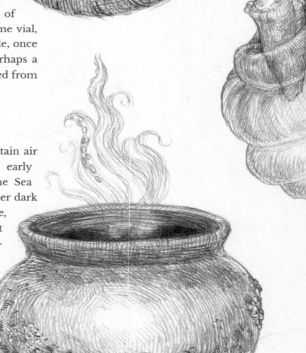

Sea snakes

Despite living isolated from polite mermaid society, the Sea Witch is hardly lonely. She shares her home with sea snakes so familiar they writhe over her body – snakes so plentiful and tame she can weave them into a sponge with which to clean her cauldron. Yet it is not only the snakes, her "little chickens," she keeps as companions. When the Little Mermaid first meets the Sea Witch, she is leisurely feeding a toad from her own mouth.

Enchanted dagger

As it takes blood – her own – to work the Sea Witch's magic, so it takes blood to undo it. She keeps a collection of knives and daggers hidden away – blades that have sunk to the sea floor through the ages, their previous owners being druids, soldiers, and seafarers. They are the only tools that can undo the damage of her clients' ill-considered wishes. The Sea Witch keeps the blades ready and sharp as splintered moonlight until the day they are eventually needed.

Tidal power

What is the Sea Witch's source of power? It is rumored to be the moon, that mystical orb ruling the tides. According to the fairy tale, if the Little Mermaid did not arrive just before sundown, she would have needed to wait another year for her potion to be brewed. Therefore, we can assume that the Sea Witch's powers are tied to the celestial bodies in some way – whether to the seasons or any other aspect of the natural world.

Studying the Witch

IDEATION

As I come up with rough sketches, I think first of the mood I am aiming to convey. Is she meant to look secretive and creepy? In this case I could choose a hunched pose (**1**), obscure her face (**3**), or add long, claw-like fingers. Is she supposed to look feral, powerful, or slick like an eel? For these, I consider textures and the direction of compositional lines; dynamic swirls add wildness, while straight lines add weight. With a mermaid character, the fish tail is a powerful compositional element to add dynamics to the pose and guide the viewer's eye.

Smaller details can help create balance or contrast in the design. For example, a twisted tail can be grounded by vertical strands of hair, while wild tangles of seaweed can add a spark of liveliness to an otherwise calm composition. The Sea Witch's sea-snake companions offer another opportunity to influence the figure's expression. They can be included as if they are an extension of the witch herself, or like beloved pets, allowing me to show an unexpected and playful side of the character.

When choosing the final thumbnail, I think about how the Sea Witch would seem to the Little Mermaid – like somebody mysterious and intimidating.

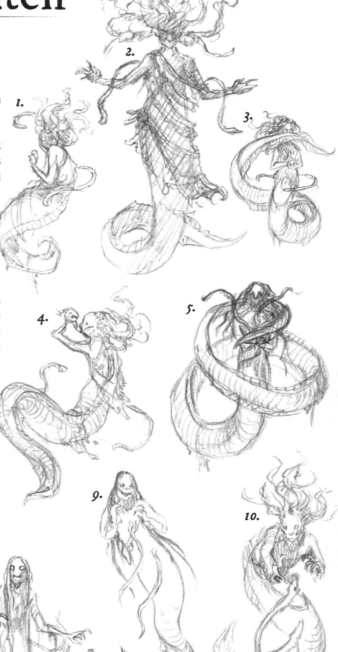

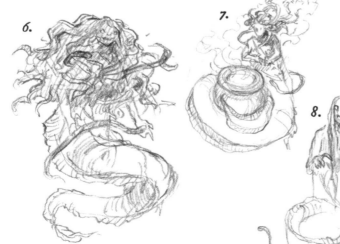

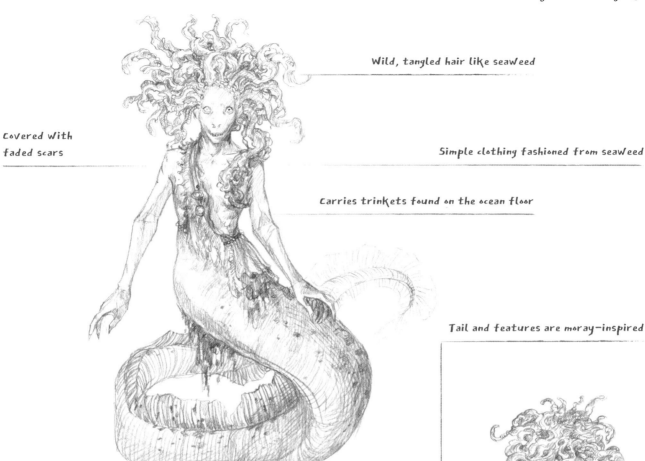

Wild, tangled hair like seaweed

Covered with faded scars

Simple clothing fashioned from seaweed

Carries trinkets found on the ocean floor

Tail and features are moray-inspired

OVERVIEW

So far I have established the Sea Witch to be a moray mermaid, a scavenger comfortable among the dead, and have designed her familiars. The witch is a wild creature with strong ties to the natural world, at odds with the orderly and strict society of the undersea court. There will be no painful adornments piercing her tail and most certainly no sea-shell bikinis!

Her facial features are mostly humanoid, but with the sharp teeth and glaring eyes of a moray eel. Her hair is a wild tangle of kelp and seaweed, while barnacles grow on her scalp. Due to her practice of blood magic, her skin is covered with scars. As her looks are of indeterminable age, we can only assume she is ancient by how much the oldest scars have faded.

The Sea Witch wraps herself in seaweed, not as a fashion choice but so she can tuck interesting finds away in the layers. However, it would be wrong to assume she is wholly immune to the glimmer and glitter of the treasure she discovers between shipwrecks and corpses. Among the strands of weed one can catch a glimpse of pearls, gold brooches, and hand-carved bone amulets.

EXPLORATIONS

These sketches show the two different sides of the Sea Witch:
the fearsome, infamous caster of dark spells, and the reclusive
hermit who spends most of her time with only her pets and
potions for company.

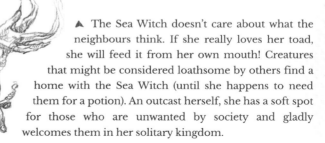

▲ The Sea Witch doesn't care about what the
neighbours think. If she really loves her toad,
she will feed it from her own mouth! Creatures
that might be considered loathsome by others find a
home with the Sea Witch (until she happens to need
them for a potion). An outcast herself, she has a soft spot
for those who are unwanted by society and gladly
welcomes them in her solitary kingdom.

◄ Comparing her simple and isolated
life with the splendor of the undersea
king's palace, it can be easy to forget how
powerful the Sea Witch truly is. She is not
simply peddling cheap tricks or old wives' tales,
but is a creature capable of calling upon the sea itself.
Nowadays few witness her wrath, but should you be foolish
enough to cross her, you might find the water squeezing your
body until the bones break.

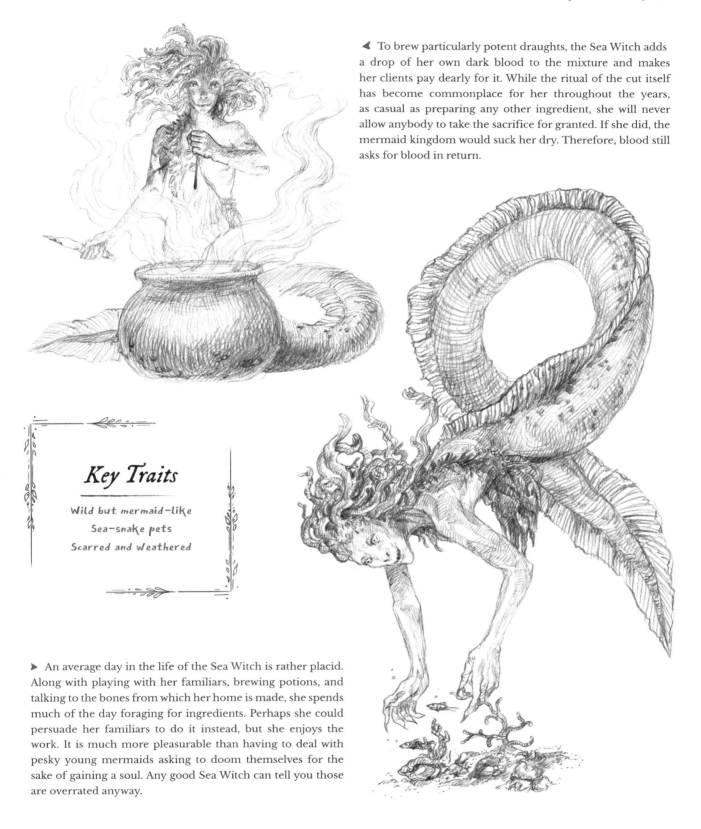

◄ To brew particularly potent draughts, the Sea Witch adds a drop of her own dark blood to the mixture and makes her clients pay dearly for it. While the ritual of the cut itself has become commonplace for her throughout the years, as casual as preparing any other ingredient, she will never allow anybody to take the sacrifice for granted. If she did, the mermaid kingdom would suck her dry. Therefore, blood still asks for blood in return.

Key Traits

Wild but mermaid-like
Sea-snake pets
Scarred and weathered

► An average day in the life of the Sea Witch is rather placid. Along with playing with her familiars, brewing potions, and talking to the bones from which her home is made, she spends much of the day foraging for ingredients. Perhaps she could persuade her familiars to do it instead, but she enjoys the work. It is much more pleasurable than having to deal with pesky young mermaids asking to doom themselves for the sake of gaining a soul. Any good Sea Witch can tell you those are overrated anyway.

Meeting the Witch

This Sea Witch is hardly fond of guests. If building her home in a dangerous, carnivorous forest doesn't prove her commitment to solitude, her attitude surely does. While partially covering the Sea Witch's face with her tail means we are unable to admire her sharp teeth and cheekbones, this pose not only underlines her reclusive nature but adds an air of mystery as well. The long, flexible tail is as expressive a feature as the Sea Witch's hands or face. It creates a kind of shelter for the witch and her familiars, blocking strangers out.

Combining the organic textures of kelp and seaweed with the occasional detail of pearls gives the design some depth beyond that of a feral swamp creature. While it is primarily a nod to the Sea Witch being a scavenger, the riches of gold and jewelry are also symbols of power. For all we know, her brooches might once have belonged to a queen. She might, by some standards, be richer than the noble mermaids at court, who only adorn their tails with sea shells.

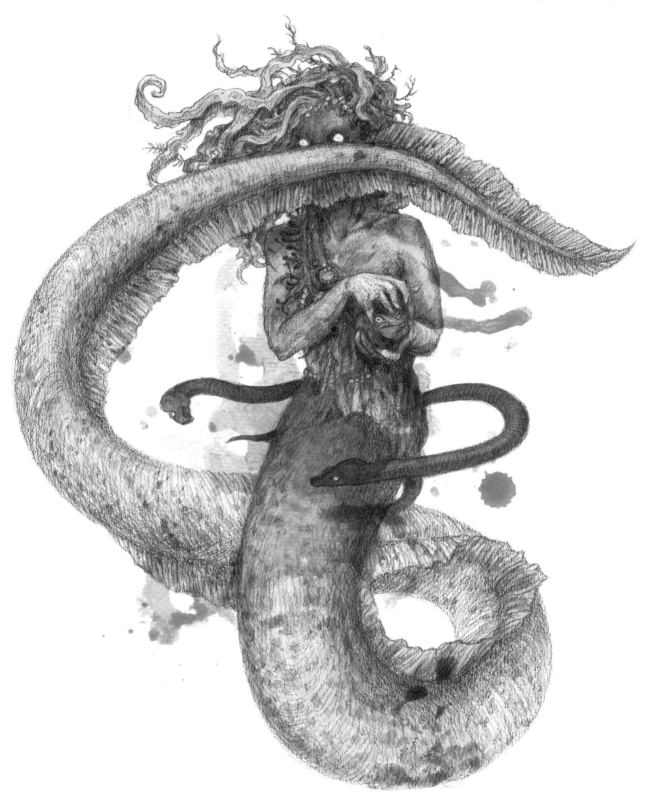

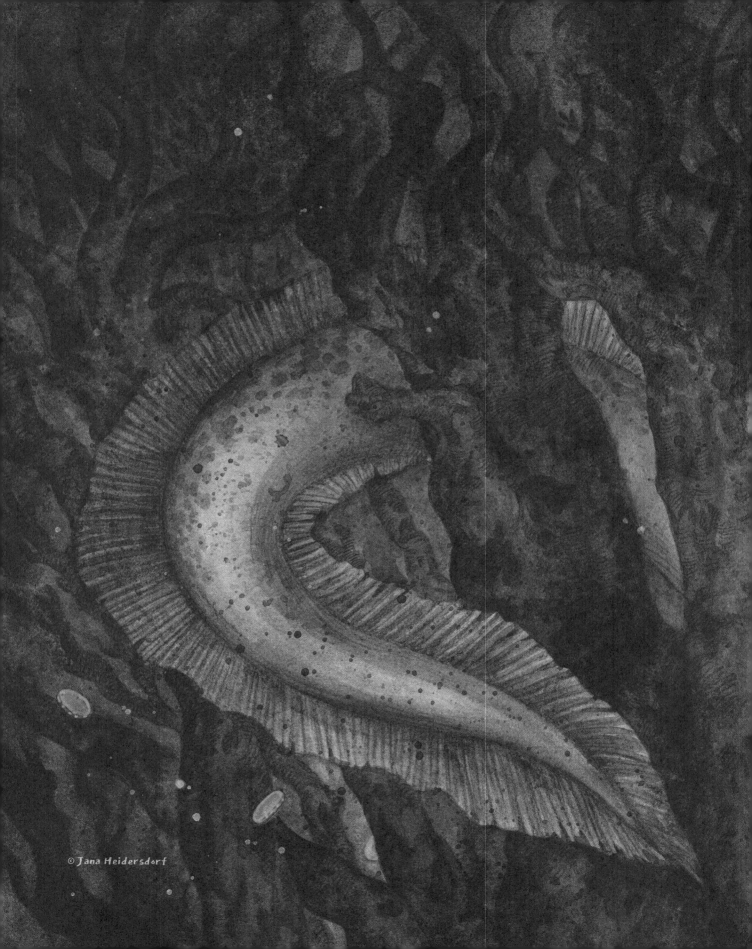
© Jana Heidersdorf

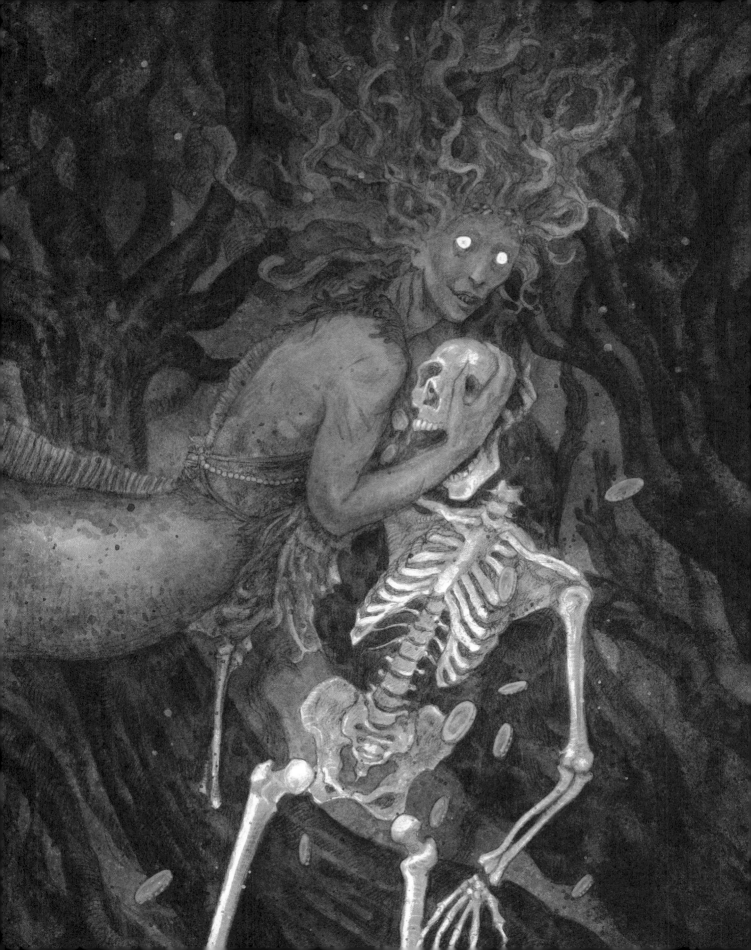

The Snow Queen

The Snow Queen is a mysterious enchantress famously found
in Hans Christian Andersen's fairy tale of the same name.
Dwelling in a snowy castle in a state of permanent winter, she
is a cold, enigmatic, and commanding figure, known to charm
children away to live in her icy home. In this chapter, illustrator
Madi Harper creates a depiction of this classic witch at home
in the halls of her frozen palace.

Madi Harper | madisonharper.myportfolio.com

Research & Rumors

Original telling

When we first encounter the Snow Queen in Hans Christian Andersen's original tale, she is seen from a window and grows from a single snowflake, as a sort of "queen bee" snowflake. She is dressed in white gauze, like snowflakes sewn together, and her skin is made of ice. When we meet her again later, she is no longer made of ice, but she still has an icy air about her.

An icy stare

One of my favorite details of the Snow Queen's description is her eyes: the little boy in the original tale describes them as sparkling like bright stars, but that they hold "neither peace nor rest" in their gaze. That is a very particular emotion to convey in an expression, but one that will set the tone for the whole character and her complexity.

A cold heart

The Snow Queen's powers are not described in great detail, but from Andersen's story, we know that she has the ability to harden a heart and make it cold, until a person can no longer remember the things they love. That is how I interpret her power – she has the ability to make you feel safe and warm, but it is a cunningly false sense of security that leaves you cold and alone. Her beauty and countenance are mesmerizing, almost hypnotic.

LOCATION

The Snow Queen's home is a castle made of ice. It has been described as having snow-drift walls, but my interpretation is a more structured look that feels grand and palatial. The witch can also be found sitting beside an intricately designed frozen lake, which I have made a key feature of the location by adding a swirling, icy floor and flowing, watery patterns. Some hanging snowflakes and an icicle chandelier add to the chilly feeling of this wintry castle.

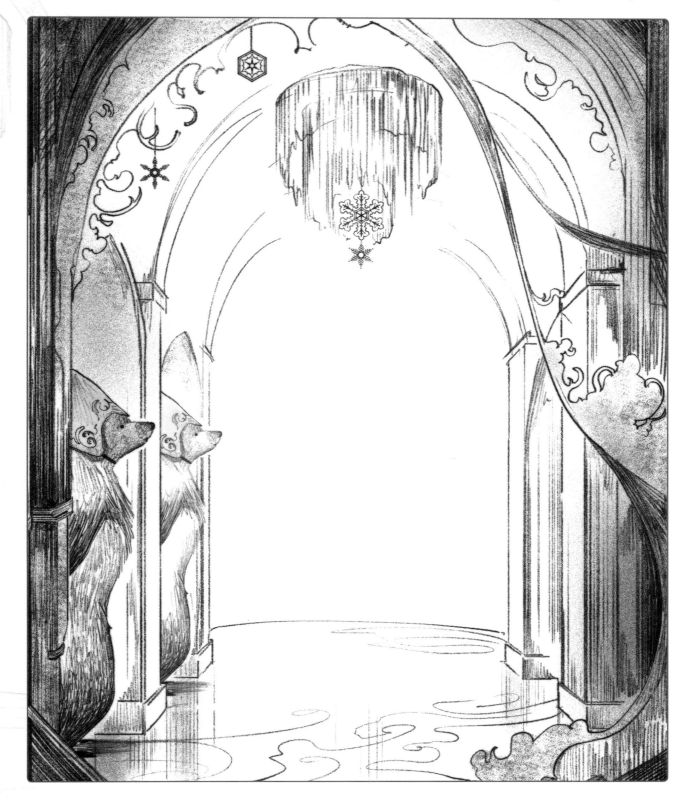

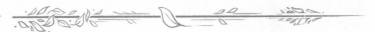

Important Notes

Sketching snow

The Snow Queen's palace is a severe, frozen place, described as being vast and glacial, with walls made from drifts of snow. Its cold, empty halls are lit from above by the aurora in the sky. Deciding how these snowy structures might look will be a key element of the piece.

A mysterious witch

The Snow Queen's expression is one of her most important features to capture, as it sets the tone for her whole look and character. Enhanced by a frozen icicle crown and a shawl made from woven snowflakes, her expression is cool, distant, and enigmatic.

Bear guards

The frozen palace is guarded by snowy creatures resembling chubby little bears. I imagine them to be quite intimidating – but also endearing, due to their small size – as they stand at the ready in a line, wearing helmets to denote their rank and the kingdom they fight for.

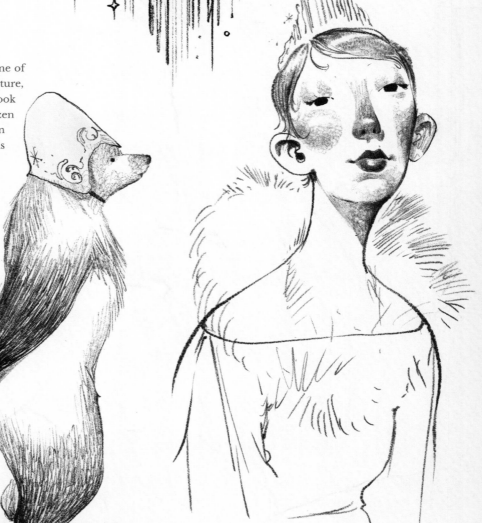

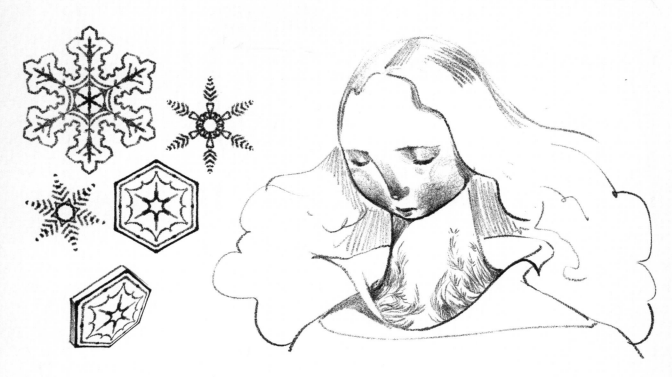

Hair & skin

The Snow Queen's hair is not specifically described in the original tale. At our very first encounter with her, she is described as seemingly being made of ice. Could her hair be flat and severe, like frost, or white and fluffy, almost resembling piles of snow? Even her skin could be patterned with frost.

Snowflakes

Snowflakes are a hugely important element to this character and her story – she is even described as being the "queen bee" over all the snowflakes. Aspects of her appearance, or the design of her palace, could be inspired by the crystalline shapes of snowflakes.

An icy gaze

Expressions, and eyes specifically, can hold so much power over a whole character and even a whole illustration. The fact that her eyes are mentioned in the story, despite the text not having much detail on her in general, emphasizes the importance of the eyes – eyes that sparkle and shine, yet hold no love or rest or contentment.

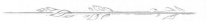

Studying the Witch

IDEATION

Among these thumbnails, I want to play around mostly with posing and body proportions. A memorable scene in Andersen's story is at the end, when the young boy is found and the witch is sitting atop her frozen lake in her palace. I imagine her sitting with an upright posture to continue to hold her prideful countenance. A couple of the sitting sketches would not work as well for this, since she slouches and gives off the opposite mood than I'm aiming for (**2**, **8**, **10**). I enjoy the idea of giving her a buff, stocky build that creates a more motherly feel – pairing those softer shapes with a slightly angry expression plays into her character's false sense of kindness quite well (**8**, **9**). In the end, though, I lean toward the sleek, sharp look of **6**, which reflects the harder side of her character.

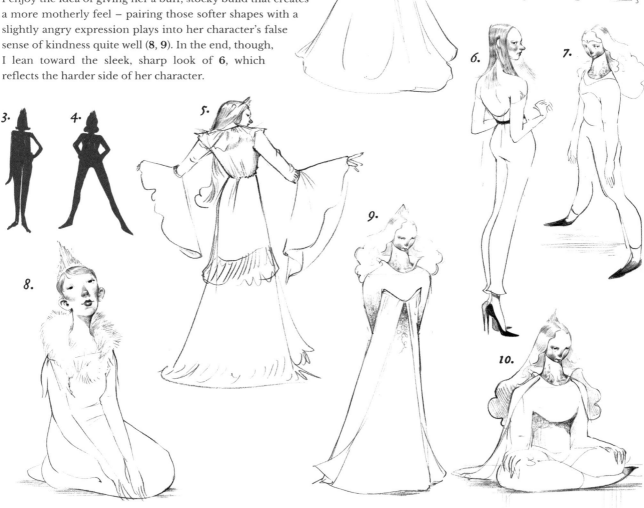

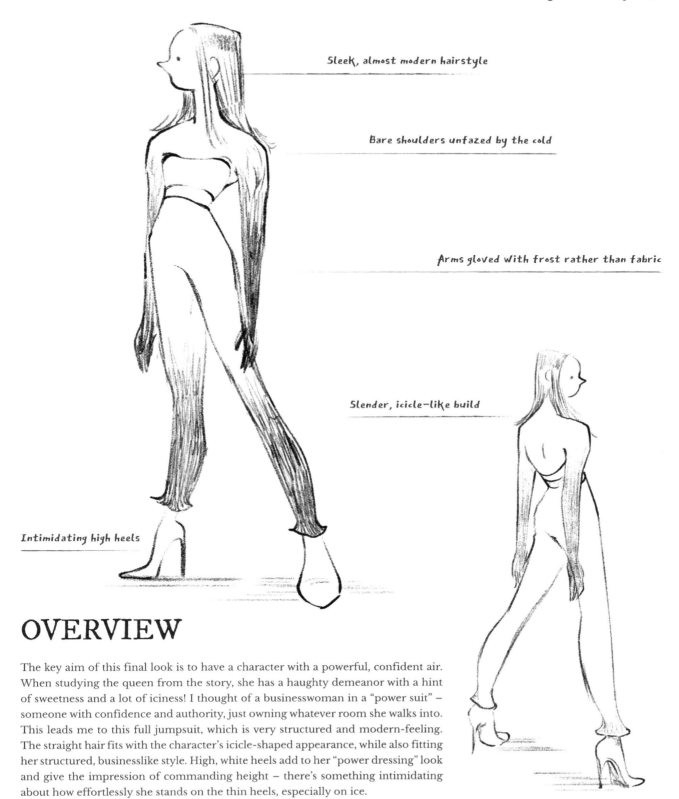

Sleek, almost modern hairstyle

Bare shoulders unfazed by the cold

Arms gloved with frost rather than fabric

Slender, icicle-like build

Intimidating high heels

OVERVIEW

The key aim of this final look is to have a character with a powerful, confident air. When studying the queen from the story, she has a haughty demeanor with a hint of sweetness and a lot of iciness! I thought of a businesswoman in a "power suit" – someone with confidence and authority, just owning whatever room she walks into. This leads me to this full jumpsuit, which is very structured and modern-feeling. The straight hair fits with the character's icicle-shaped appearance, while also fitting her structured, businesslike style. High, white heels add to her "power dressing" look and give the impression of commanding height – there's something intimidating about how effortlessly she stands on the thin heels, especially on ice.

EXPLORATIONS

I want to try out some different hairstyles and outfit elements here before cementing my final design. The story suggests many tempting options for grand, regal outfits, and while my idea is more minimalist, I still want to try out a range of looks.

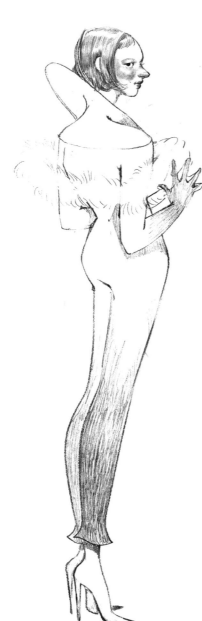

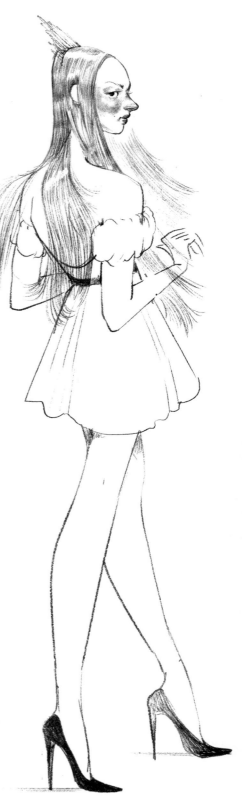

▶ Longer hair gives her a slightly creepier look, which work wells with the confident, powerful pose. The shorter dress is an idea that I wanted to try, but it ends up looking a bit too young on her.

◀ Here I want to try out a shorter hairstyle to see both extremes: long and short. I like the juxtaposition of the sweet, curled bob with the stern face and the slightly judgmental pose. It captures her character as a whole – a sinisterly sweet leader figure. The story also describes the top of her outfit as looking like snowflakes linked together, so I incorporate that here in the form of some soft, fluffy trim.

▼ I try a variation with a classic long, white dress. I draw inspiration from the original story; it does not give many visual details of the witch's look, but her first appearance describes her as dressed in "garments of white gauze." I interpret this as being piles of white fabric. The result is very elegant and more traditional, but misses the visual sharpness of the trousers and heels.

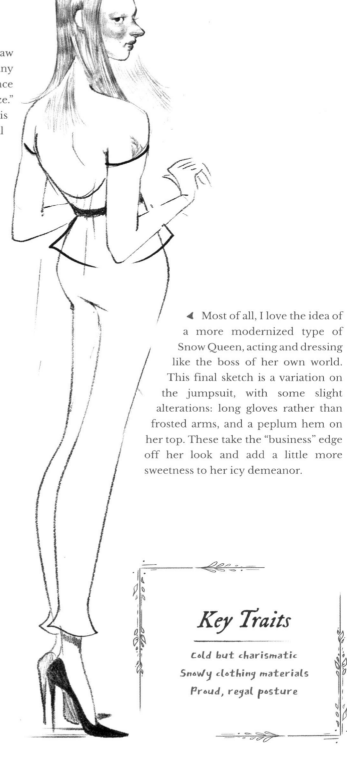

◄ Most of all, I love the idea of a more modernized type of Snow Queen, acting and dressing like the boss of her own world. This final sketch is a variation on the jumpsuit, with some slight alterations: long gloves rather than frosted arms, and a peplum hem on her top. These take the "business" edge off her look and add a little more sweetness to her icy demeanor.

Key Traits

Cold but charismatic
Snowy clothing materials
Proud, regal posture

Meeting the Witch

This final design incorporates elements gathered from all aspects of the Snow Queen's personality and the research undertaken throughout the project. The sleek form of the jumpsuit is a nod to her role as the metaphorical "queen bee" of the snowflakes, emphasizing the proud, confident, sometimes haughty air with which she carries herself. For the gloves, I wanted to add a cold, icy element somewhere in the design, so, rather than fabric, the gloves appear to creep up her arms like frost on a windowpane. The same goes for the design on the trousers, which ties her arms and legs together visually.

Her expression was the most important part to capture, with her bright eyes and restless gaze. Leaving off her eyebrows creates even more of an intimidating, inscrutable, and slightly eerie look.

> "Her expression was the most important part to capture, with her bright eyes and restless gaze"

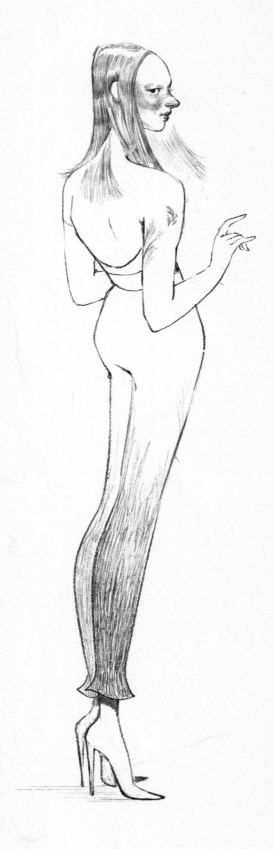

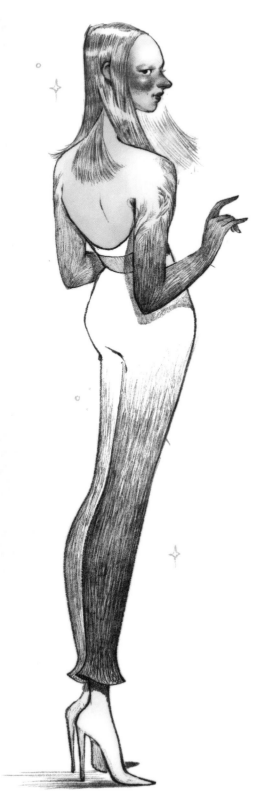

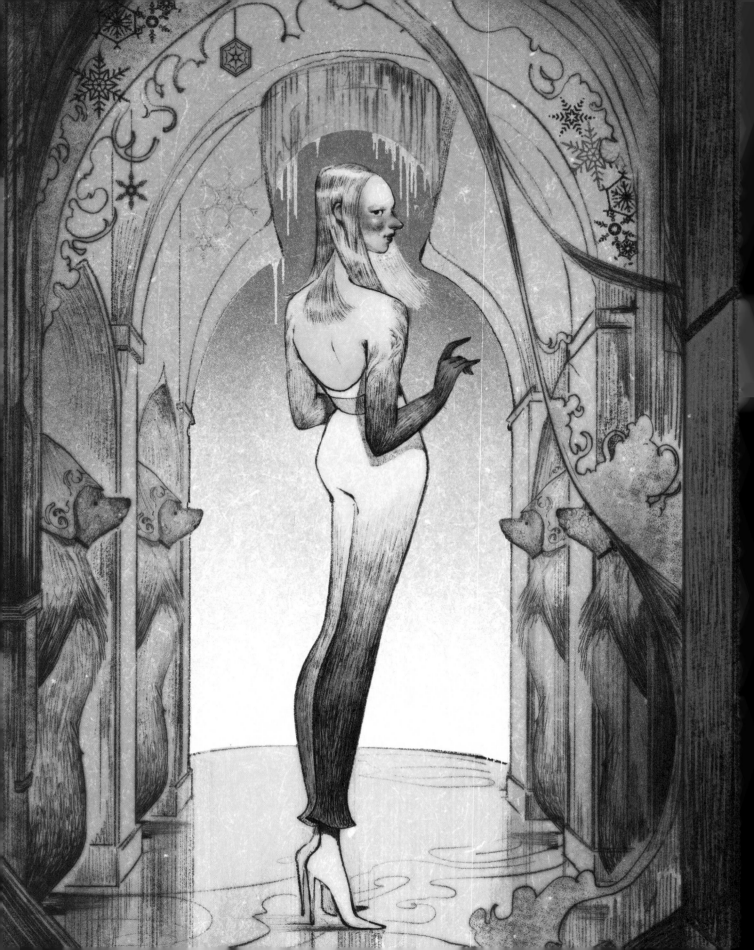

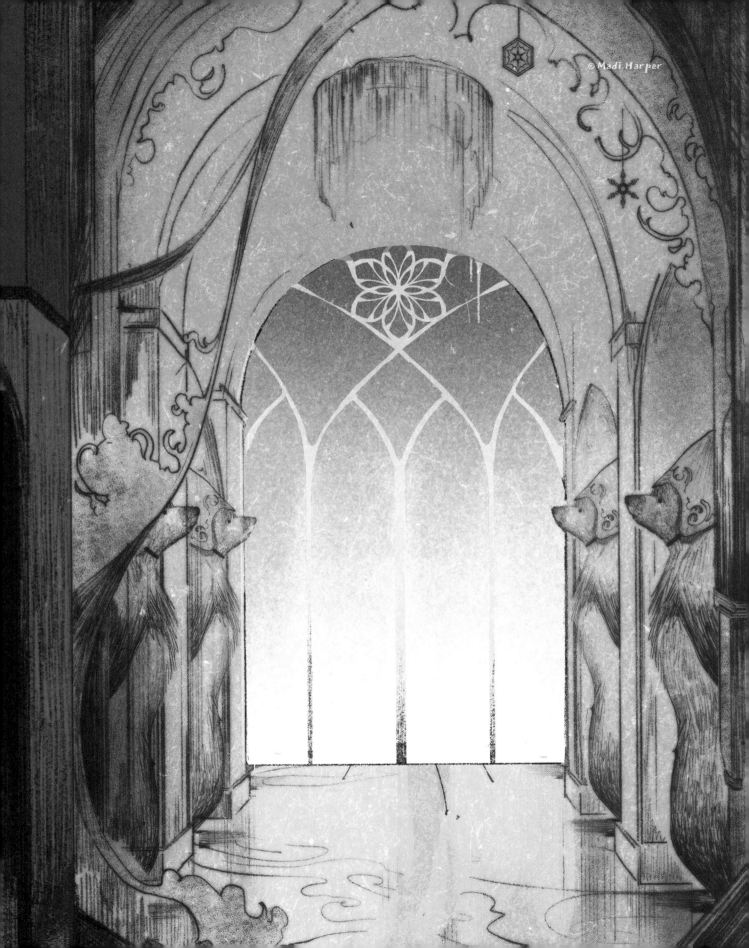

© Madi Harper

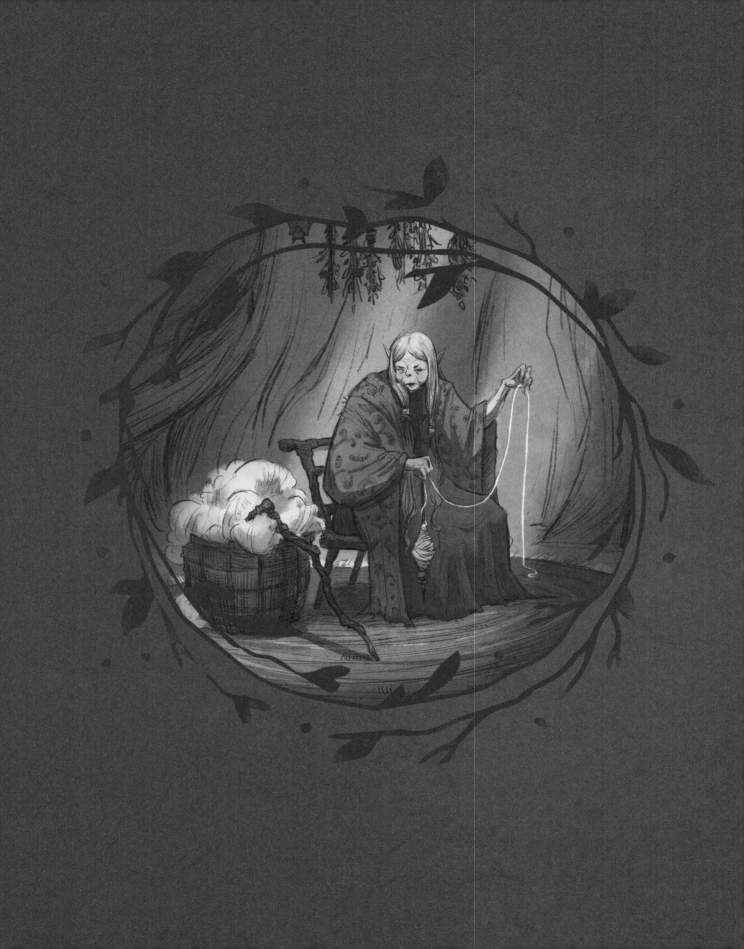

The Spinning Witch

One of the many fairy tales still beloved in popular culture is
Sleeping Beauty. *In the many versions of this story, a princess is cursed
by a so-called "wicked fairy," usually out of jealousy or over some perceived
slight. The fairy foretells that the princess will prick her finger on a spindle
and die. Other fairies manage to temper the curse, which results in a long
sleep rather than death. In this chapter, illustrator Kacey Lynn Brown
explores the mysterious, ominous figure of this fairy witch and crafts
her own unique interpretation.*

Kacey Lynn Brown | instagram.com/untroubledheart

Research & Rumors

A witch of many names

Our witch has been known by many names, such as Uglyane, Carabosse, the Wicked Fairy, and a few other malevolent nicknames that should not be repeated here. But if you ask her, she prefers "the Spinning Witch." This moniker is most apt to describe her, for she spends her days wielding her drop spindle, spinning the fates of those unfortunate souls who happen to stumble upon her tree.

Curses & cradles

Rumors abound concerning the Spinning Witch. One tale speaks of when our witch allegedly cursed a princess. It has been said that in a fit of rage at having been excluded from the christening of the new child, the witch cursed the babe in the cradle to prick her finger on a spinning wheel at the age of sixteen, consequently meeting an untimely death. The Spinning Witch finds this rumor absurd, as she never deals in curses, and she much prefers the elegance of the drop spindle (a simple, portable tool for spinning wool) over the cumbersome wheel.

An unwelcome sight

To go searching for the Spinning Witch is something always cautioned against. However, the witch sometimes seeks out those for whom her threads of fate weave a story. If you see her walking on the road before you, spinning as she goes, beware! She does not appear to all, and to those who see her, she holds a chilling future.

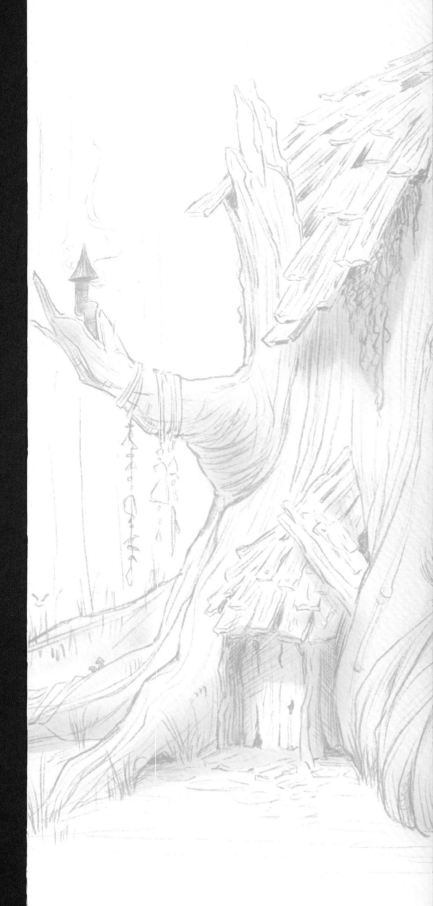

LOCATION

Far across the land, hidden deep within an ancient forest, there sits the stump of a once-great tree. After centuries of standing tall as a sentinel of the woodland, the tree's remains live on as the home of a curious and most eccentric character. Some say she is a witch; others will tell you she is an old and powerful fairy. Whichever she is, it is common knowledge that passersby beware – for whoever enters the tree will find a grim fate awaiting them.

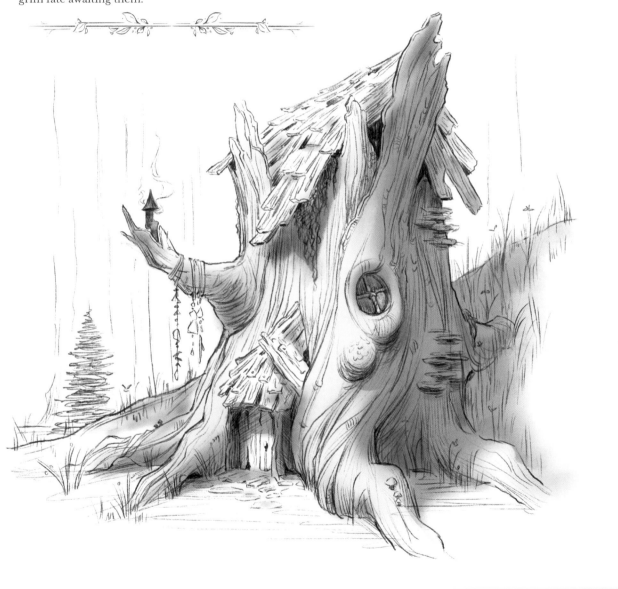

Important Notes

Distaff & spindle

The witch does not only use spinning to predict the future; the art of spinning thread from wool is one that she has perfected over countless centuries. She wraps her distaff (a tool used to hold unspun wool) with wool taken from the sheep belonging to farms that lie just outside the forest, much to the farmers' chagrin. She delicately spins the fibers into fine threads using her beloved drop spindles. There is never a time in which she feels more at peace than when she is spinning.

Walking cane

No one knows the exact age of the Spinning Witch, but it comes as no surprise that she needs a little help getting around sometimes. Her trusty cane – a gnarled yet sturdy object – is said to be a gift from the little gnome that lived under the hill her tree rests upon. The friendship was short-lived, however, for he made the mistake of asking for his fate to be read and met the due consequences not long after.

Winged companions

While not many would want our witch for company after hearing of the gnome's wretched story, the exception lies with the bats that share the witch's home. It is believed they venture out to bring the witch news of all the happenings of the land, including all the rumors about her, and present her with little gifts found during their nocturnal excursions.

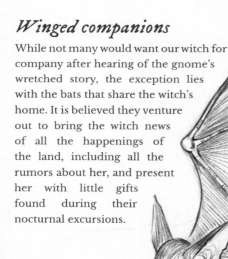

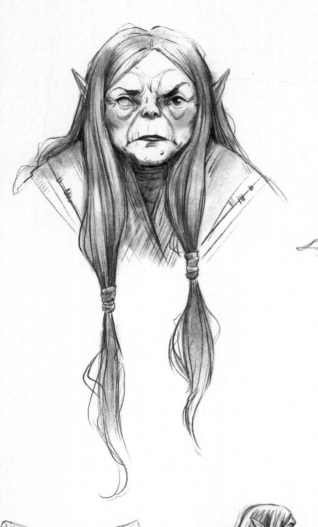

A piercing gaze

Those who have met our witch (and are still capable of relaying the story) will tell of her most striking feature: her eyes, one light and one dark, both working together to see the light and dark sides of a person's soul. This duality allows her to read the many possible paths their future might take, often foreseeing unfortunate fates that may seem, to the hearer, like a terrible curse. Only those with true strength of character are able to withstand her gaze. Many lesser persons have been known to go mad under that piercing stare.

A price to pay

No service comes for free, and for those who come to the fairy's door seeking fortunes, the payment is often of a unique kind. She has been known to ask for ordinary objects in exchange for her talents, but the catch lies with how these objects are found. It appears she finds amusement in watching her customers attempt to fulfill her outlandish requests, such as a feather taken from the first bird you see at dawn, the last bloom of the season, a doll stolen from the cradle of a baby born in June, or a candle extinguished by a queen's sneeze.

Woven adornment

All the beautiful thread the witch spins is never wasted, for she loves to weave and create intricate garments, including the shawl she is often seen wearing. While the pattern has no obvious meaning to the layman's eye, one can be sure it holds significance to the witch. If you receive a shawl from her, pay close attention to the design – you may just find your destiny spelled out with delicate craftsmanship.

Studying the Witch

IDEATION

It took a few attempts to discover what the Spinning Witch looked like. Accounts of her appearance are varied and usually accompanied by incoherent babbling or fainting spells from the poor souls who have seen her. I try a few different versions, seen here in sketches **1** to **5**. When determining a face, it can be a useful trick to draw only the profile at first, before attempting the face in perspective. The more soft and approachable versions, such as **1** and **5**, do not seem to encapsulate the witch's potentially terrifying nature.

I decide sketch **4** is a better direction and proceed to make some small full-body sketches (**6** to **10**). In these rough little drawings, I explore how hunched she is, and how it might look to see her using her spinning equipment. These thumbnails give a good idea of the overall design before I commit to detail.

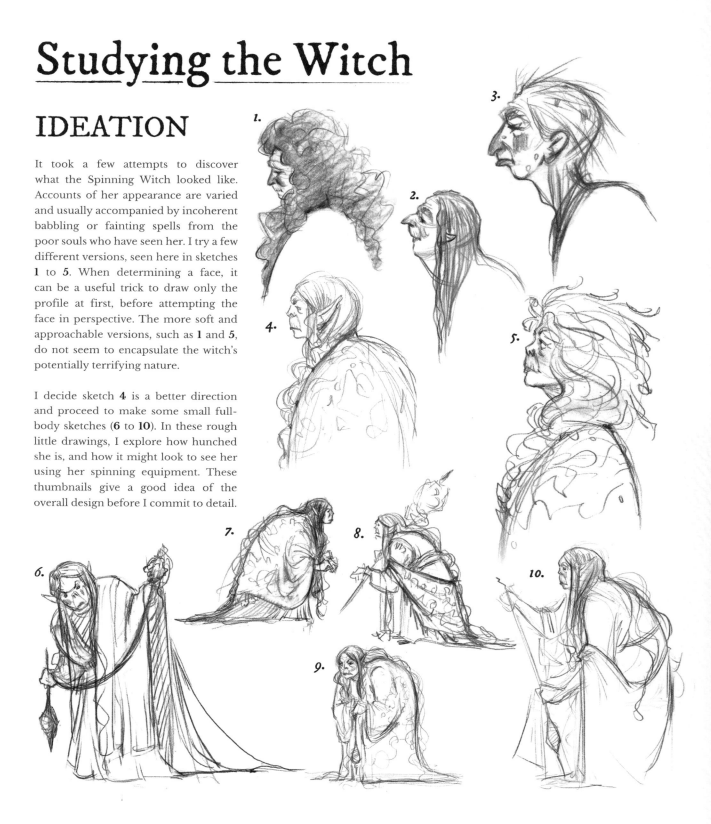

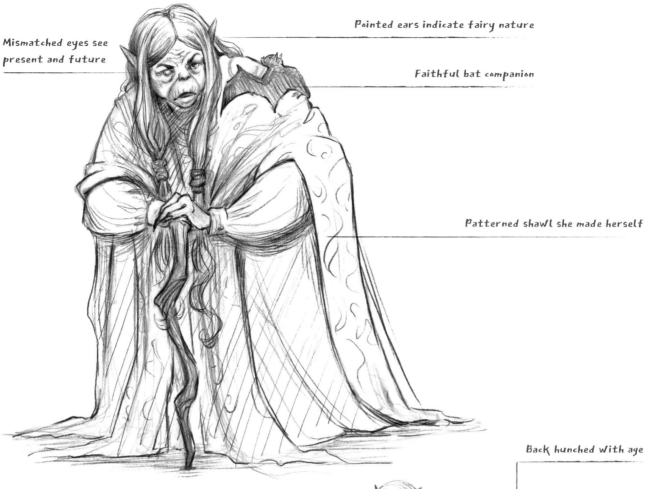

Mismatched eyes see present and future

Pointed ears indicate fairy nature

Faithful bat companion

Patterned shawl she made herself

Back hunched with age

OVERVIEW

In these drawings, we are getting closer to the witch's true appearance. When I allowed a witness to see these sketches, he subsequently ran screaming from the room – a bit of an overreaction, in my opinion! I have included the cane she uses, to remind us of her superior age, and to add some visual interest to the sketches. Every account I have heard of her mentions the shawl she wears, so I have made it a dominant part of the drawing; I assume it must get damp and chilly living inside an old tree, so the shawl would be worn consistently for warmth. The bat on her shoulder furthers the peculiarity of her character and hints at the inspiration for her facial features, as though one who spends so much time with bats begins to look like them!

EXPLORATIONS

Despite her reputation as a spiteful, wicked fairy who deals in curses, I imagine this witch is truly a withdrawn hermit who rarely seeks out human company. Here we can explore and speculate on the activities that might occupy the Spinning Witch in her reclusion.

▲ Always a creative spirit, the witch takes every opportunity to make something beautiful out of the ordinary. Her home is adorned with trinkets the bats bring her, as well as the odd payments received from desperate visitors seeking fortune. If she's not spinning or weaving, she's probably stringing her little treasures together, creating decorations for her tree.

▲ Here we see our witch in the act of spinning. Out of convenience, she has forsaken her large distaff for a bit of wool wrapped around her hand – an easy way to make a quick prediction. Spinning requires much concentration; it is a well-known fact that you should never bother a witch when she's concentrating. The last person to be an annoyance lived out the rest of his days as a mosquito – not a very long life when you're in a room full of bats!

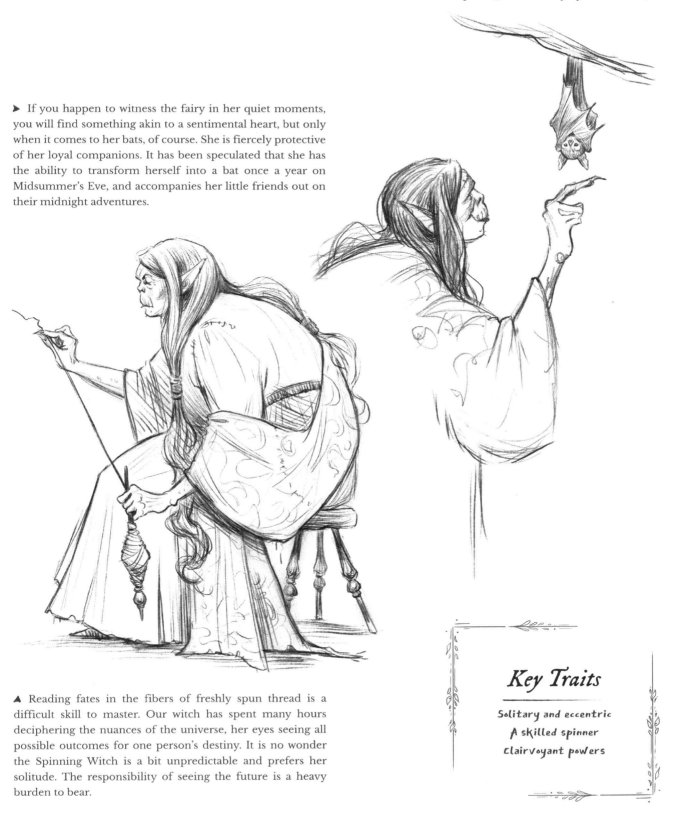

▶ If you happen to witness the fairy in her quiet moments, you will find something akin to a sentimental heart, but only when it comes to her bats, of course. She is fiercely protective of her loyal companions. It has been speculated that she has the ability to transform herself into a bat once a year on Midsummer's Eve, and accompanies her little friends out on their midnight adventures.

▲ Reading fates in the fibers of freshly spun thread is a difficult skill to master. Our witch has spent many hours deciphering the nuances of the universe, her eyes seeing all possible outcomes for one person's destiny. It is no wonder the Spinning Witch is a bit unpredictable and prefers her solitude. The responsibility of seeing the future is a heavy burden to bear.

Key Traits

Solitary and eccentric
A skilled spinner
Clairvoyant powers

Meeting the Witch

Throughout all my research of the Spinning Witch, I have discovered her to be a most formidable personality, despite her seemingly harmless old woman's facade. Many will tell you she is simply evil, with no good intentions, but truthfully she is more of an enigma. She possesses a mercurial temperament and a stare that will judge you straight to hell's fiery furnace; yet this is balanced by quiet creativity, intelligence, and sensibility. To capture all of this in one image is certainly a difficult task, but I have made an attempt. The fairy witch addresses the viewer with a bold gaze, displaying with a flourish the tools that are an extension of herself. Her signature handmade shawl drapes heavily across her shoulders, the wear and tear on the garment reflecting her long life.

> "Many will tell you she is simply evil, with no good intentions, but truthfully she is more of an enigma"

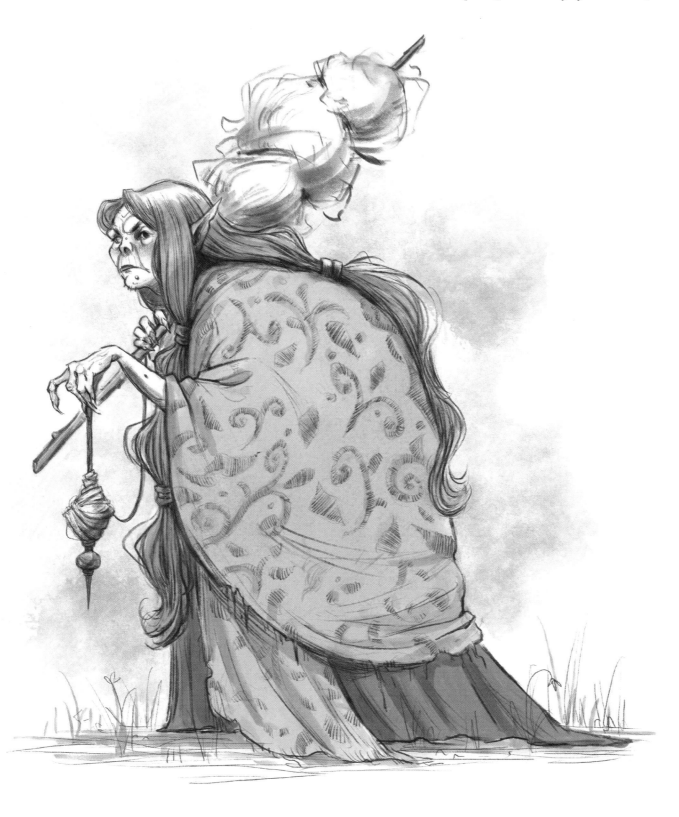

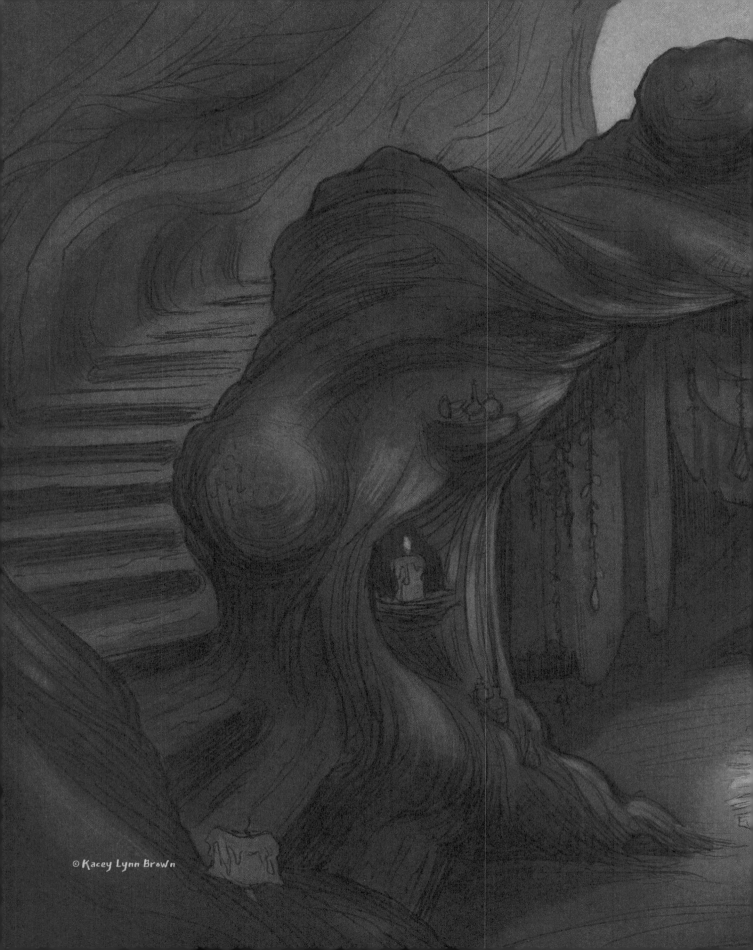
© Kacey Lynn Brown

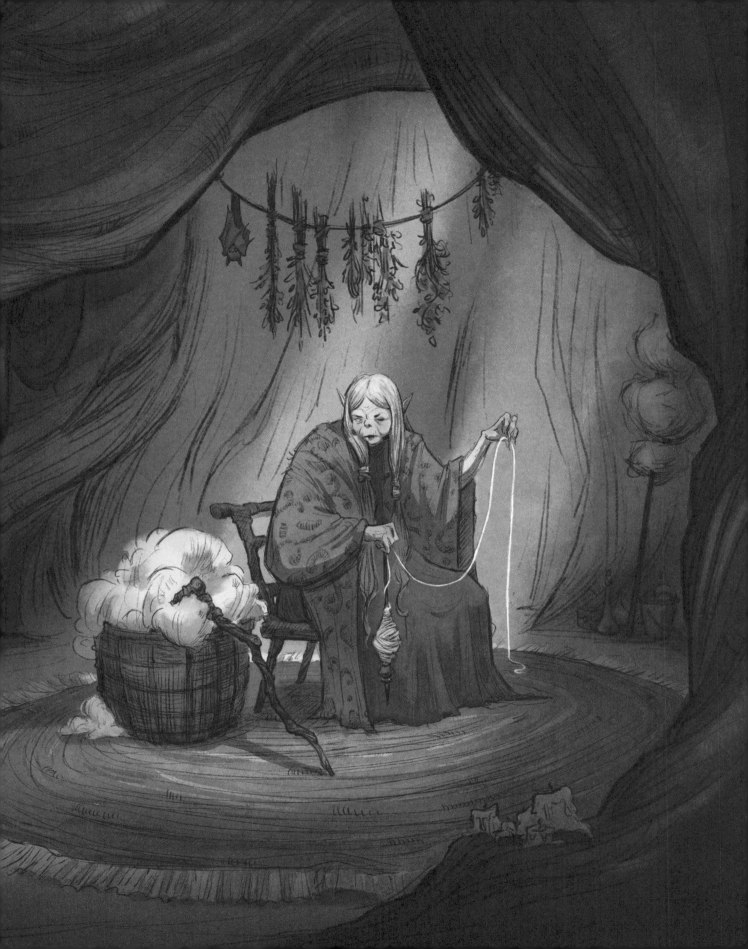

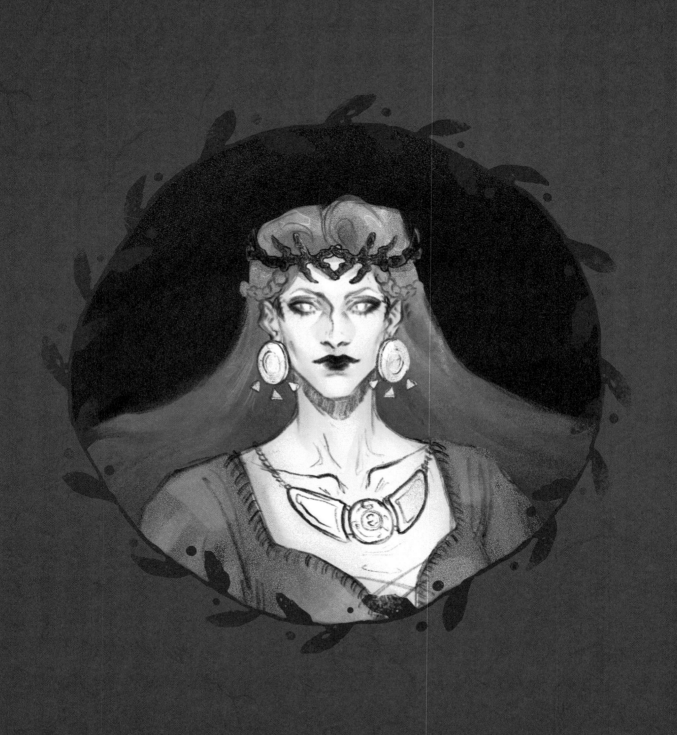

Morgan Le Fay

The Arthurian sorceress Morgan Le Fay (also called Morgana)
is a complicated figure whose portrayals are many, varied, and
contradictory. According to some sources, she is a wise, powerful,
and benevolent healer. According to others, she is a wicked, ruthless
nemesis of King Arthur and his loyal knights, reflecting the fears
and suspicions of the times. Illustrator Karolina Derecka explores
these stories to portray this mysterious enchantress.

Karolina Derecka | artstation.com/clouv

Research & Rumors

A skilled enchantress

Morgan Le Fay is often described as a fairy enchantress skilled in the arts of healing and powerful sorcery. She even possesses the ability to shapeshift. She learned magic from the renowned wizard Merlin, and from studying magic books. She later passed that knowledge to her sisters.

Varying portrayals

Morgan's character has been described differently throughout time, depending on whether the author of the text liked or disliked her. She is described by some texts as a gracious, powerful sorceress or healer. Others describe her as jealous and manipulative, with a secret rivalry with King Arthur's wife, Guinevere, over the affection of the knight Lancelot.

Rivals in court

According to some writers, there was a period when Morgan lived in court with Arthur and Guinevere, which is when the lifelong feud between Guinevere and Morgan began. Due to this, Morgan eventually left court and sought out Merlin, to study under his eye in the hope of earning great power.

LOCATION

Morgan Le Fay is said to be a queen and a ruler of a mystical island called Avalon – a sacred place where heroes' souls wander after death. It is described as a land of enchanted apple trees, peace, and serenity. The island is impossible to reach on your own unless you have a guide. Some researchers also link the name "Avalon" to Afallach, a dark Celtic divinity of the Otherworld.

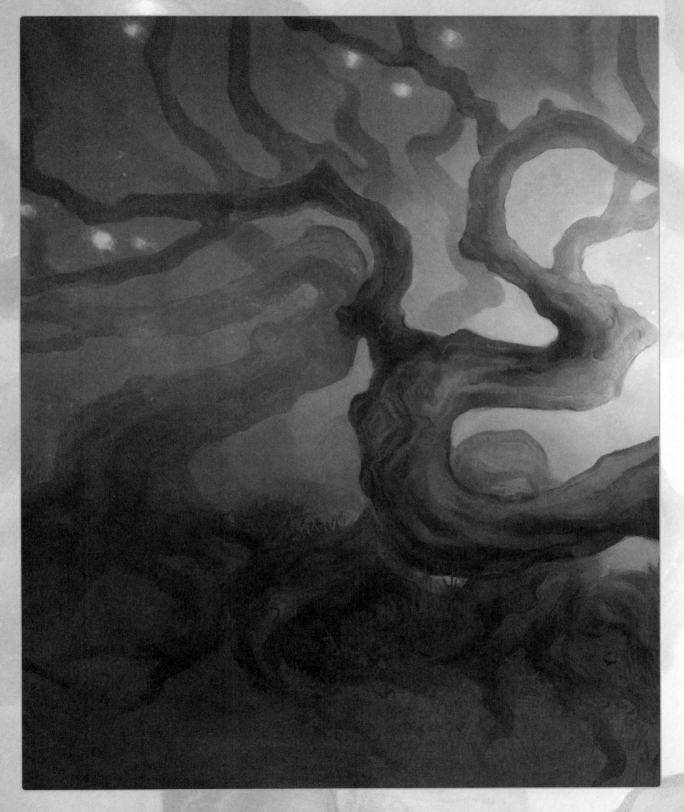

Important Notes

Wooden crown

Morgan Le Fay rules the island of Avalon with her eight sisters. She is the most powerful of them all, and shares with them all her healing crafts and sorcery secrets. I imagine her wearing a crown made from apple-tree wood, as it is the most common tree that grows on Avalon.

Excalibur

The sword Excalibur possesses great powers, granting its wielder immunity to any wound. The sword was a gift to Arthur from the mysterious Lady of the Lake, after he broke his previous blade. In some tellings of the Arthurian myth, Morgan steals Excalibur from him and throws away its magical scabbard, negating its powers and leaving Arthur vulnerable to grievous injury.

Magic spells

As a powerful, legendary enchantress, Morgan is a skilled magician who is capable of casting all manner of spells, whether for healing, shapeshifting, flight, or to test the mettle of her foes with challenges and trickery.

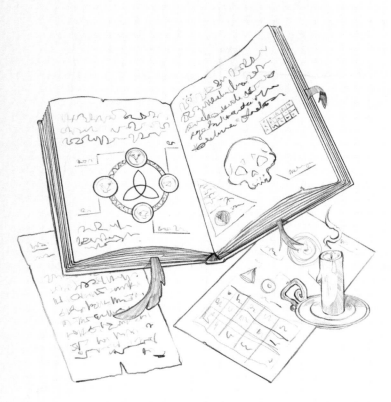

A studious witch

Morgan Le Fay was Merlin's student and is sometimes described as his female equivalent. However, she would also have learned many of her skills by studying books and practicing on her own. I imagine her spending all her free time reading ancient texts to further expand her knowledge.

Healing herbs

Most of Morgan's healing skills are based on herbs and plants, which she uses to create powerful potions. Early accounts of her, in particular, emphasize her being a wise, caring healer. Even in later, less sympathetic portrayals, Morgan uses her skills to tend to a mortally wounded Arthur.

Illusions

After stealing Excalibur, Morgan uses her shapeshifting powers to change herself and her soldiers into rocks, narrowly avoiding being captured by Arthur. The optical phenomenon of "Fata Morgana" is named after her – these mirages were periodically seen floating above the sea in the Strait of Messina, between Sicily and southern Italy, and were attributed to her sorcery.

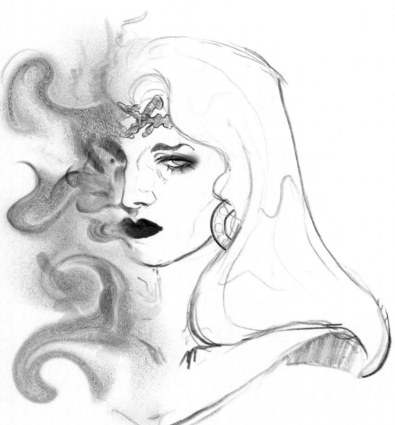

Studying the Witch

IDEATION

While gathering research for Morgan's design, I stumble on various sources that describe her in very different ways. I decide to try to individually dissect and portray the different aspects of her personality to see which version turns out the strongest.

From the beginning, I knew that I wanted to embrace her powerful character, portraying a skilled sorceress with a mystical aura around her. Thumbnail **6** looks like more of a warrior, while sketches **9** and **10** have winglike shapes that suggest her powers of flight. I decide to go with a mix of **1**, **2**, and **4**, which capture the look of a proud, mysterious sorceress.

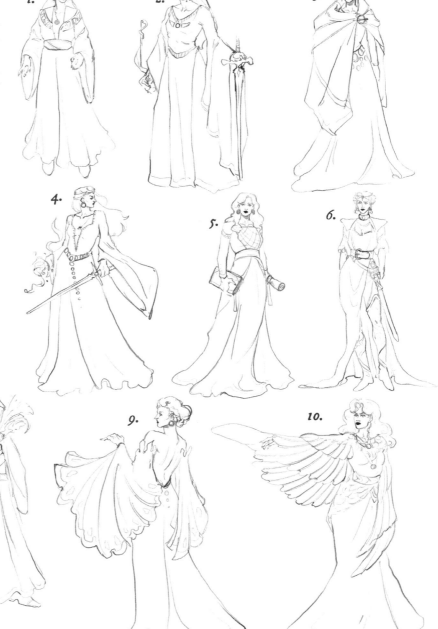

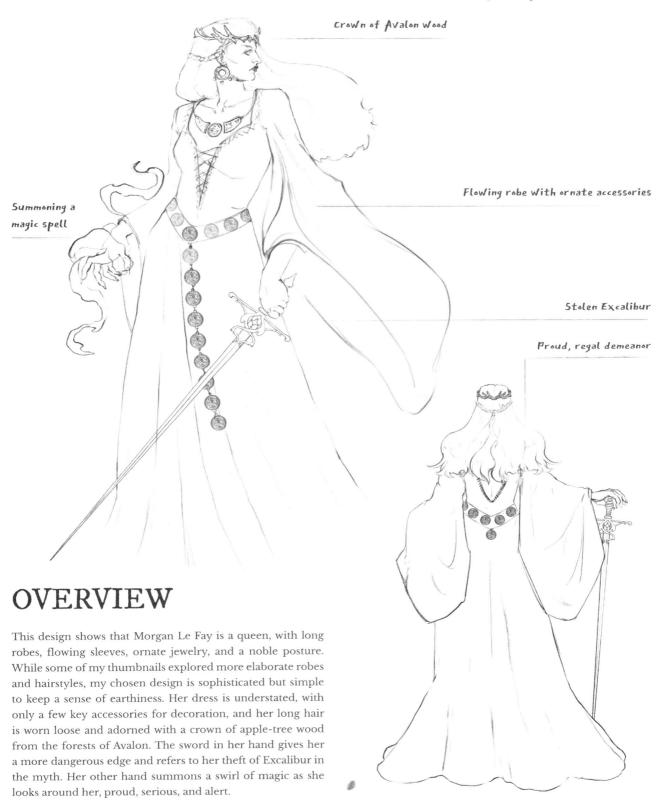

Crown of Avalon Wood

Summoning a
magic spell

Flowing robe with ornate accessories

Stolen Excalibur

Proud, regal demeanor

OVERVIEW

This design shows that Morgan Le Fay is a queen, with long robes, flowing sleeves, ornate jewelry, and a noble posture. While some of my thumbnails explored more elaborate robes and hairstyles, my chosen design is sophisticated but simple to keep a sense of earthiness. Her dress is understated, with only a few key accessories for decoration, and her long hair is worn loose and adorned with a crown of apple-tree wood from the forests of Avalon. The sword in her hand gives her a more dangerous edge and refers to her theft of Excalibur in the myth. Her other hand summons a swirl of magic as she looks around her, proud, serious, and alert.

EXPLORATIONS

Morgan Le Fay has had many roles and traits attributed to her, but I am most keen on exploring her sympathetic qualities. These sketches show her as a confident, powerful sorceress with a keen intellect and a skill for healing.

▶ In light of her preoccupation with stealing Excalibur, copying it, or destroying its powers, it seems right to explore the idea of a sword-wielding Morgan even further. Here she is wearing an alternative outfit, more geared toward battle, with metal pauldrons and a collar, scale armor, and a sword.

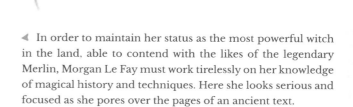

◀ In order to maintain her status as the most powerful witch in the land, able to contend with the likes of the legendary Merlin, Morgan Le Fay must work tirelessly on her knowledge of magical history and techniques. Here she looks serious and focused as she pores over the pages of an ancient text.

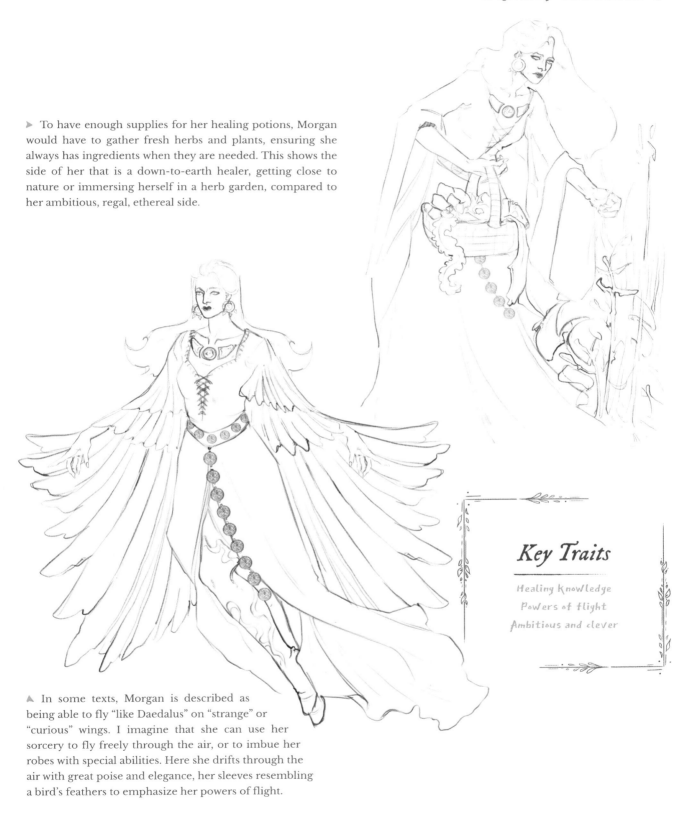

▶ To have enough supplies for her healing potions, Morgan would have to gather fresh herbs and plants, ensuring she always has ingredients when they are needed. This shows the side of her that is a down-to-earth healer, getting close to nature or immersing herself in a herb garden, compared to her ambitious, regal, ethereal side.

Key Traits

Healing Knowledge
Powers of flight
Ambitious and clever

▲ In some texts, Morgan is described as being able to fly "like Daedalus" on "strange" or "curious" wings. I imagine that she can use her sorcery to fly freely through the air, or to imbue her robes with special abilities. Here she drifts through the air with great poise and elegance, her sleeves resembling a bird's feathers to emphasize her powers of flight.

Meeting the Witch

In this drawing, I try to convey all of Morgan's confident, regal posture, befitting one of the most powerful and ambitious enchantresses of her times. She looks like a worthy, challenging opponent – not evil, but with an air of mystery and power about her.

Standing tall on the misty grounds of Avalon, wearing a crown of her own making, with her long hair swirling in the breeze and her hand resting elegantly on her stolen sword, she stares down anyone who dares to set foot on her mythical domain.

> " She looks like a worthy, challenging opponent – not evil, but with an air of mystery and power about her"

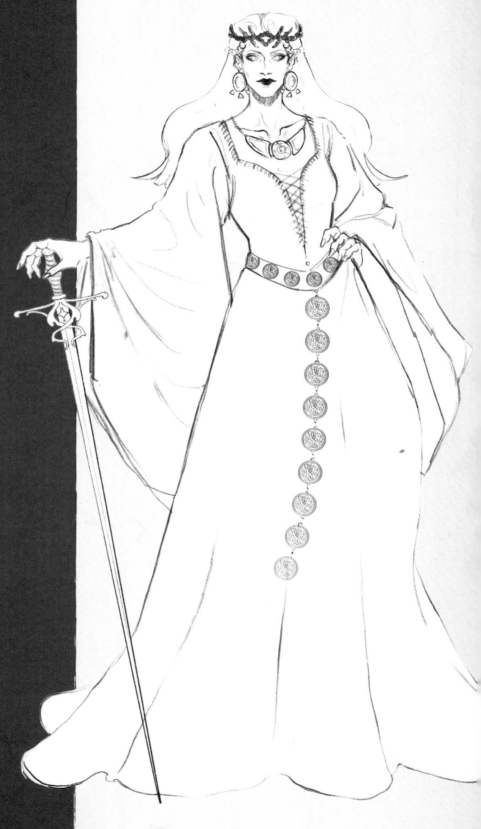

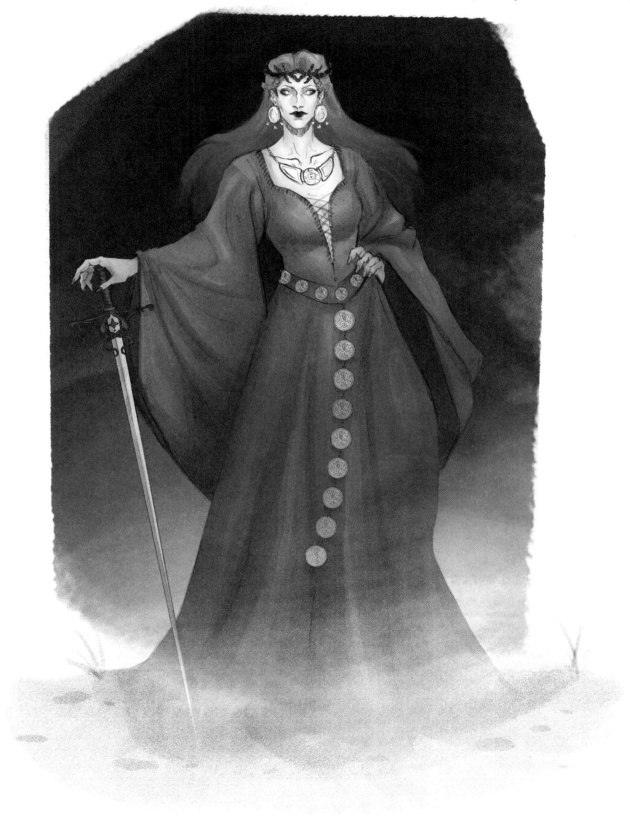

© Karolina Derecka

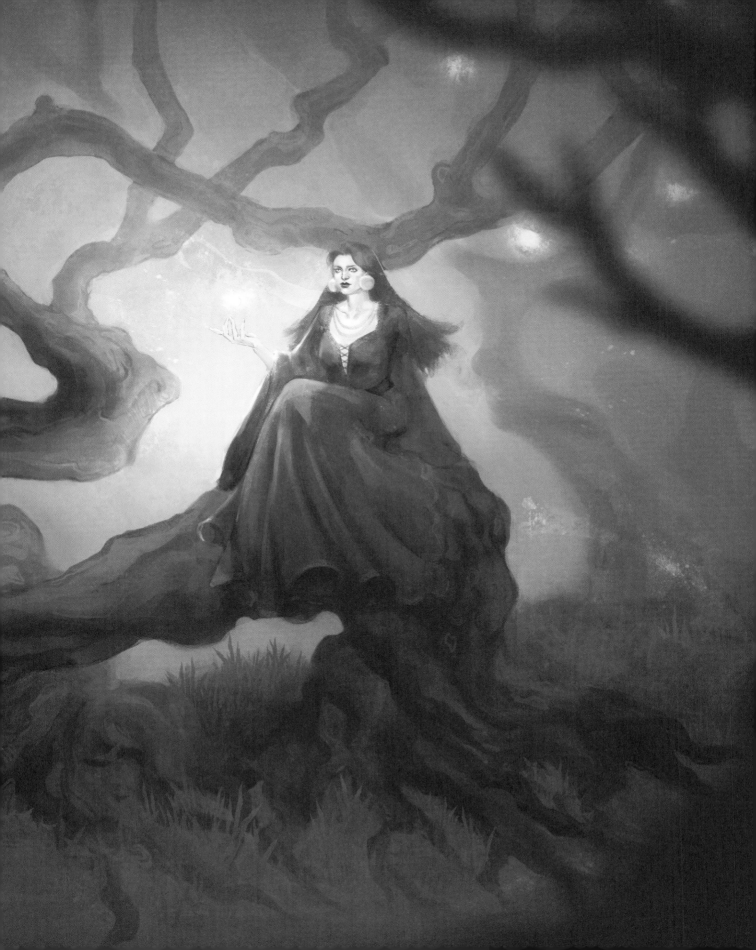

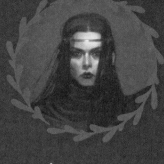

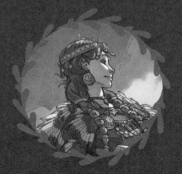

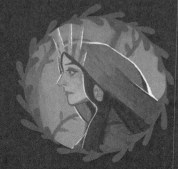

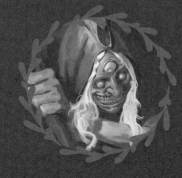

Goddesses
& Guardians

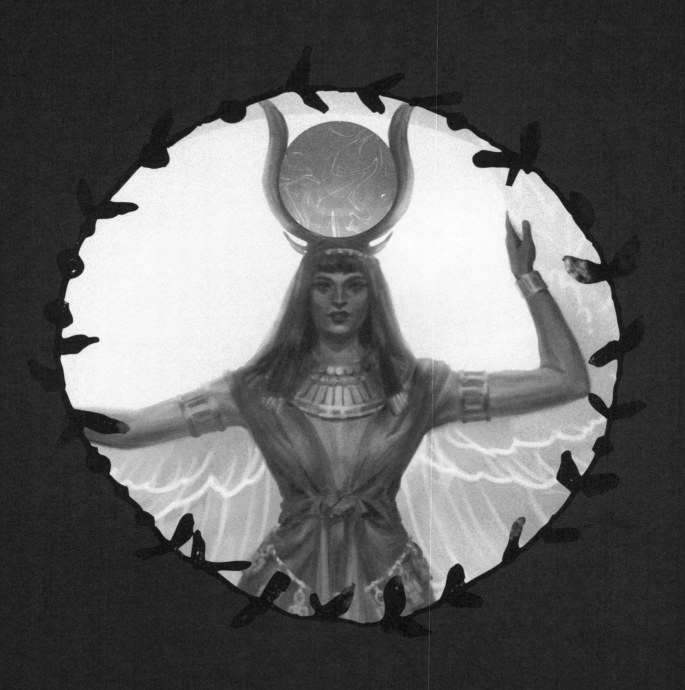

Goddesses & Guardians

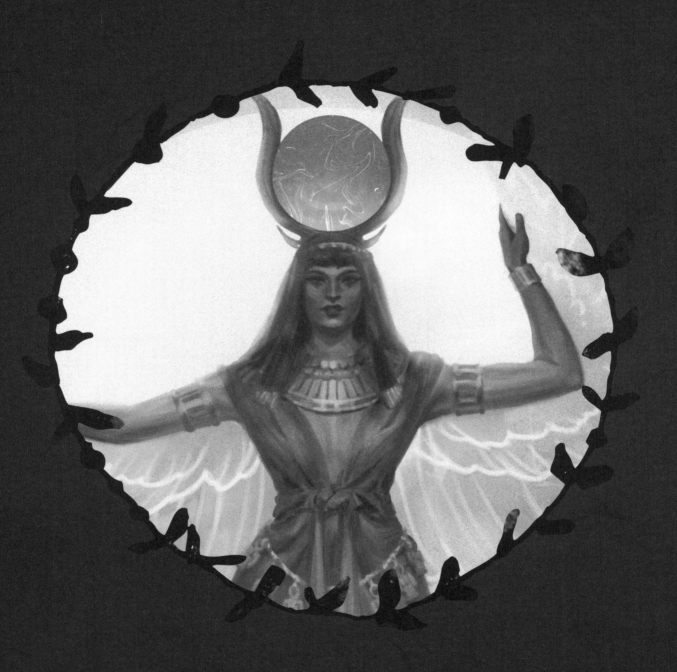

Isis

Isis is an ancient Egyptian goddess associated with magic, healing, death, wisdom, and motherhood. A multifaceted figure whose story has changed through countless retellings, she has been depicted as a woman, a winged woman, or even a bird, crowned with a headdress shaped like a throne or a solar disk. Illustrator Janna Sophia draws upon ancient art and myth to depict this fascinating magical deity.

Janna Sophia | jannasophia.art

Research & Rumors

Magic & wisdom

Isis is a goddess of many things, including magic, healing, and wisdom. She cleverly tricks Ra, the sun god, by creating a magical serpent from his saliva and hiding it where he would pass by. When Ra is bitten and poisoned, neither he nor any other gods can cure him, except for Isis, who only heals him when he reveals to her his secret name – the key to his great power.

Mourner & protector

Isis is one of several deities associated with the ancient Egyptian afterlife, guiding and protecting the dead as she does the living. When her husband Osiris is slain by his brother Set, and his body parts scattered across the land, the mourning Isis recovers his remains and revives him with her magic, making him the first mummy.

Mother goddess

As well as being a protective maternal figure to ordinary people, Isis is known as the mother of the god Horus. In one story, when they are hunted by Set, Isis protects her son by hiding in the Nile's marshes, where she must also defend him from wild creatures. She is not just a nurturing figure, but a determined, clever, and sometimes ruthless one.

LOCATION

Revered as a goddess, Isis is firmly tied to the ancient pharaohs of Egypt. Her original home is the Nile Delta, but word of her spread far and wide as the Romans carried rumors of her powers beyond the borders of Egypt and throughout their entire empire.

Important Notes

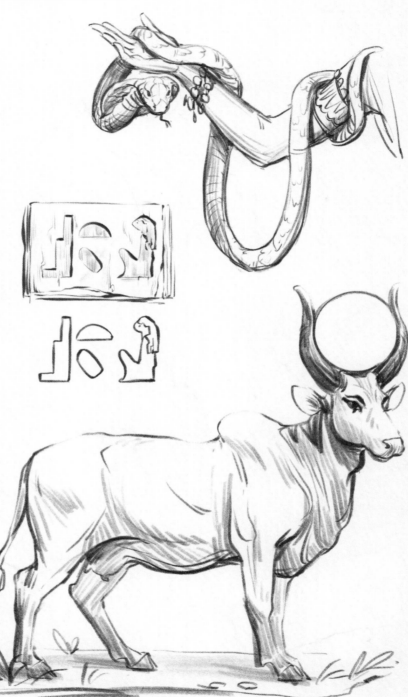

Cobra

Cobras are one of a few animals strongly associated with Isis. One of her forms is that of a woman with a snake's body, which represents agricultural fertility. There are numerous depictions of Isis with cobras wrapped around her arms, as they are also symbols of power and protection. In the story where Isis has to hide Horus from the god Set, she is aided by the cobra goddess Wadjet.

Name in hieroglyphs

Befitting a goddess of her stature, even Isis' name includes the sign of a throne, underscoring her importance to the pharaohs. In ancient Egyptian art, she is often depicted with a large, throne-shaped headdress.

Cow horns

A cow's head was considered a symbol of wisdom, and the cow itself a symbol of nourishment, motherhood, and abundance. Originally it was the sky goddess Hathor who wore a headdress of a cow's horns, but as Isis is also associated with wisdom, healing, and motherhood, she is often depicted with the same headdress. This kind of crossover was very common among ancient Egyptian deities.

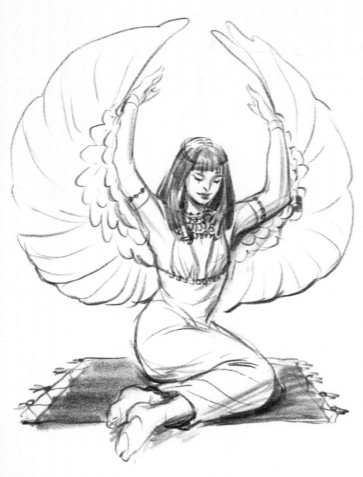

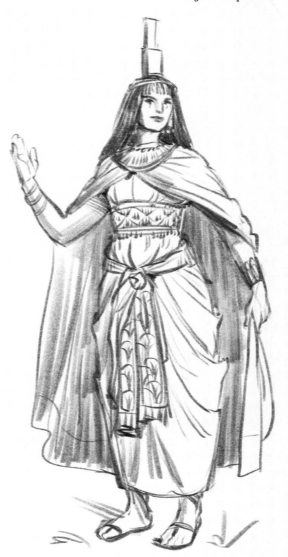

Wings

In ancient Egyptian artwork, Isis is often depicted as a kite or with the wings of a kite – a kite or kestrel being one of her sacred animals. Outspread wings were also a common symbol for protection in portrayals of Egyptian deities.

Clothes of a queen

Isis is not only associated with the throne of Egypt, but is a symbol for *being* queen – someone who gives the pharaohs their divine right to rule. I may not opt for the throne-shaped headdress in my design, but I want her robes and accessories to befit a regal goddess.

Tjet

The Tjet, also called "the knot of Isis," is a symbol with great protective power. Typically carved from red stone, Tjet amulets were often buried with the dead so that Isis' magic would keep them from harm.

Studying the Witch

IDEATION

Since there are many different symbols that are associated with Isis, and she is sometimes depicted with or without them, I want to find a combination that works best visually. I play around with her clothing, different headdresses, and wings or no wings, to draft a good range of ideas. In many frescoes she wears a simple red shift dress, but that seems a little plain for a powerful witch and goddess, so I decide to go for something more opulent. I really like the rounded silhouette and layered dresses of **7** and **8**, but the wings are such an integral part of her design and a feature that would really set her apart. I decide to go for **4** as I think it embodies her protective and healing nature the best.

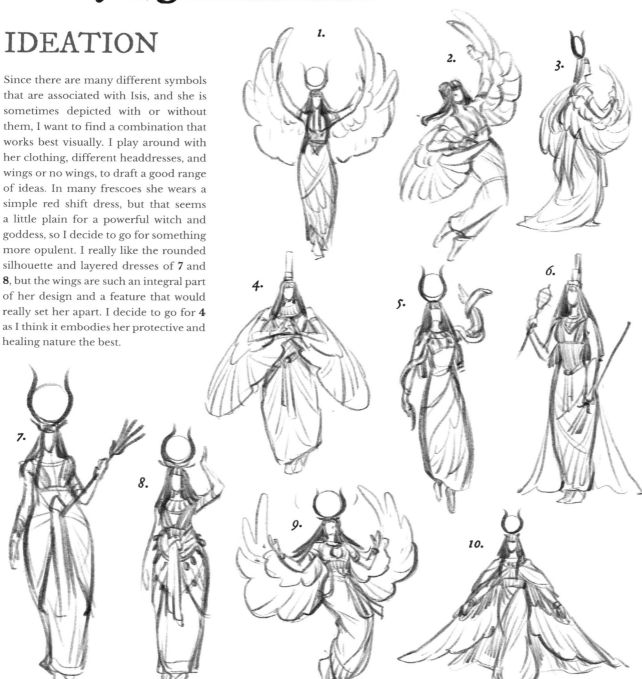

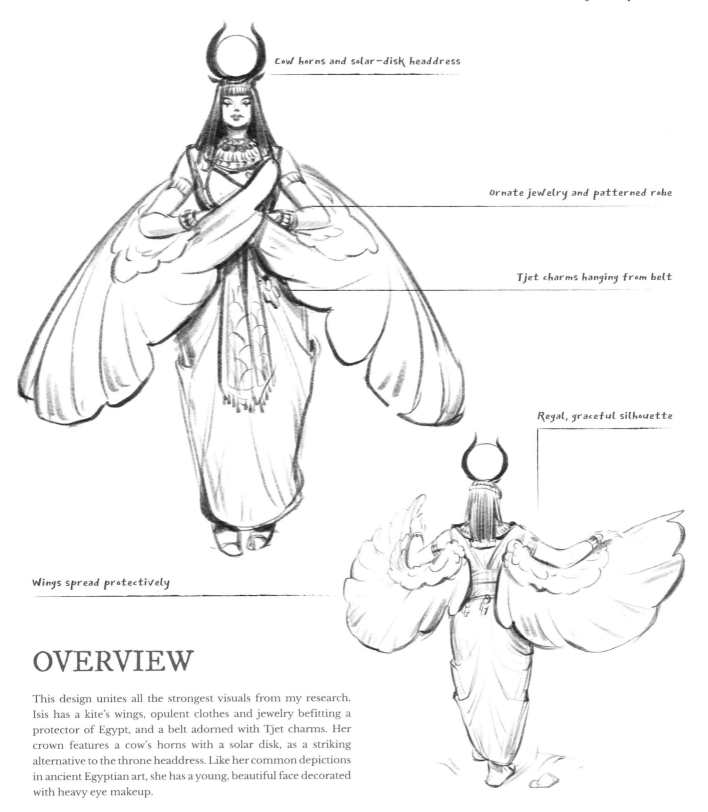

Cow horns and solar-disk headdress

Ornate jewelry and patterned robe

Tjet charms hanging from belt

Regal, graceful silhouette

Wings spread protectively

OVERVIEW

This design unites all the strongest visuals from my research. Isis has a kite's wings, opulent clothes and jewelry befitting a protector of Egypt, and a belt adorned with Tjet charms. Her crown features a cow's horns with a solar disk, as a striking alternative to the throne headdress. Like her common depictions in ancient Egyptian art, she has a young, beautiful face decorated with heavy eye makeup.

EXPLORATIONS

Isis' many roles and powers in the ancient Egyptian mythos are reflected in these sketches: a sorceress, guardian, and mother goddess, representing aspects of both life and death.

▶ Isis is the mother of Horus, the falcon-headed sky god, and goes to great lengths to protect him. Here I wanted to depict an everyday, very human interaction between the mother goddess and her young son.

▼ Here is Isis in snake form, known as Isis-Thermouthis. It was not uncommon for Egyptian deities to have composite forms or shared features. In this case, two nurturing goddesses, Isis and Renenutet (also called Thermouthis), combine into a cobra figure representing prosperity and protection.

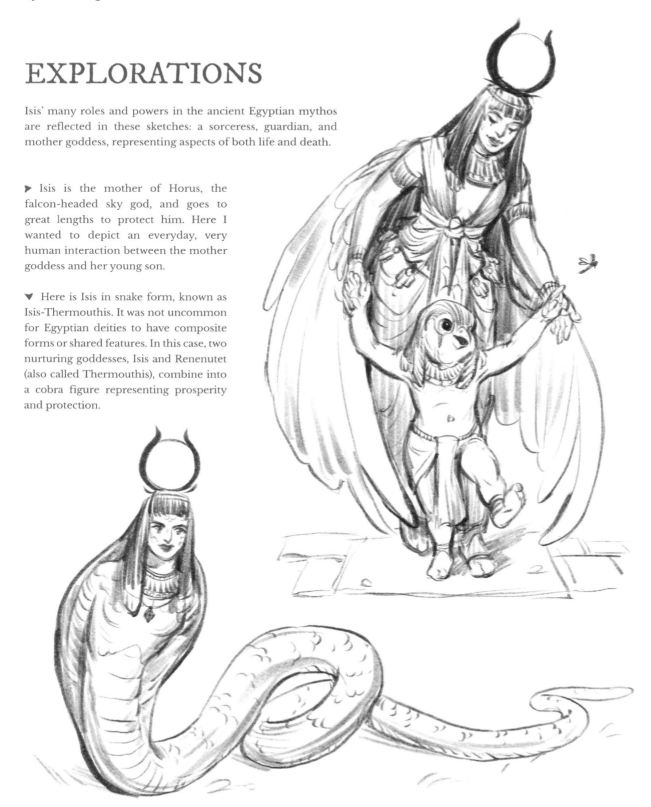

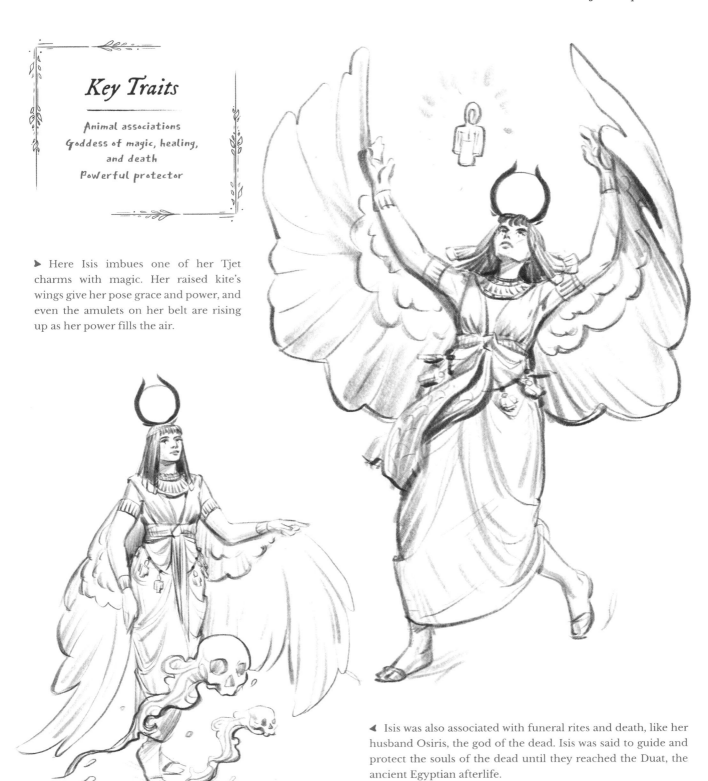

Key Traits

Animal associations
Goddess of magic, healing,
and death
Powerful protector

▶ Here Isis imbues one of her Tjet charms with magic. Her raised kite's wings give her pose grace and power, and even the amulets on her belt are rising up as her power fills the air.

◀ Isis was also associated with funeral rites and death, like her husband Osiris, the god of the dead. Isis was said to guide and protect the souls of the dead until they reached the Duat, the ancient Egyptian afterlife.

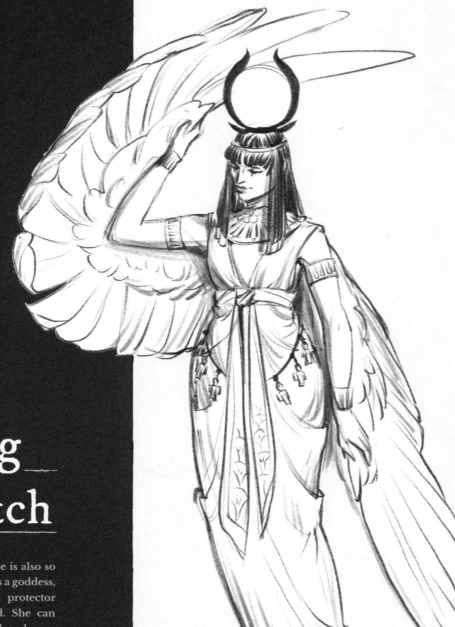

Meeting
the Witch

Isis might be a witch, but she is also so much more than that – she is a goddess, a queen, a mother, and a protector of the living and the dead. She can be cunning if it keeps her loved ones from harm, and she can be wise and kind to those who deserve it. Despite her powers, she appears humble and compassionate, even healing those who have wronged her. No matter if they are a mother, king, or soldier, she keeps them all protected under her wings.

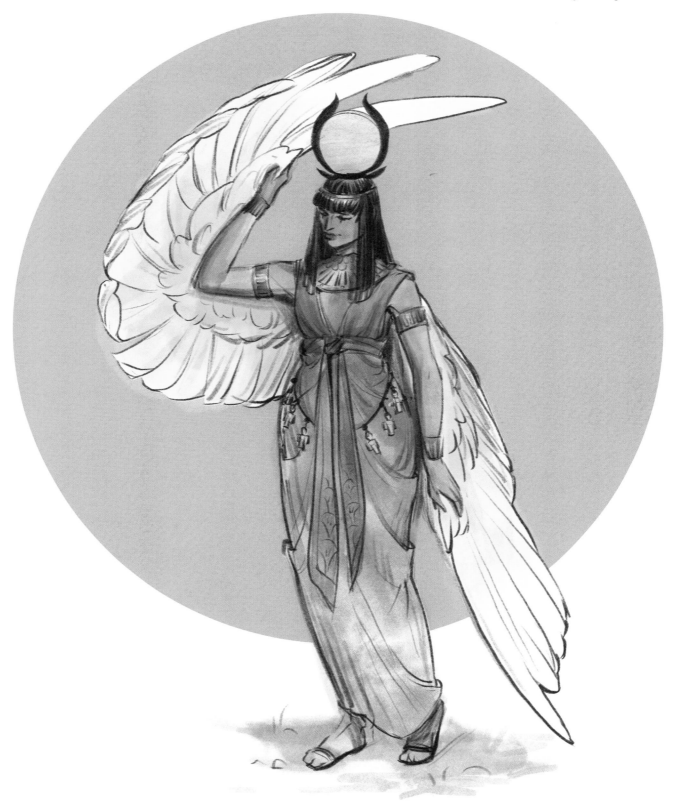

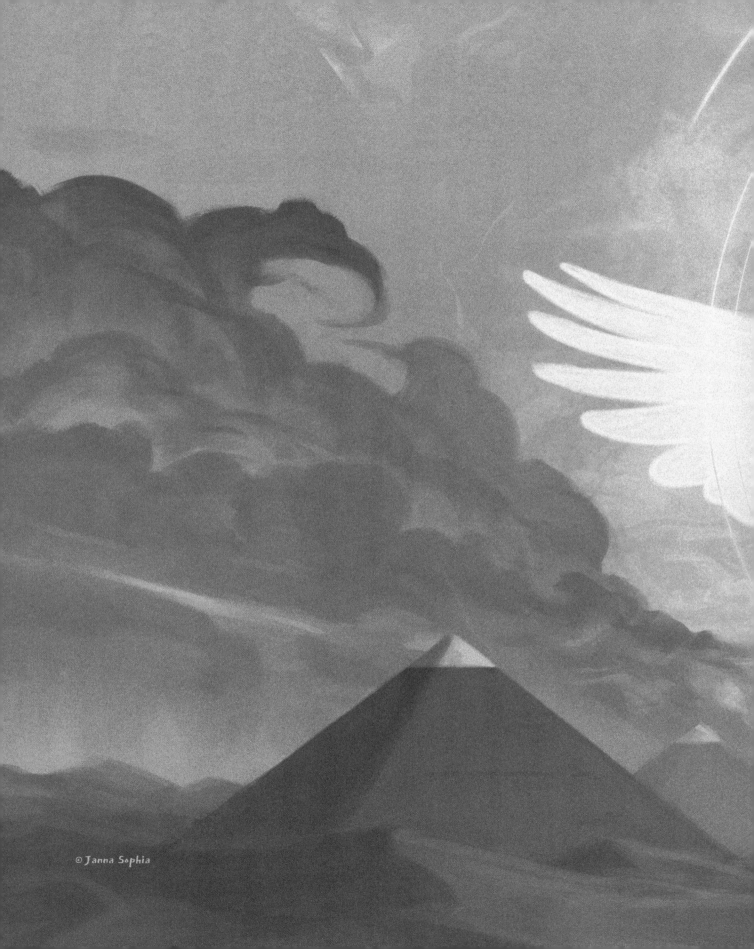

© Janna Sophia

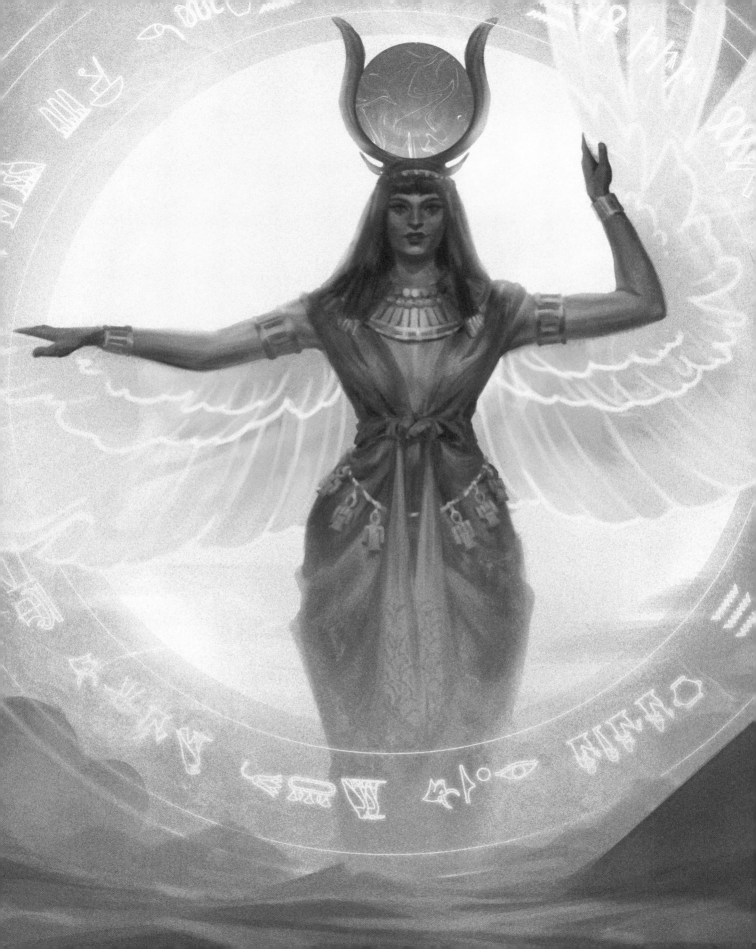

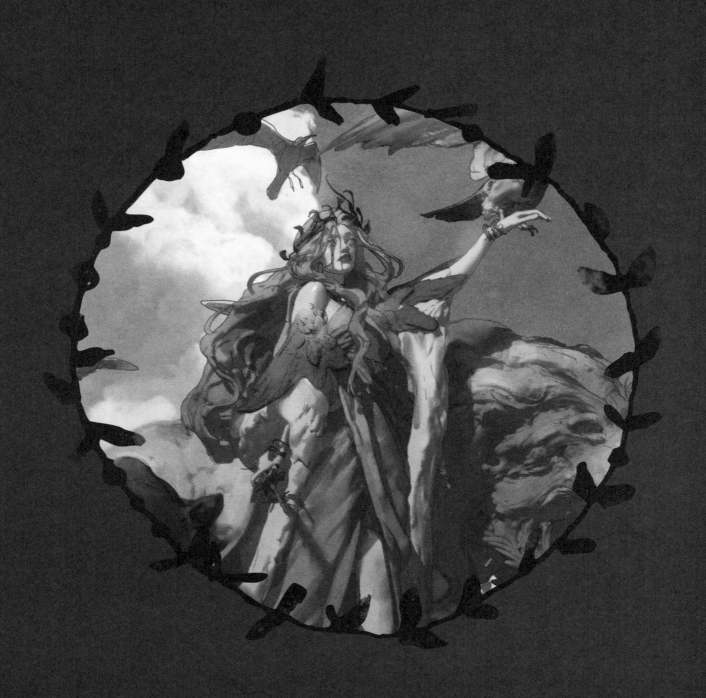

Circe

The sorceress Circe is a striking figure in Greek myth:
a seductive, often jealous witch-goddess with a penchant for
transforming her enemies into animals. Those who insult or
displease her may find themselves condemned to live the rest
of their days as a wild beast. In this chapter, concept artist
Entei Ryu explores the stories of Circe in order to depict
this legendary enchantress.

Entei Ryu | artstation.com/badzr

Research & Rumors

A sorceress-goddess

Circe is an enchantress and goddess of ancient Greek myth. She is sometimes described as the daughter of the god Helios and the nymph Perse, and sometimes as the daughter of the goddess Hecate and the king Aeëtes. She is adept with plants, potions, and poisons, and is known to punish her enemies by turning them into animals.

Odysseus

In Homer's *Odyssey*, Odysseus' crew is thwarted by Circe, who lures the sailors into her palace with food and wine before drugging them and transforming them into swine. On the god Hermes' advice, Odysseus confronts Circe while carrying a herb to defend himself from her magic, and persuades her to free his men. Odysseus remains with Circe on the island for a while, and they eventually have three sons together.

Vindictive magic

Circe's ability to turn others into animals is her most legendary skill, occurring in several stories besides her famous altercation with Odysseus' crew. She transforms King Picus into a woodpecker after failing to seduce him. She turns her love rival, the beautiful nymph Scylla, into a many-headed monster by poisoning the pool in which she bathes.

LOCATION

The island of Aeaea is Circe's home. The ancient Greeks believed this mysterious island was located near River Okeanos, the great river encircling the flat world. In Homer's *Odyssey*, when the hero Odysseus and his crew arrive on the island, they find lush vegetation, woodland, and wild beasts made tame by Circe's potions. According to some tales, she was banished there by her father, and now lives in exile practicing her magic.

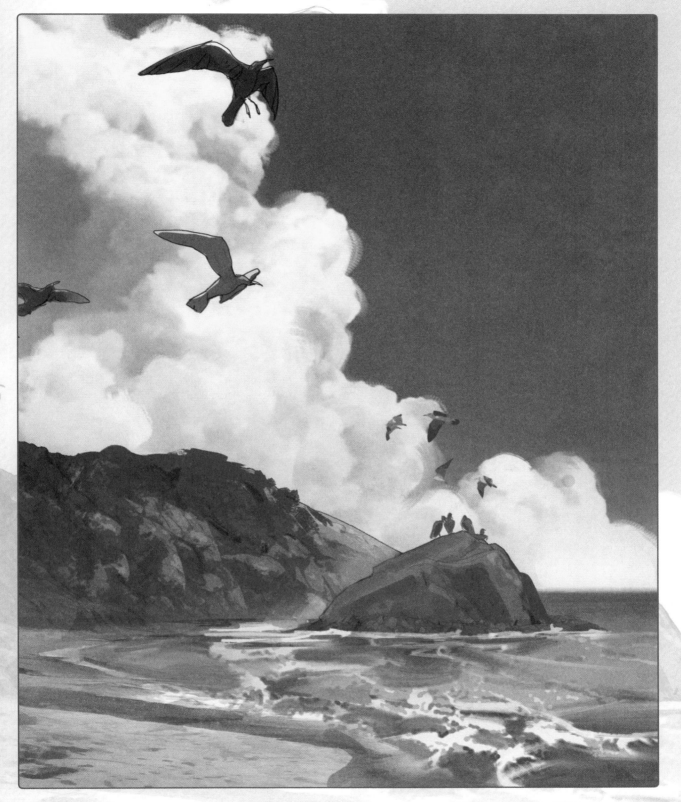

Important Notes

Greek goddess

There are many varying accounts of Circe's life, parentage, and siblings. Most sources, such as the tales by Homer, Hesiod, Apollodorus of Athens, and Apollonius of Rhodes, refer to her as the daughter of Helios, the sun god, and the water nymph Perse, daughter of the ocean god Oceanus.

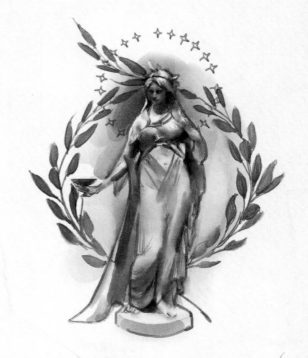

A cursed cup

The nineteenth-century British Pre-Raphaelite painters, intrigued by the themes of Greek mythology and romantic poetry, especially loved the story of Circe. The renowned artist John William Waterhouse painted *Circe Offering the Cup to Ulysses* in 1891, portraying Circe holding up a cup of cursed wine, trying to turn Odysseus (sometimes called Ulysses) into a pig. Many legends describe her creating potions and committing acts of poisoning.

Vengeful poisons

Circe is described by Homer as "knowing many drugs or charms." Her knowledge of herbalism and potion-making is renowned. By mixing her concoctions with wine, or pouring them into a pool, she can turn her enemies and rivals into beasts. She is also described as carrying a wand or staff, with which she casts her enchantments.

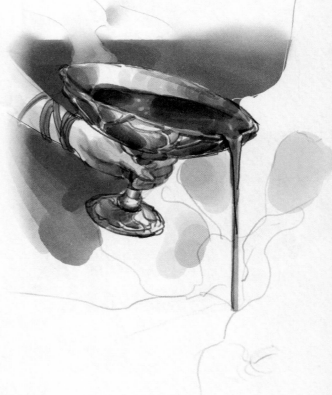

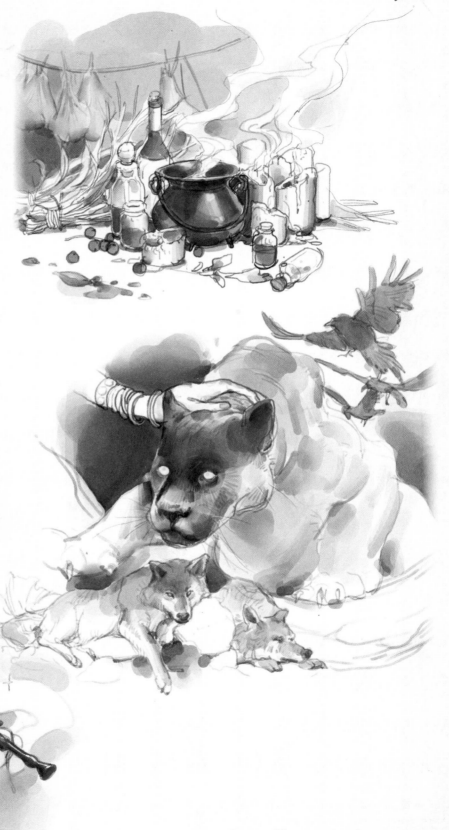

Herbs & plants

Circe's knowledge of herbs, plants, and potions is vast, and the forest island of Aeaea is a perfect setting to practice her craft. I imagine her brewing potions while surrounded by fresh and dried flowers, plants, and herbs gathered from the lush surroundings of her island palace.

Animal servants

Circe's palace is full of exotic animals – powerful lions and wolves tamed by her magic. Perhaps these were men who drank the goddess's potions, lost their human form, and became her faithful servants. When Odysseus' sailors arrive on the island, they are amazed to encounter these tame beasts.

A magic wand

A wand or staff is a must for a witch. Beyond brewing her magic potions, Circe uses a wand called a "rhabdos" to manipulate her magic. I imagine it being a wooden wand, with living branches and decorative herbs, to tie her close to the woodland flora of the island.

Studying the Witch

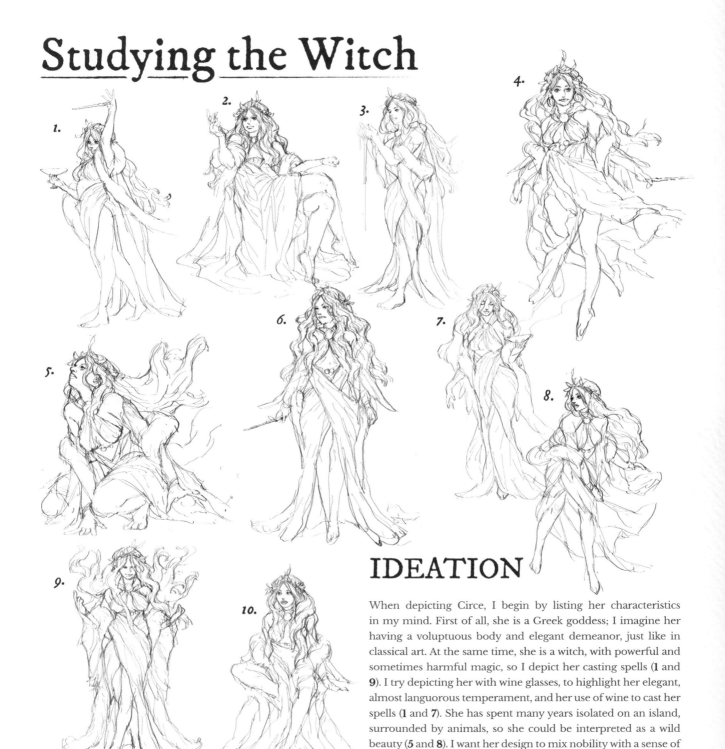

IDEATION

When depicting Circe, I begin by listing her characteristics in my mind. First of all, she is a Greek goddess; I imagine her having a voluptuous body and elegant demeanor, just like in classical art. At the same time, she is a witch, with powerful and sometimes harmful magic, so I depict her casting spells (**1** and **9**). I try depicting her with wine glasses, to highlight her elegant, almost languorous temperament, and her use of wine to cast her spells (**1** and **7**). She has spent many years isolated on an island, surrounded by animals, so she could be interpreted as a wild beauty (**5** and **8**). I want her design to mix nobility with a sense of wildness. She is also described as having long, fiery hair, which is a key feature in all these sketches.

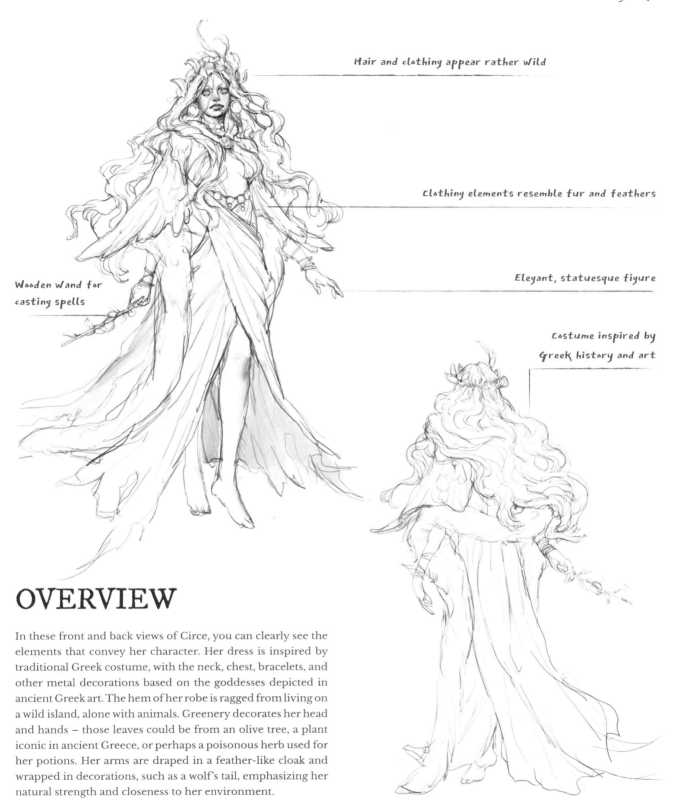

Hair and clothing appear rather wild

Clothing elements resemble fur and feathers

Wooden wand for casting spells

Elegant, statuesque figure

Costume inspired by Greek history and art

OVERVIEW

In these front and back views of Circe, you can clearly see the elements that convey her character. Her dress is inspired by traditional Greek costume, with the neck, chest, bracelets, and other metal decorations based on the goddesses depicted in ancient Greek art. The hem of her robe is ragged from living on a wild island, alone with animals. Greenery decorates her head and hands – those leaves could be from an olive tree, a plant iconic in ancient Greece, or perhaps a poisonous herb used for her potions. Her arms are draped in a feather-like cloak and wrapped in decorations, such as a wolf's tail, emphasizing her natural strength and closeness to her environment.

EXPLORATIONS

In these sketches, we can see the design applied to two of
Circe's pivotal moments from Greek myth: poisoning Scylla
and transforming sailors into swine.

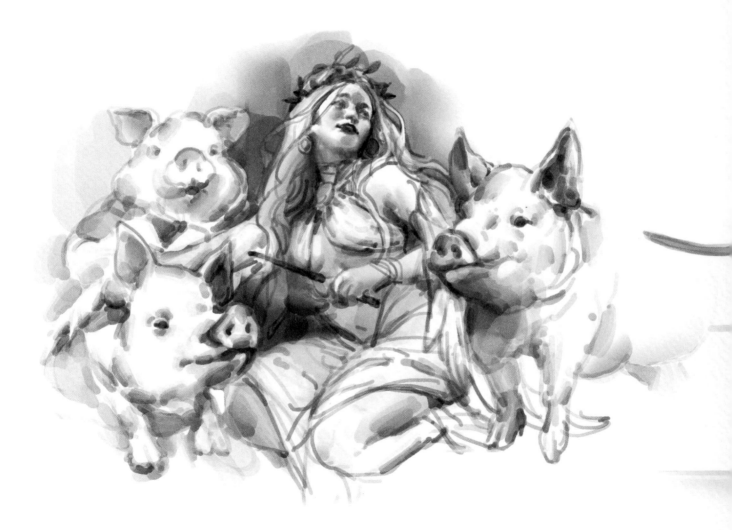

▲ Here we see Circe in one of her most well-known moments
from *The Odyssey*: surrounded by pigs created by a magical
curse. She appears comfortable, confident, and even amused
as she lounges in her palace with Odysseus' unfortunate crew.

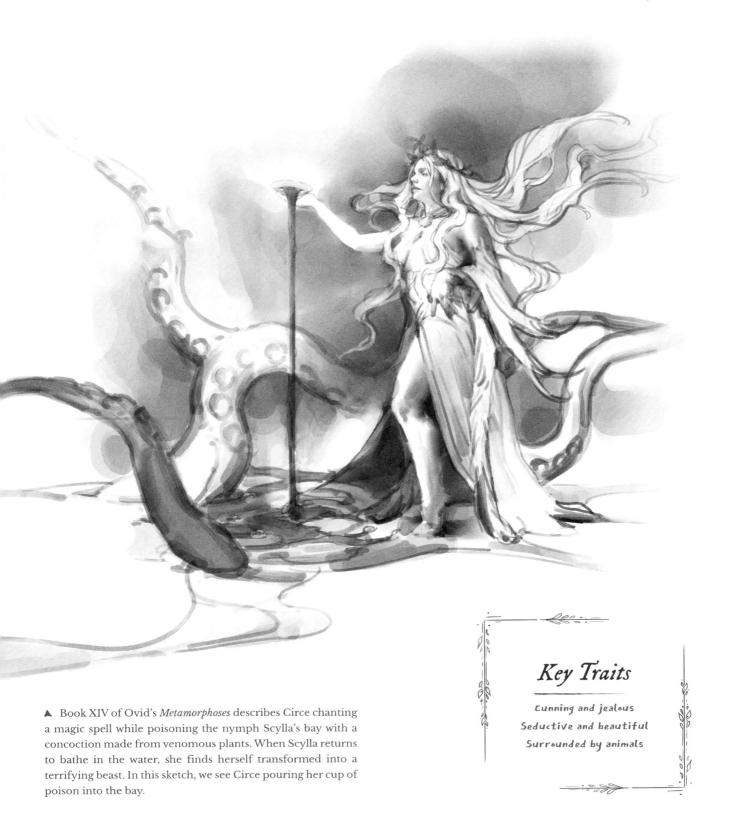

▲ Book XIV of Ovid's *Metamorphoses* describes Circe chanting a magic spell while poisoning the nymph Scylla's bay with a concoction made from venomous plants. When Scylla returns to bathe in the water, she finds herself transformed into a terrifying beast. In this sketch, we see Circe pouring her cup of poison into the bay.

Key Traits

Cunning and jealous
Seductive and beautiful
Surrounded by animals

Meeting the Witch

So what kind of existence would Circe have, behind those poets' stories and legends told by others? I imagine her strolling along the seashore of Aeaea, alone except for the animal servants she has transformed. She is lonely but powerful; wild but graceful. The long years surrounded by nature and beasts have left her hair and clothes disheveled, but her bright, fiery hair is unfaded. Fate has given her a troubled life of abandonment and exile, but her eyes nevertheless still shine with clarity and curiosity like a newborn child's. Her great magical power is a curse as well as the key to her defying authority and finding her own freedom.

> "I imagine Circe strolling along the seashore of Aeaea, alone except for the animal servants she has transformed"

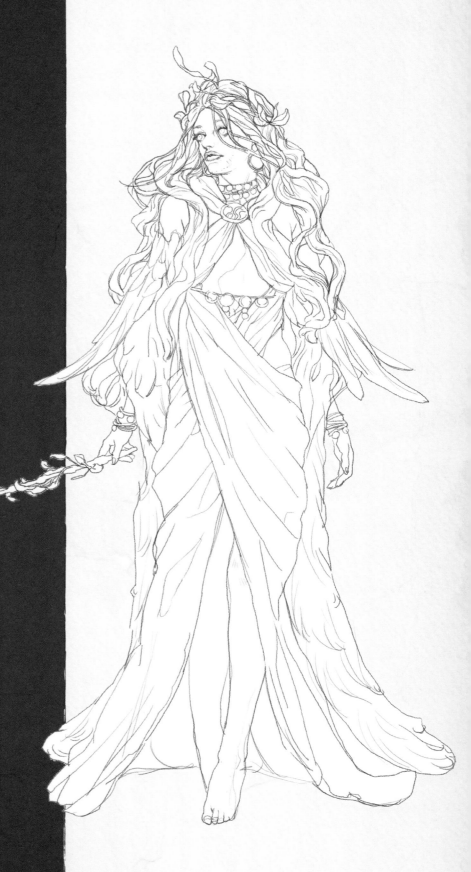

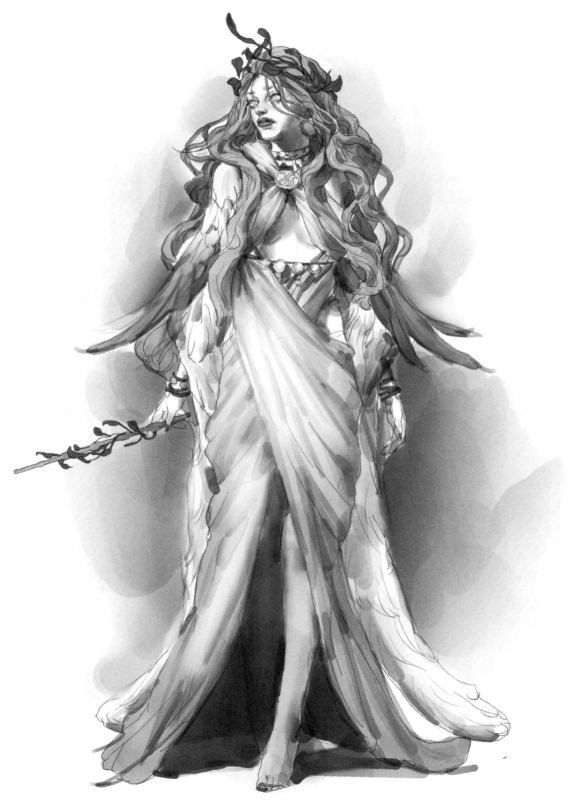

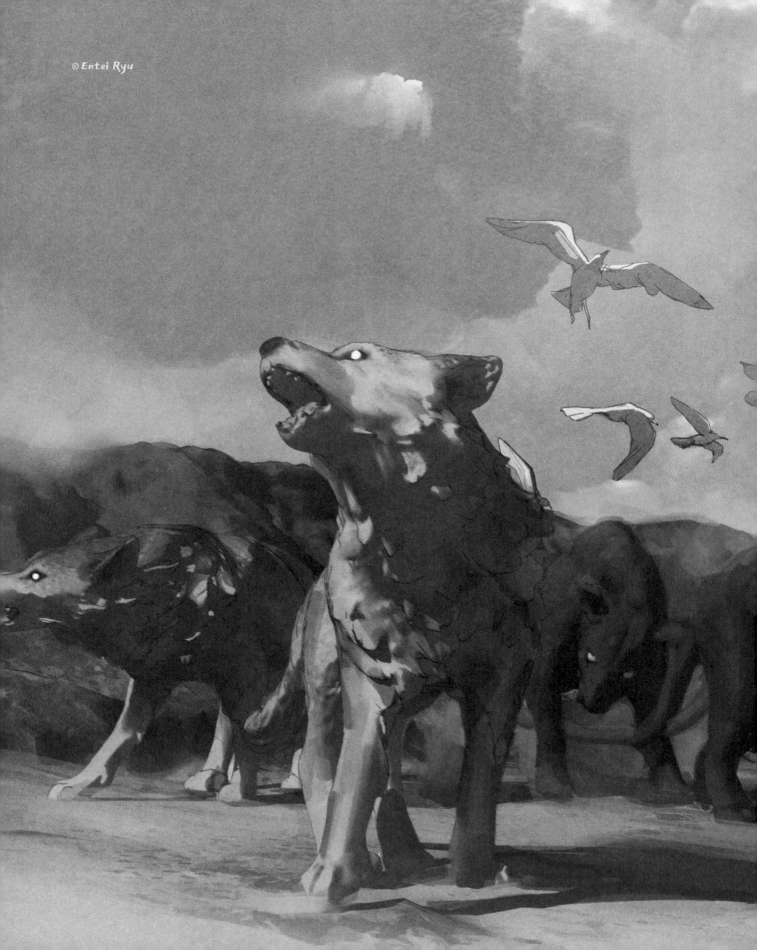

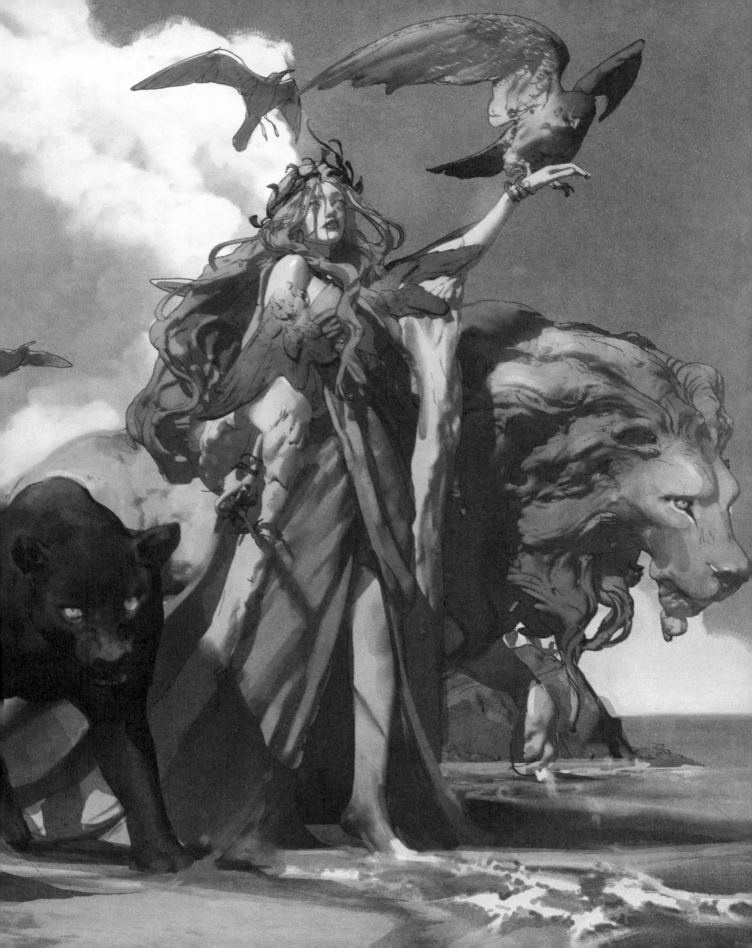

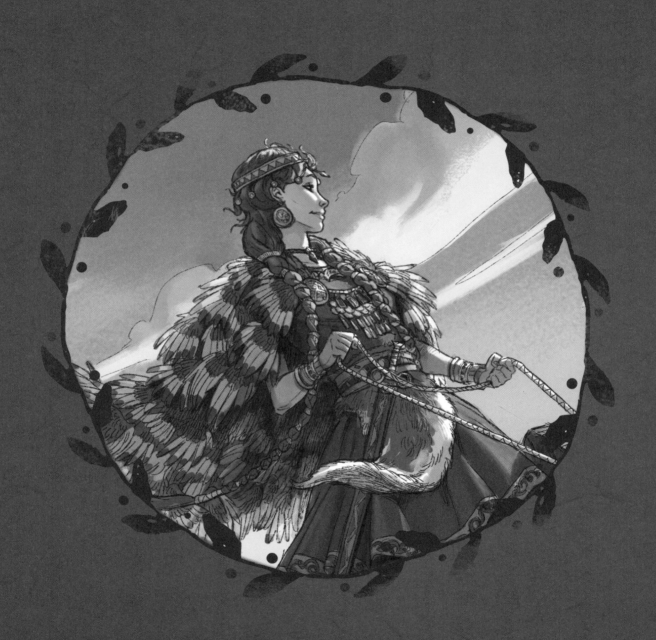

Freyja

An icon of the vibrant Norse pantheon, Freyja is the goddess of love, war, and prophetic seiðr magic. She has many roles and guises, from a fearsome warrior queen, to a leader for the spirits of fallen warriors, to an elusive herbalist witch. In this chapter, character designer and illustrator Hazem Ameen explores the rich world of Viking mythology as a basis for his own design.

Hazem Ameen | instagram.com/caninebrush

Research & Rumors

Vanir origins

Freyja spent most of her life as one of the Vanir (a tribe of Norse gods). Her father was Njord, god of the frigid seas, but no one knows of her mother, for Freyja never speaks of her. She came to Asgard after the brutal wars between the Æsir and Vanir gods, as a peace offering between the two tribes. She brought seiðr magic (the ability to see the future) to the Æsir.

Fólkvangr

Though Odin's Valhalla is better known today, half of the slain warriors are not taken there, but to Freyja's domain. There, they fight in the heavenly fields of Fólkvangr and feast in its beautiful hall Sessrúmnir. Freyja might be known as the goddess of love and beauty, but she is also a fierce warrior. When Ragnarök comes – the fated doom of all the gods – it is not Odin alone who will have an army.

Seiðr powers

Freyja is known as the mother of the völva – the female seers who live among mortals. Using her legendary skill with seiðr magic, she can see the future and maybe even influence it a little – but not too much, for the Norns of Fate have already carved the destiny of all. For her magical skills and divine beauty, Freyja is coveted and admired by gods and jötnar (sometimes called giants) alike.

LOCATION

Although originally from Vanaheim, the realm of the nature-oriented Vanir gods, Freyja has made her home in Asgard, home of the Æsir gods. Here you will find Odin the Allfather and his sons Thor and Baldr. The god Heimdall keeps a watchful eye over Asgard's shimmering rainbow bridge lest any troublesome jötnar enter, for they are the Æsir's oldest enemies. Asgard is also the home of Odin's stronghold, Valhalla, where fierce Valkyries carry half of those who die in battle to an afterlife of eternal feasting and fighting. The other half go to Freyja's heavenly domain of Fólkvangr.

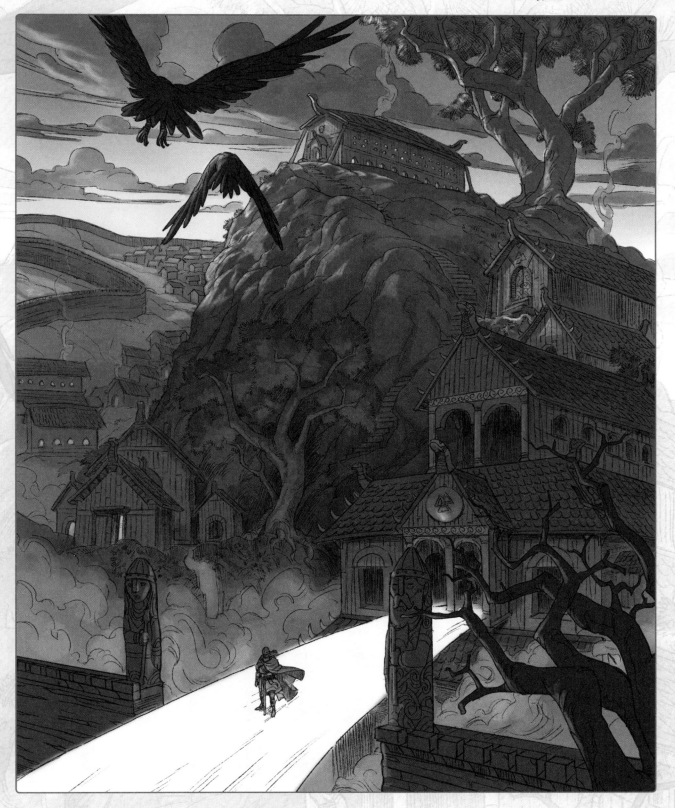

Important Notes

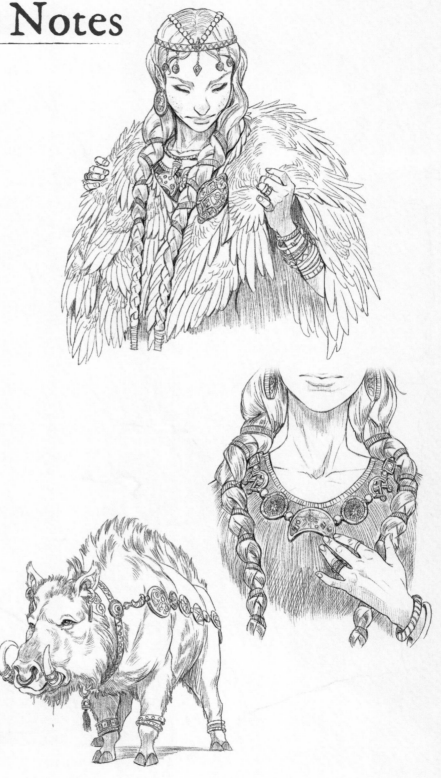

The cloak of flight

This cloak of magically sewn falcon feathers was a souvenir brought by Freyja from her homeland of Vanaheim as a parting gift from her kin. It gives the freedom of flight to anyone who wears it. With it, Freyja soars through the many realms of Yggdrasil (the great tree connecting nine worlds) or across the human kingdom of Midgard, in search of her husband Óðr, who is always traveling. When she isn't using the cloak, she may let others borrow it for a time, as long as they agree to do her bidding.

The golden necklace

Freyja's most prized possession is surely Brísingamen, a gleaming necklace of amber. Its golden frame was beaten and shaped in the mountains of Svartalfheim and bought by the goddess from its studious dwarves. It is said that she paid a heavy price for it, though most do not know how much. For this reason and more, she guards the necklace well, sending her pets and devotees to keep watch over it when needed, for many thieves hunger after it – none more so than Loki, the scheming god of mischief.

The loyal boar

All in Asgard know of Freyja's hulking boar, Hildisvíni. He guards her wares from prying hands and fights any who speak foul of the goddess. He was not always a beast in mind or body, but is Freyja's most loyal friend, Óttar, in disguise. In one tale, Freyja and Óttar (in the guise of Hildisvíni) trick a seeress into disclosing Óttar's ancestry, helping him win a costly wager of family heirlooms.

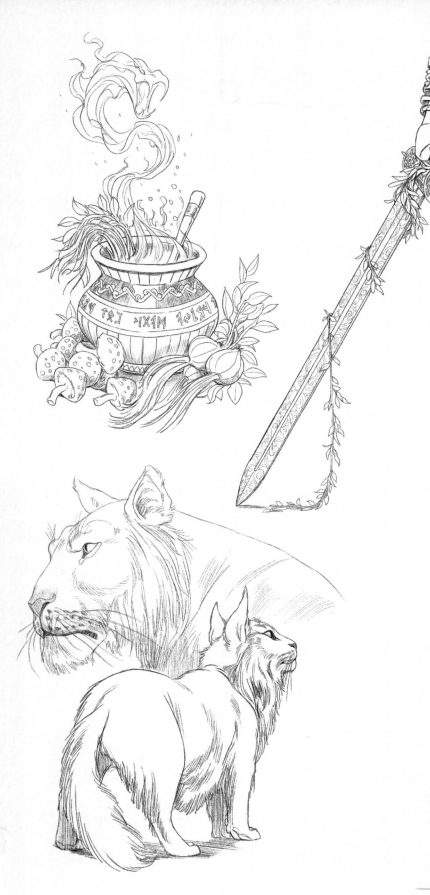

The herbs of Vanaheim

One of Freyja's famed skills is the art of handling herbs and plants, such as the wild mushrooms of Valhalla or the fruits of Iðunn's garden. Her alcove lies in the woods, far away from her stronghold in Sessrúmnir, where slain warriors riled with mead and battle-rage would disturb and interrupt her arts of healing and forest magic. On her many travels, she is happy to share her knowledge with the mortals of Midgard.

Freyja's sword

When Freyja and her brother Freyr arrived in Asgard, they were met with much pomp and celebration. I imagine Odin gifting her a dwarf-forged sword worthy of her warrior's spirit. This sword would be used to lead her army in Fólkvangr during the final doomed days of Ragnarök.

Freyja's cats

The inhabitants of Midgard are known to respect and honor cats, seeing them as the agents of the goddess Freyja. This is true, for Freyja adores all cats, but none more so than her two divine pets. The two companions that follow her around Asgard appear as house cats to most, until Freyja calls for her sky chariot. Then they transform into large, majestic beasts – great leonine creatures that run across the clouds. Just as the thunder god Thor's chariot is pulled by his mountain goats, Freyja's chariot is pulled by her shapeshifting cats.

Studying the Witch

IDEATION

Finding the goddess Freyja's gesture is a study of her many characteristics and the myriad ways she has been described in the Norse sagas: a deity of love and fertility; a witch who practices the most feminine crafts of magic; a warrior who fights on the battlefield and hoards fallen warriors; and even someone who slinks into the mortal world, disguised and hooded. It's a challenge to find a look that encompasses all these traits and still feels consistent.

1 and 2 emphasize her role as a witch, but the confident seiðr practitioner with the famous feathered cloak in 1 seems the more consistent option. Similarly, both 3 and 8 show her in warrior form, but 3 gives more of a hulking and savage silhouette, while the sharp yet fierce pose of 8 serves the character better. Additional poses flesh out the character, such as 7 showing her more playful side, and 5 showing her disguised while traveling through Midgard.

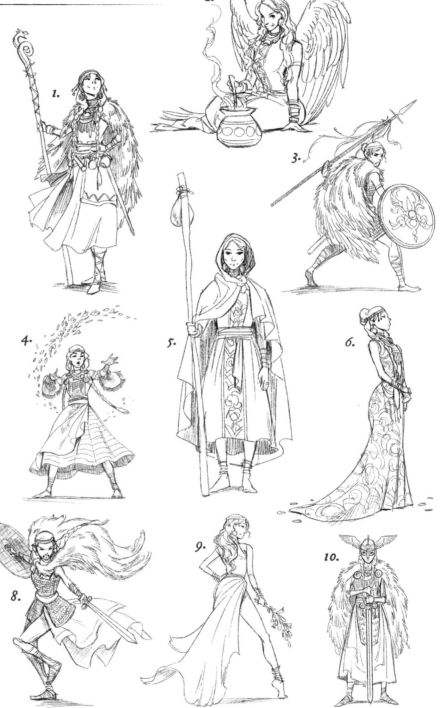

Faithful cat companions

Herbalist's accessories and equipment

Clothing based on historical Scandinavian dress

Carries a sword, ready for battle!

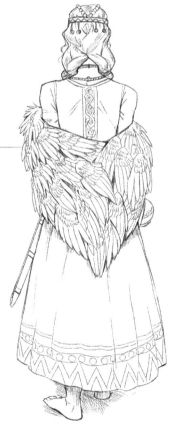

Magical cloak of feathers

OVERVIEW

Since the goddess Freyja is the epitome of Norse femininity and beauty, and what every Viking woman aspires to be, her appearance is very much what you would expect from the wealthy women of the Viking world. Her braided hair, jewelry, ornaments, and clothing very much reflect the everyday reality of ancient Scandinavia. As Freyja is also known to be a herbalist, her reeds and pots are never far behind. She is also known to be a fighter, commanding a hall of slain warriors, so her sword sits in a comfortable scabbard, ready if the need arises. Her famous enchanted feathers are wrapped around her in the same way a cloak would be for others. Her two cats are never far from their mistress, enjoying the comfort of her feather cloak. This final design reflects her many magical properties, as well as the simplicity and earthiness of many a Norse deity.

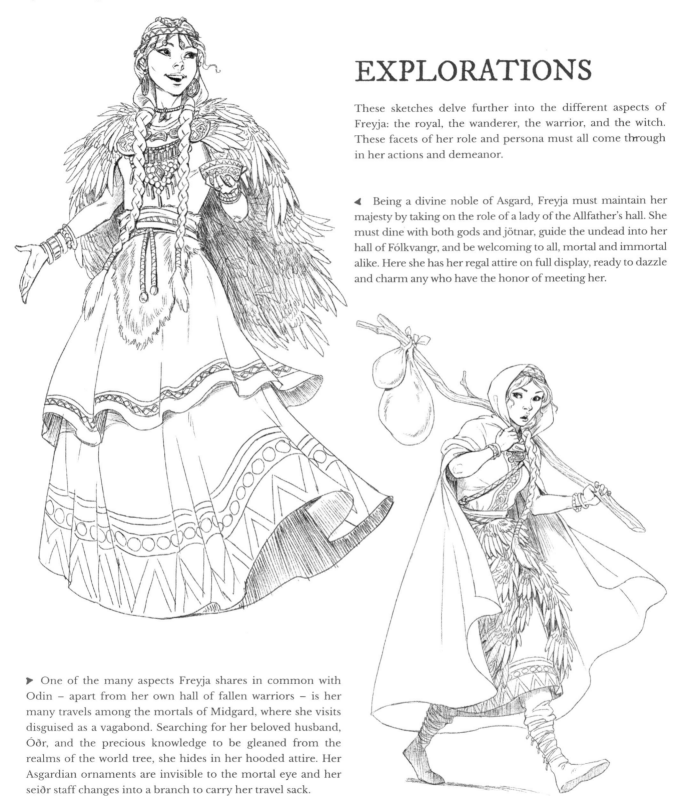

EXPLORATIONS

These sketches delve further into the different aspects of Freyja: the royal, the wanderer, the warrior, and the witch. These facets of her role and persona must all come through in her actions and demeanor.

◄ Being a divine noble of Asgard, Freyja must maintain her majesty by taking on the role of a lady of the Allfather's hall. She must dine with both gods and jötnar, guide the undead into her hall of Fólkvangr, and be welcoming to all, mortal and immortal alike. Here she has her regal attire on full display, ready to dazzle and charm any who have the honor of meeting her.

► One of the many aspects Freyja shares in common with Odin – apart from her own hall of fallen warriors – is her many travels among the mortals of Midgard, where she visits disguised as a vagabond. Searching for her beloved husband, Óðr, and the precious knowledge to be gleaned from the realms of the world tree, she hides in her hooded attire. Her Asgardian ornaments are invisible to the mortal eye and her seiðr staff changes into a branch to carry her travel sack.

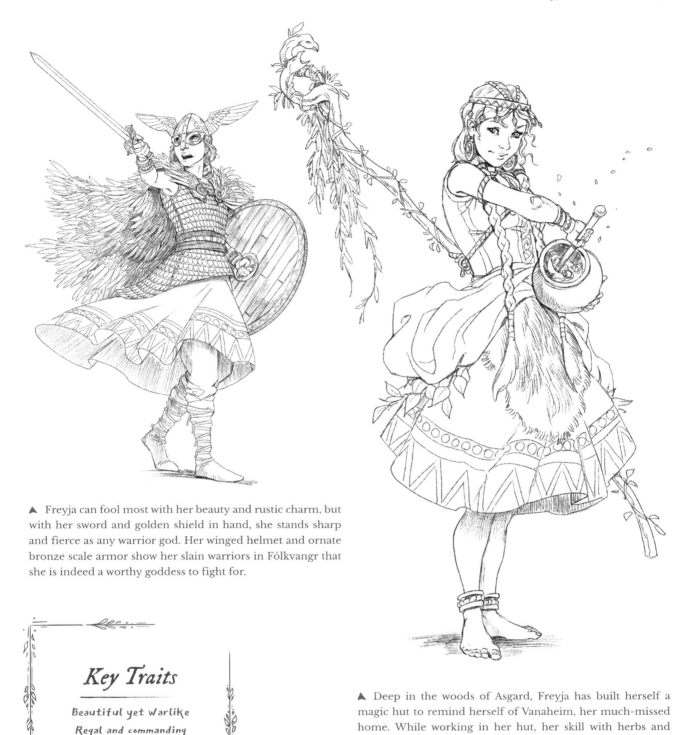

▲ Freyja can fool most with her beauty and rustic charm, but with her sword and golden shield in hand, she stands sharp and fierce as any warrior god. Her winged helmet and ornate bronze scale armor show her slain warriors in Fólkvangr that she is indeed a worthy goddess to fight for.

Key Traits

Beautiful yet warlike

Regal and commanding

Close to nature

▲ Deep in the woods of Asgard, Freyja has built herself a magic hut to remind herself of Vanaheim, her much-missed home. While working in her hut, her skill with herbs and plants melds with her seiðr craft, awakening spirits and manipulating the strings of fate. She does away with her Asgardian finery in favor of keeping company with the many creatures and plants that dwell around her hut.

Meeting the Witch

The Norse goddess Freyja has been depicted here in the form that most embodies her role as a witch, healer, seiðr magic user, and the pride of all Vanaheim. Depicting a character with multiple known personas can be tricky, but committing to one strong version can be more effective than trying to create a combination of all of them.

Freyja here seems inviting in her heavenly forest abode, confident in her charms and beauty, as she is of course the goddess of love. Her attire shows that she is the ultimate model of a Viking matron, and her seiðr staff shows how she practices arts that are unknown and feared by many. She finds comfort in her feather cloak, which allows her to fly; her necklace, Brísingamen, gleams in the firelight for all to see. Her cauldron, which she uses to produce untold wonders and cures, boils away behind her. Her two legendary pet felines can also be seen lazing around their mistress in their house-cat form, until they are called to transform and pull her chariot across the skies of Asgard.

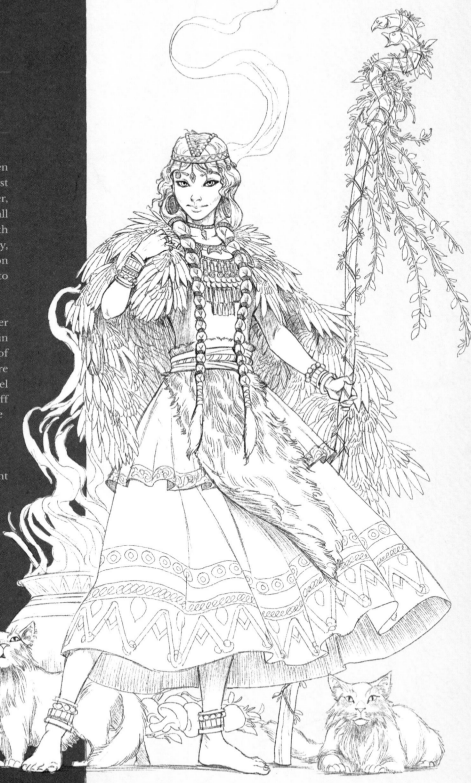

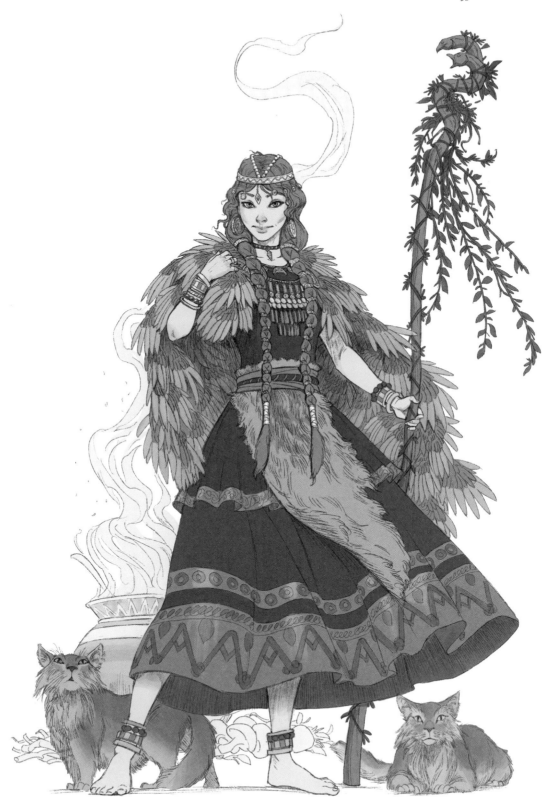

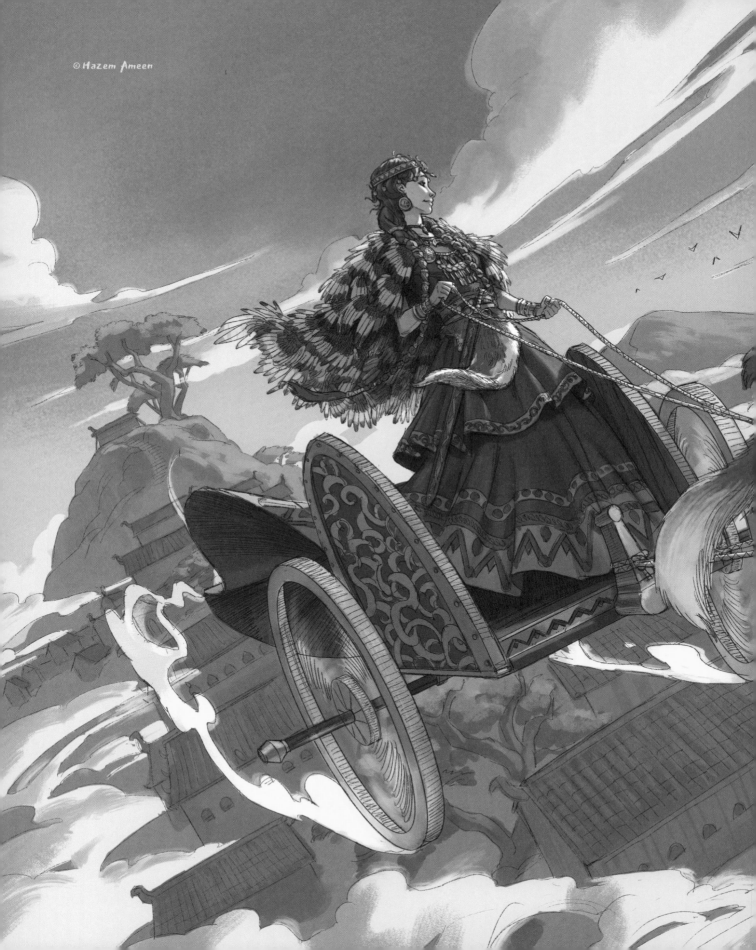

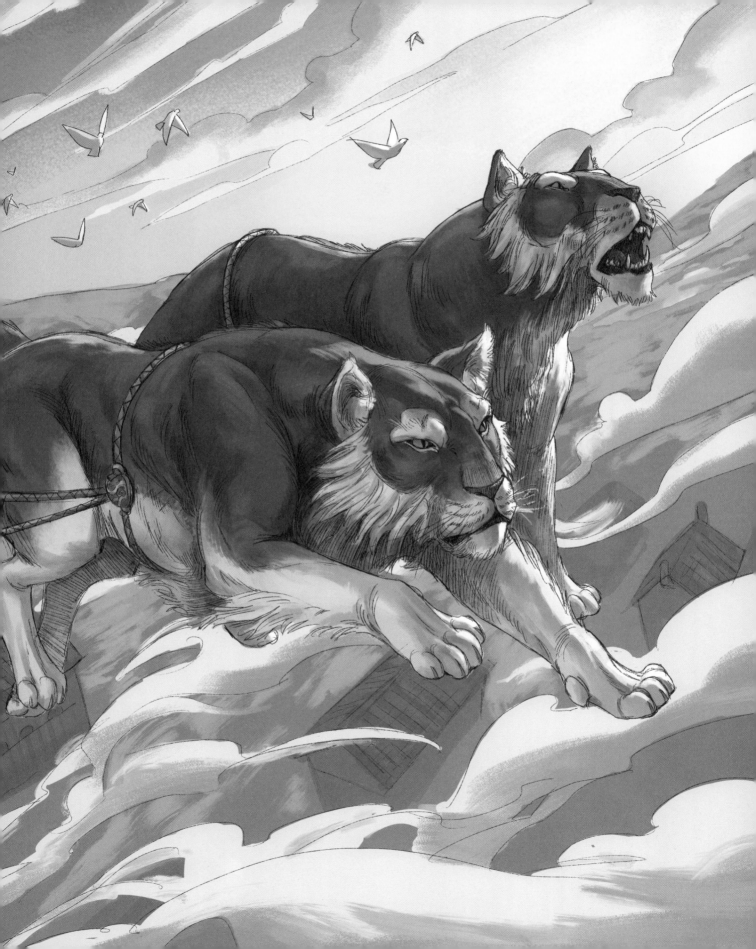

The Morrigan

The Morrigan is an iconic warrior goddess of
Irish legend. A queen of death and battle, with powers
of prophecy, sorcery, and shapeshifting at her disposal,
she is a formidable figure with many roles and guises.
In this chapter, fantasy illustrator Jodie Muir explores
the Morrigan's myths and symbols to create a depiction
of this battle-hardened goddess.

Jodie Muir | jodiemuir.squarespace.com

Research & Rumors

The Phantom Queen

The name "Morrígan" loosely translates as "Phantom Queen" or "Great Queen." It can refer to an individual goddess, or to a trio of sister goddesses known as Nemain, Badb, and Macha. Badb translates to "crow" or "raven," and it is rumored she would feast on the unfortunates who did not make it home from the battlefield. Macha means "pasture" or "plain" and connects the goddess to the earth; she also represents feminine strength. Nemain, the third sister, represents the violent, chaotic aspect of the trio, though the meaning of her name has been lost with time.

Tuatha Dé Danann

The Morrígan is thought to have belonged to the Tuatha Dé Danann, the children of Danu. This was a group or tribe of gods and supernatural beings that made their way to Ireland, led by their king, Nuada, on ships shrouded in dark mists and cloud. It is said there were three days and three nights of darkness upon their arrival.

The Dagda

It is believed that the Morrigan was the wife of the Dagda, a fellow member of the Tuatha Dé Danann, a king, druid, and god who was closely associated with fertility and agriculture. They are said to have met when he saw her bathing and fell instantly under her spell of beauty. This meeting took place at Samhain. This is significant when you consider that she is viewed as a symbol of death and he one of life; during Samhain, the veil between the land of the living and the dead is at its thinnest.

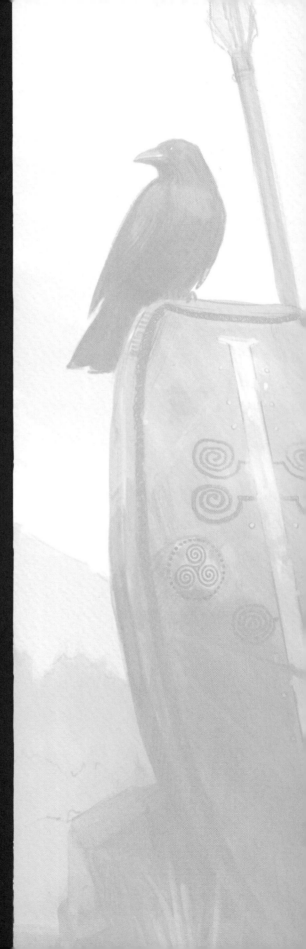

LOCATION

The Morrígan is very strongly associated with war, death, and fate. She is thought to have appeared as a crow or a fierce queen alongside her people on the battlefield. She can instill courage into the hearts of warriors and spur them fearlessly into battle. The Morrígan also appeared to soldiers in many guises as an omen of victory or defeat.

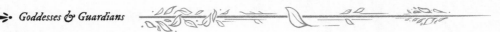
Important Notes

Crow

The crow is the most prominent symbol of the Morrígan, appearing in nearly all visual depictions of her. As she was a war goddess, it makes sense that she would have a close association with a bird that is a scavenger of carrion and would likely be found among the fallen. There may be more to it than the association with death, though; crows are also very intelligent and are thought of as a good omen by many people. They also symbolize transformation and destiny.

Shapeshifting

The Morrígan is often described as a beautiful woman with long, black hair, but she also appears in many other guises. Along with being a fearsome warrior queen, she is also a shapeshifter, and many tales tell of her transforming into various different animals to get her way, from heifers and wolves to crows and eels. Sometimes these are auspicious sightings and other times they are a prediction of a grim future.

Symbols of three

The Morrígan is sometimes referred to as a triple goddess, part of a sister trifecta of goddesses. These types of goddess are sometimes signified by the triple moon, or are characterized as "the maiden, mother, and crone." Knotted designs such as the triquetra and the triskele are also emblematic of this triplicate nature. Groupings of three are very commonly associated with the Morrígan, and figure prominently in magic and mythology in general.

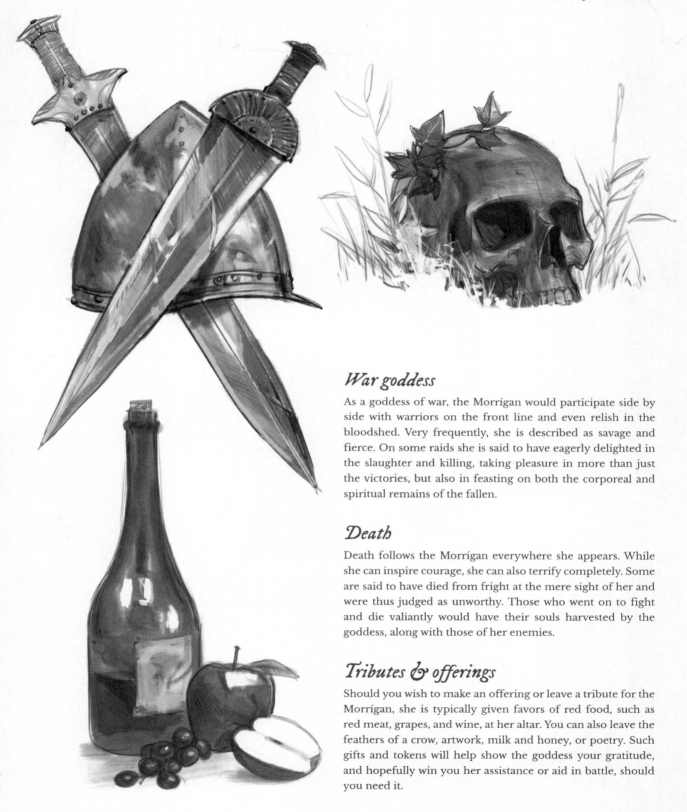

War goddess

As a goddess of war, the Morrígan would participate side by side with warriors on the front line and even relish in the bloodshed. Very frequently, she is described as savage and fierce. On some raids she is said to have eagerly delighted in the slaughter and killing, taking pleasure in more than just the victories, but also in feasting on both the corporeal and spiritual remains of the fallen.

Death

Death follows the Morrígan everywhere she appears. While she can inspire courage, she can also terrify completely. Some are said to have died from fright at the mere sight of her and were thus judged as unworthy. Those who went on to fight and die valiantly would have their souls harvested by the goddess, along with those of her enemies.

Tributes & offerings

Should you wish to make an offering or leave a tribute for the Morrígan, she is typically given favors of red food, such as red meat, grapes, and wine, at her altar. You can also leave the feathers of a crow, artwork, milk and honey, or poetry. Such gifts and tokens will help show the goddess your gratitude, and hopefully win you her assistance or aid in battle, should you need it.

Studying the Witch

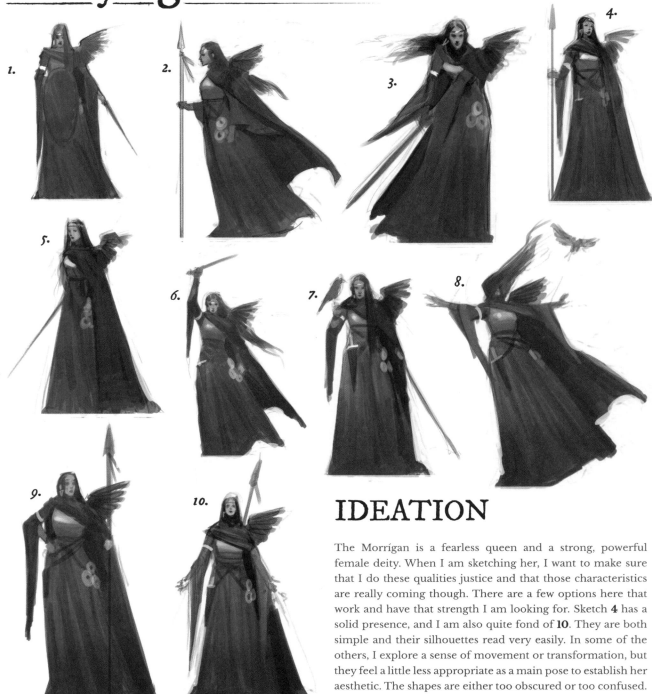

IDEATION

The Morrígan is a fearless queen and a strong, powerful female deity. When I am sketching her, I want to make sure that I do these qualities justice and that those characteristics are really coming though. There are a few options here that work and have that strength I am looking for. Sketch **4** has a solid presence, and I am also quite fond of **10**. They are both simple and their silhouettes read very easily. In some of the others, I explore a sense of movement or transformation, but they feel a little less appropriate as a main pose to establish her aesthetic. The shapes are either too obscured or too confused.

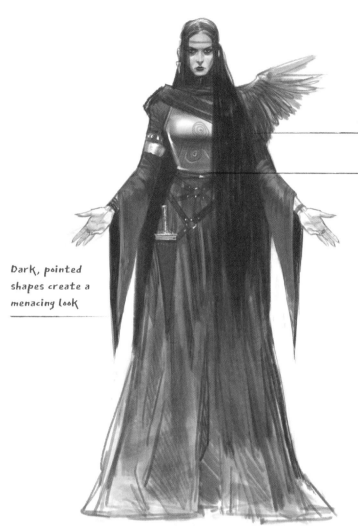

Long hair keeps an element of wildness

Armored and equipped for battle

Dark, pointed shapes create a menacing look

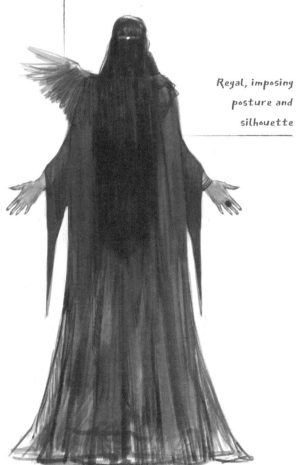

Bird motifs show her association with crows

Regal, imposing posture and silhouette

OVERVIEW

Here we can see the Morrígan from the front and back. A fearless goddess, her outward appearance contains plenty of nods to war and battle, and also to her dark, gothic character. She is so closely aligned with death and the black crow, I want her long, pointed sleeves to reinforce this. She wears a chest plate and a dagger to show her readiness for battle. There is a large crow wing on her shoulder to suggest her shapeshifting qualities, as if she could vanish into flight at any moment. Maybe she is partially transformed already. As she is a queen and a goddess, it is necessary to maintain a powerful, imposing, and somewhat other worldly appearance, too. The long, heavy skirts and black cowl have that sense of regal sovereignty, while the loose, flowing hair keeps her somewhat feral and untamed.

EXPLORATIONS

The Morrígan is an imposing figure who strikes awe into the hearts of both her followers and foes. That feeling of power and portent must come across in these pose explorations, wherever she is seen and whatever form she takes.

▶ The Morrígan is a shapeshifter who can transform into a myriad of animals to achieve her wants and desires, or as an ill omen to those who behold her. However, her most prominent tie to the animal kingdom, and her most recognized symbol, is the crow. Here we see her in the middle of a transformation, shifting between her human and crow form. Quite the fearsome sight to behold!

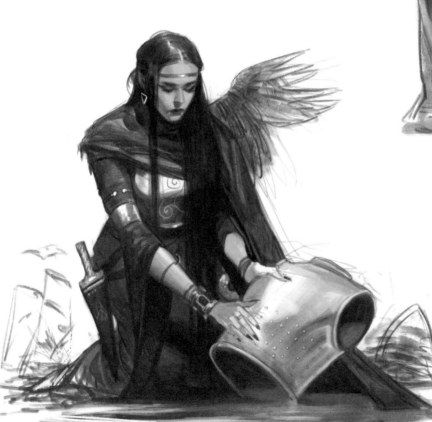

◀ If the Morrígan appears to you as a beautiful woman, or as a weathered hag, washing bloodstains from your armor or belongings by a brook or ford, your fate is already sealed. Your victory is uncertain and you are unlikely to make it home from the coming conflict.

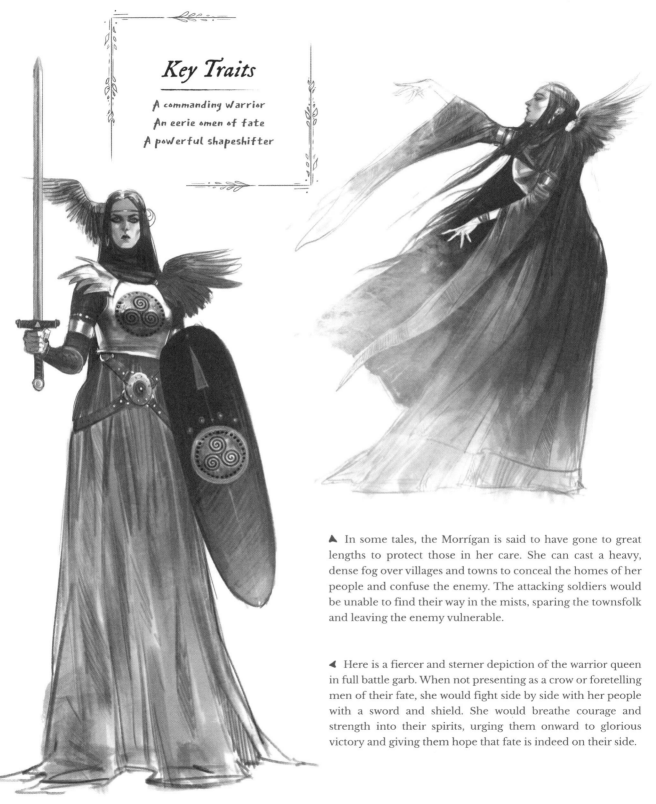

Key Traits

A commanding warrior
An eerie omen of fate
A powerful shapeshifter

▲ In some tales, the Morrígan is said to have gone to great lengths to protect those in her care. She can cast a heavy, dense fog over villages and towns to conceal the homes of her people and confuse the enemy. The attacking soldiers would be unable to find their way in the mists, sparing the townsfolk and leaving the enemy vulnerable.

◀ Here is a fiercer and sterner depiction of the warrior queen in full battle garb. When not presenting as a crow or foretelling men of their fate, she would fight side by side with her people with a sword and shield. She would breathe courage and strength into their spirits, urging them onward to glorious victory and giving them hope that fate is indeed on their side.

Meeting the Witch

The Morrigan is an intimidating and quite elusive figure to try to capture. There are many different tales and fractured accounts of her appearances through history. She is both beautiful and strong, but also wild and aggressive. She is a human and a beast; a goddess and a queen. She is both a good and ill omen. Her character is multifaceted, which is mirrored in the frequent representations of her as a triple goddess. Here she is shown as one figure that incorporates all the elements of the Morrigan's lore.

There are many "threes" in her design; her small decorative discs and the exaggerated triangular shapes of her dagger and earring all reinforce the triquetra. Her expression is one of an unsmiling and serious queen. Her pose is upright, purposeful, and strong. She is battle-ready and equally as imposing to her enemies as she is inspiring to the warriors of her own people.

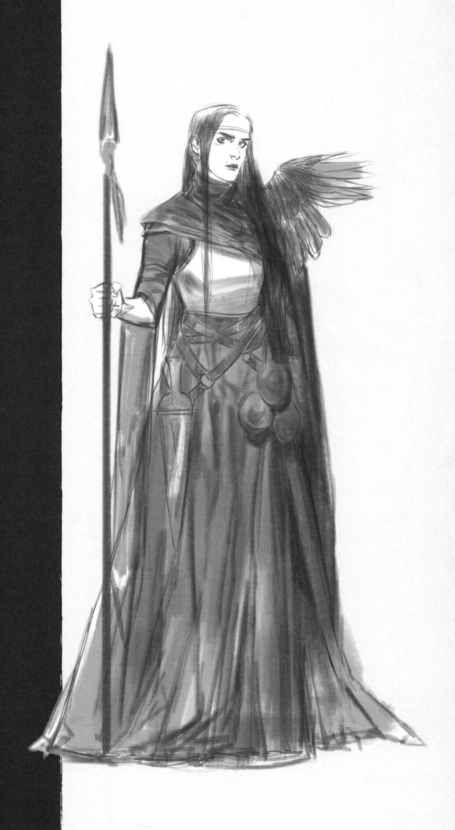

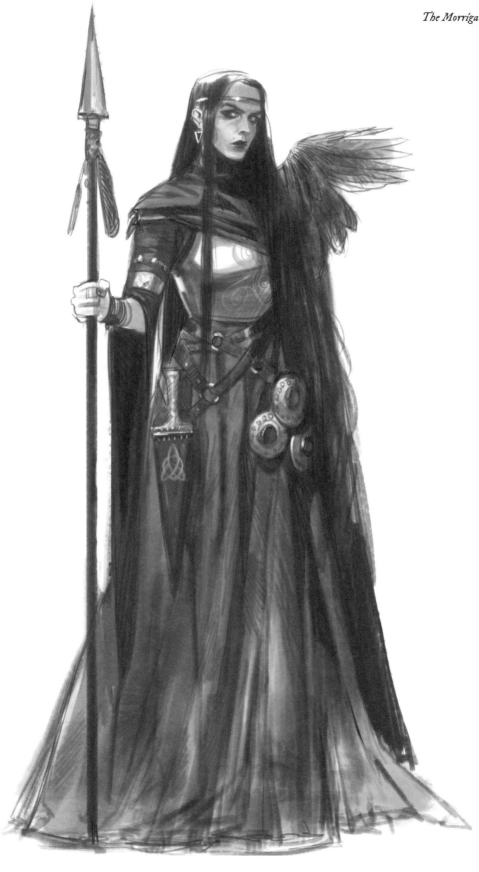

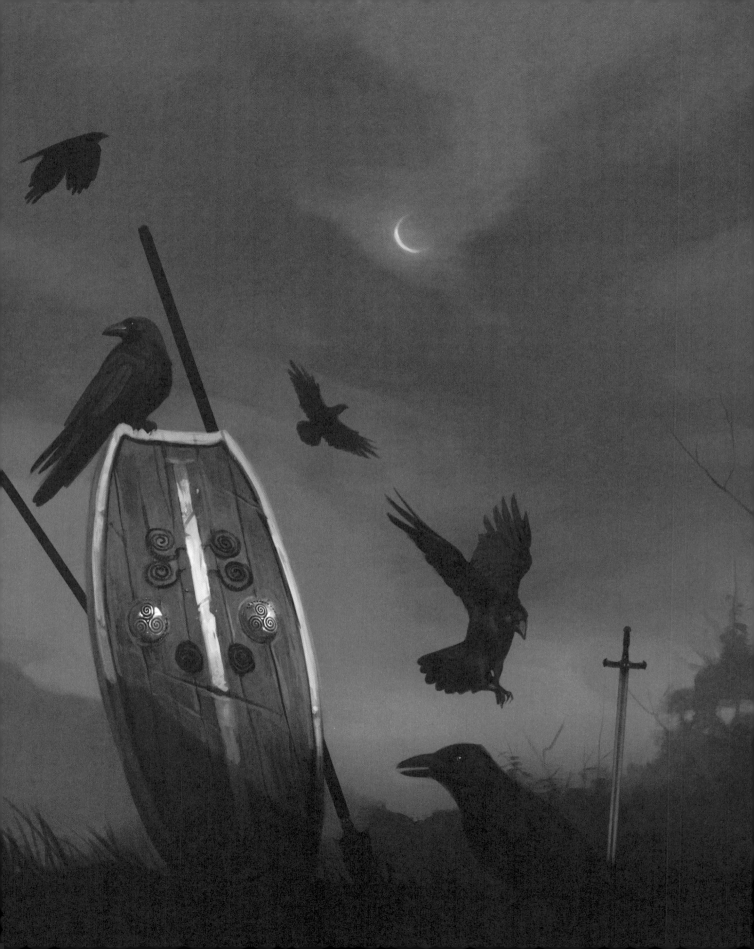

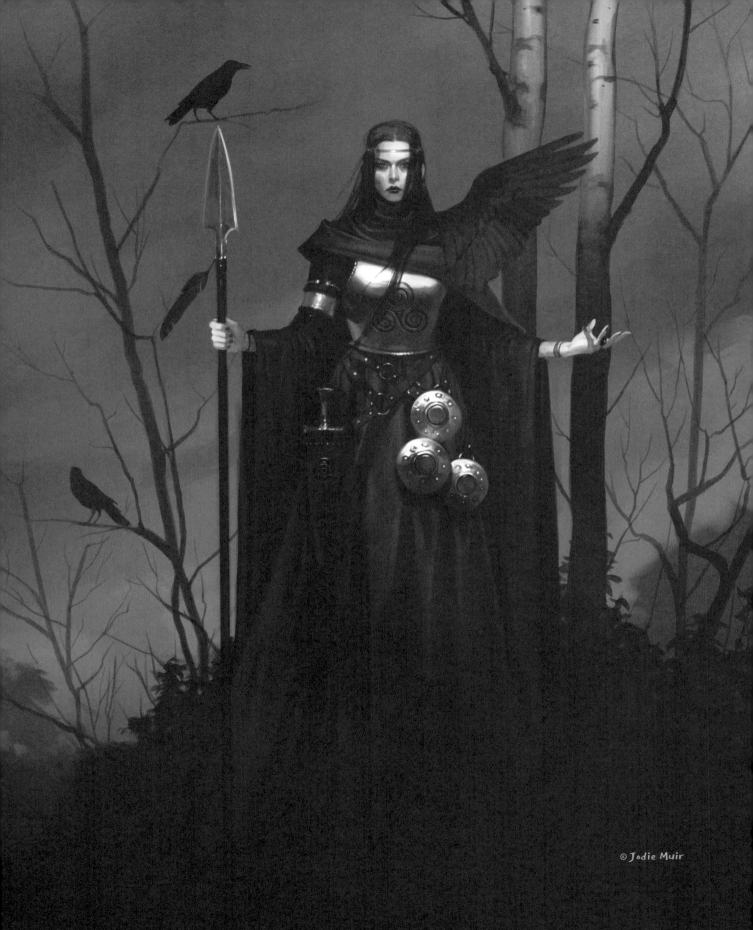

© Jodie Muir

Hecate

Hecate, or Hekate, is the ancient Greek goddess of magic, witchcraft, and the night. Accompanied by faithful dogs and bearing a flaming torch to illuminate the darkness, she is the keeper of thresholds and crossroads, where worshippers leave offerings to her. In this chapter, illustrator Amagoia Agirre researches ancient myth to create an atmospheric portrayal of this guardian goddess.

Amagoia Agirre | lacont.artstation.com

Research & Rumors

Greek origin

Hecate, or Hekate, is a chthonic (meaning "of the underworld") goddess in ancient Greek mythology. She is the goddess of witchcraft, crossroads, night, the moon, and poisons, among many other things. She is often associated with similar goddesses such as Artemis, the goddess of hunting, and may also have been a foreign deity adopted by the Greeks.

Orphic Hymns

The *Orphic Hymns* are a series of religious poems composed in the late Hellenistic or early Roman era. In one poem, Hecate is described as lovely, wearing a saffron veil, and likened to a queen wandering at night.

Hecate in Shakespeare

Hecate even appears in Shakespeare's *Macbeth*, showing her evolution in popular culture from a nature goddess to a more classically sinister witch figure. She reprimands the three prophetic witches for dealing with Macbeth without her permission, calling herself "the close contriver of all harms."

LOCATION

Some places are ideal for souls to dwell – places where the dead and living meet. Such places are where Hecate can be found, since she is strongly associated with the spirit world. Crossroads, cemeteries, doorways, and other liminal places are her natural habitat. It is important to bring an offering of food if you want the goddess witch to answer your call. Choosing the right time of day is important, too, with twilight being the perfect hour to summon her.

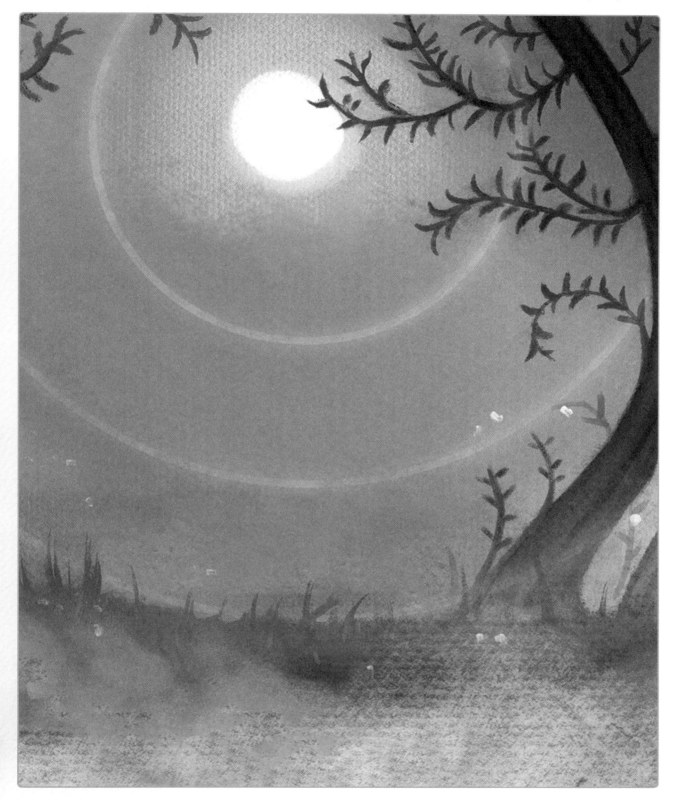

Important Notes

Hekataia

While early depictions shown Hecate as a single-headed figure, she is later portrayed in three-headed forms known as "hekataia." The three heads are sometimes those of animals: a dog, a lion, and a horse. However, most of the time, the three heads are human ones. In my portrayal, these three heads may not be explicit, perhaps appearing as accessories or references in her garments.

Torches

According to the *Homeric Hymns*, another series of ancient Greek hymns, Hecate was, alongside Helios, the only divinity to witness the abduction of Persephone, who was taken to the underworld by Hades. Hecate, carrying flaming torches, accompanied the goddess Demeter in search of Persephone so that mother and daughter could reunite. She remained as Demeter's companion on her journeys through the underworld. She has, since then, been portrayed with torches as a symbol of her ability to guide souls and spirits between the dead and living worlds.

Nocturnal goddess

Pale-skinned, covered in a long robe, with a crown adorning her head; under the moonlight she stands. Almost every depiction of Hecate illustrates her with these three attributes. Being a dweller of the night, the pale skin fits her well, and the robes and crown bestow her with a mysterious and imposing appearance. Her robe is referred to as saffron-colored in the *Orphic Hymns*, but will be a distinct feature of her figure regardless of the final color I choose.

Plants & poisons

Plants, flowers, and the concoction of medicines and poisons are closely related to Hecate. In the epic poem *The Argonautica*, she is said to be the sorceress Medea's teacher in the art of drug-making. Offerings, called Hecate's Deipnon ("Deipnon" being the ancient Greeks' supper), are served to her at crossroads in exchange for potions and knowledge of witchcraft. These offerings usually consist of garlic. Many plants, usually poisonous, are associated with Hecate, such as aconite, belladonna, dittany, and mandrake. Some trees, like the cypress and the yew, which are symbolic of the underworld, are also linked with her.

The moon

As goddess of the night, the moon is a pivotal element for Hecate. She is one of the deities governing the "Middle Sky," the lands between the moon and the surface of the sea. This land is where spirits and those who wait for rebirth wander. Hecate will only appear during twilight, though, when it is neither day nor night, and the moon is already visible in the sky. Some say it is best to serve her an offering on a new moon; others say her three-headed form represents the moon's different phases.

Animal companions

Animals are often related to Artemis, goddess of the hunt and nature, but some are also associated with Hecate. In her three-headed form, Hecate is sometimes shown as a dog, a lion, and a horse. Her traditional animal familiars are the black she-dog and the polecat. She is often accompanied by black dogs, announcing their mistress's presence as they howl to the moon. Snakes are also a common companion of Hecate, perhaps representing the poisons she handles in her witchcraft.

Studying the Witch

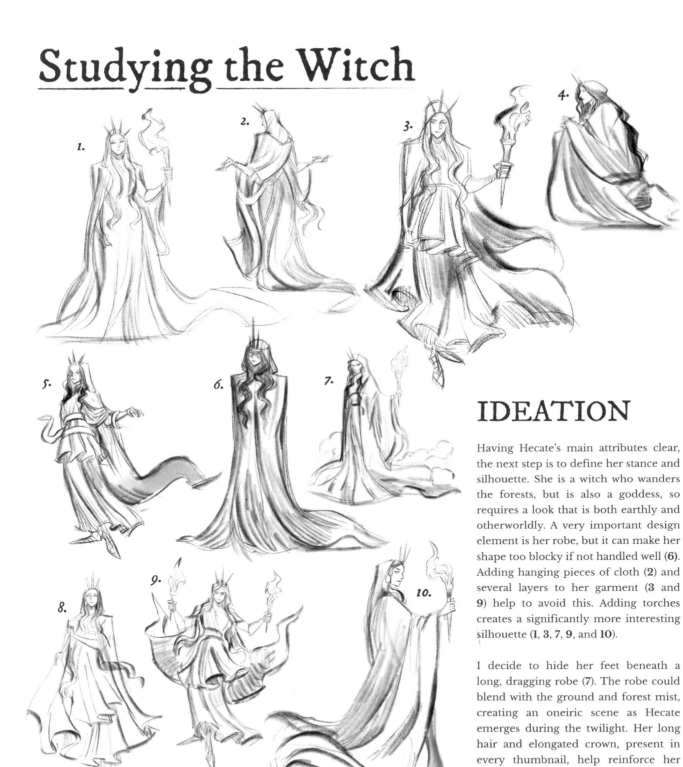

IDEATION

Having Hecate's main attributes clear, the next step is to define her stance and silhouette. She is a witch who wanders the forests, but is also a goddess, so requires a look that is both earthly and otherworldly. A very important design element is her robe, but it can make her shape too blocky if not handled well (**6**). Adding hanging pieces of cloth (**2**) and several layers to her garment (**3** and **9**) help to avoid this. Adding torches creates a significantly more interesting silhouette (**1**, **3**, **7**, **9**, and **10**).

I decide to hide her feet beneath a long, dragging robe (**7**). The robe could blend with the ground and forest mist, creating an oneiric scene as Hecate emerges during the twilight. Her long hair and elongated crown, present in every thumbnail, help reinforce her imposing, vertical figure, an idea I was fixed on from the very beginning.

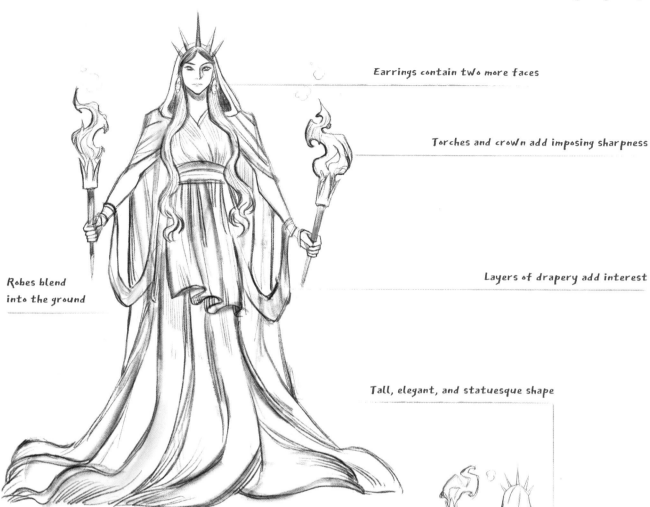

Earrings contain two more faces

Torches and crown add imposing sharpness

Layers of drapery add interest

Robes blend
into the ground

Tall, elegant, and statuesque shape

OVERVIEW

Hecate's figure is a tall, vertical one. Delicate and imposing at the same time, she has the appearance of a goddess. Her figure is somewhat static, resembling a Greek statue, giving her a calm, superior demeanor. She is young, but neither a child nor a crone, both of which are depicted in her earrings as a reference to the "maiden, mother, and crone" forms that triple goddesses often embody. The faces in her earrings guard the different intersections of the crossroads.

She is wielding torches, which help balance her shape and make her visible in the darkness of the nearing night. Her robes are ceremonial, not fit for a mortal wandering roads and forests. The fabric hanging from her wrists by bracelets and the different layers of clothing add variety to her design. When encountered in the wilderness, it is difficult to say where her garments end and the surroundings begin. From the back, she is holding her cloak aside to show that the layered details extend around the back of her robe.

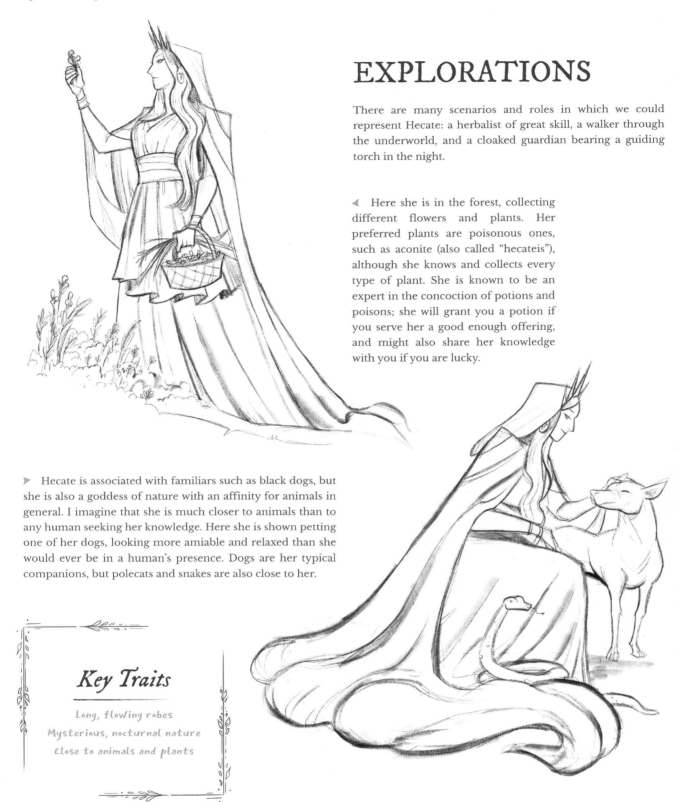

EXPLORATIONS

There are many scenarios and roles in which we could represent Hecate: a herbalist of great skill, a walker through the underworld, and a cloaked guardian bearing a guiding torch in the night.

◄ Here she is in the forest, collecting different flowers and plants. Her preferred plants are poisonous ones, such as aconite (also called "hecateis"), although she knows and collects every type of plant. She is known to be an expert in the concoction of potions and poisons; she will grant you a potion if you serve her a good enough offering, and might also share her knowledge with you if you are lucky.

▶ Hecate is associated with familiars such as black dogs, but she is also a goddess of nature with an affinity for animals in general. I imagine that she is much closer to animals than to any human seeking her knowledge. Here she is shown petting one of her dogs, looking more amiable and relaxed than she would ever be in a human's presence. Dogs are her typical companions, but polecats and snakes are also close to her.

Key Traits

Long, flowing robes
Mysterious, nocturnal nature
Close to animals and plants

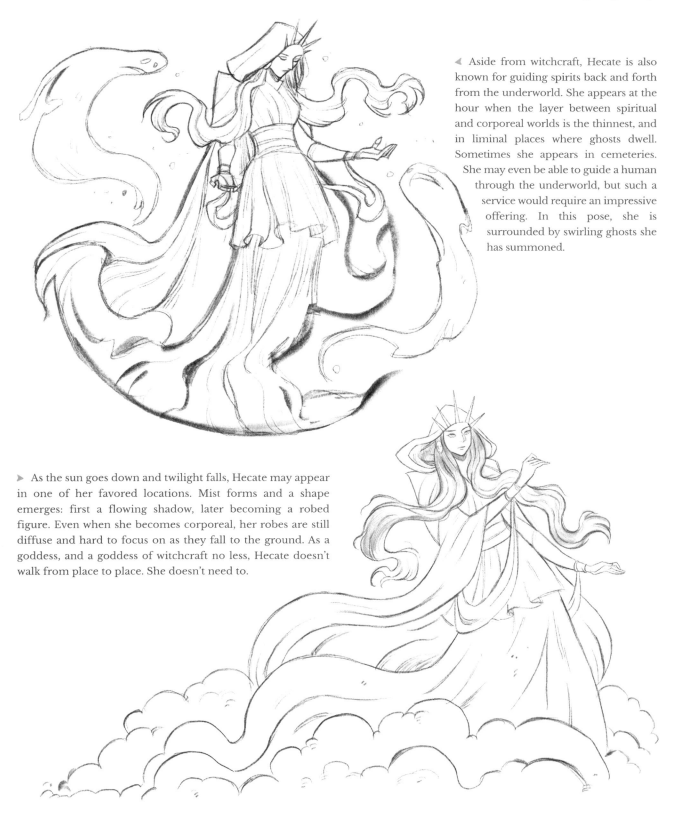

◄ Aside from witchcraft, Hecate is also known for guiding spirits back and forth from the underworld. She appears at the hour when the layer between spiritual and corporeal worlds is the thinnest, and in liminal places where ghosts dwell. Sometimes she appears in cemeteries. She may even be able to guide a human through the underworld, but such a service would require an impressive offering. In this pose, she is surrounded by swirling ghosts she has summoned.

► As the sun goes down and twilight falls, Hecate may appear in one of her favored locations. Mist forms and a shape emerges: first a flowing shadow, later becoming a robed figure. Even when she becomes corporeal, her robes are still diffuse and hard to focus on as they fall to the ground. As a goddess, and a goddess of witchcraft no less, Hecate doesn't walk from place to place. She doesn't need to.

Meeting the Witch

Hecate is a robed figure you could very well encounter while strolling through the forest just before night falls. Although mysterious, she looks like a regular human from a distance. However, on a closer look, she appears stranger. She has very pale skin, almost as pale as the moon. Her clothes are ceremonial, almost regal with her golden crown and ornaments. Her robes flow around her and it's difficult to see where they end.

The key elements defined in the sketches – the tall robed figure, flowing silhouette, and ornaments – come together in the final design of Hecate. She is tall, imposing without effort, and her gaze is filled with knowledge. As snakes are a common element in Hecate's depictions throughout history, she is accompanied by a snake who twists around her waist – a hint at her supernatural nature and a warning to be cautious in approaching her.

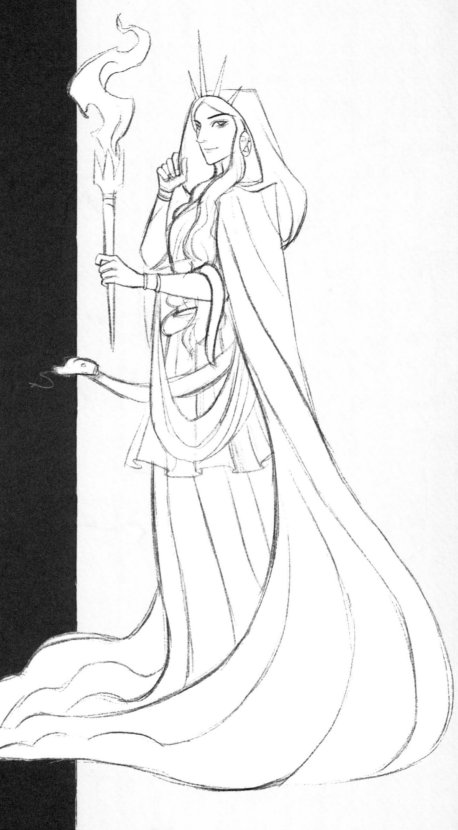

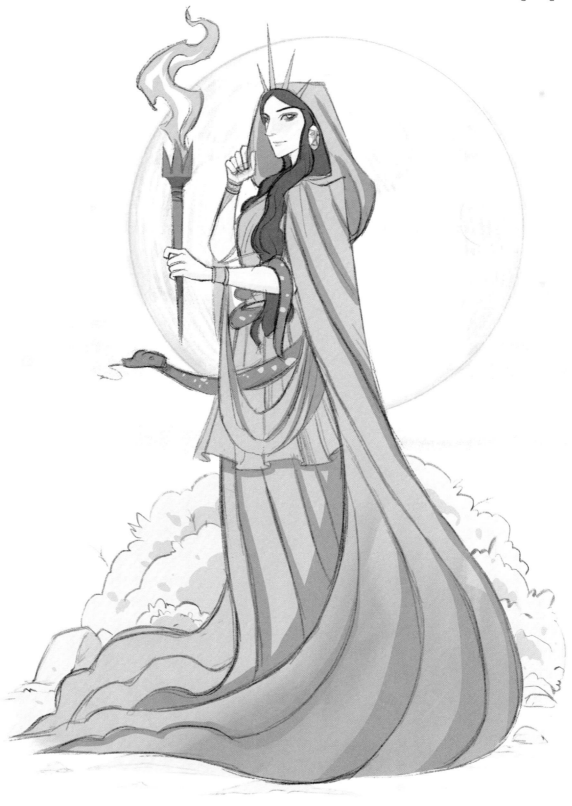

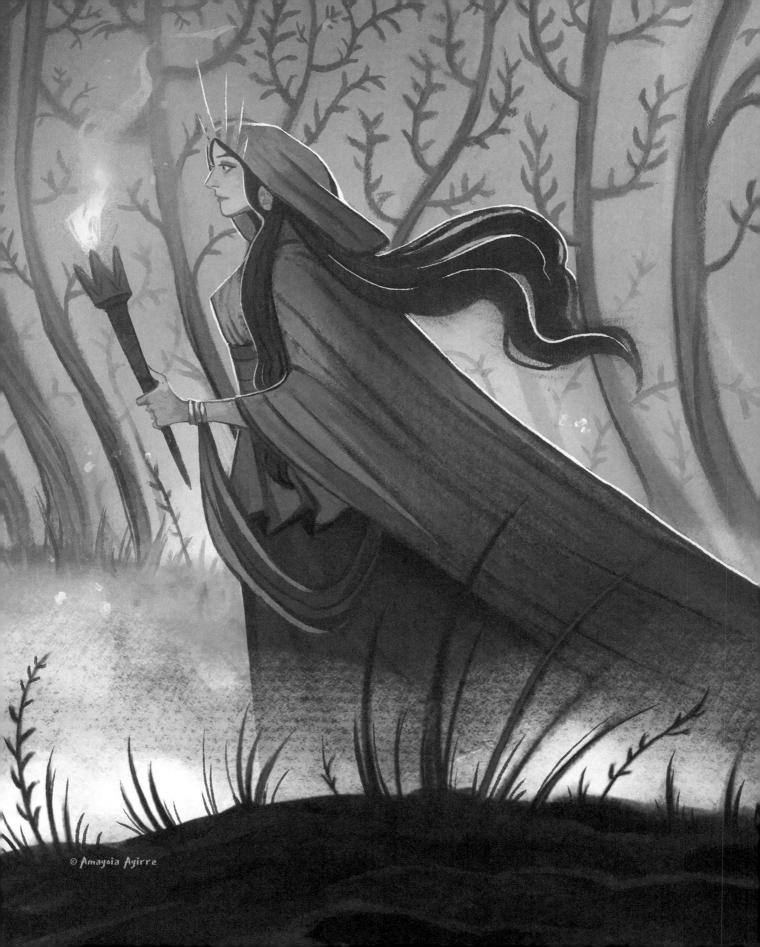

© Amagoia Agirre

The Cailleach

The Cailleach is the goddess of winter, a deity from Celtic legend,
with the power to control the weather and shape the landscape with swings of
her hammer. She is said to have created the mountains found in her domains
of Ireland, Scotland, and the Isle of Man. The Cailleach is neither good nor
evil, but a force of creation and destruction. In this chapter, freelance artist
Emanuel Pantaleon explores the myth of the Cailleach to create
a depiction of her and the consequences of her immortality.

Emanuel Pantaleon | artstation.com/emanuelpantaleon

Research & Rumors

Hag goddess

The Cailleach is a deity that dictates the coldness and length of the harsh winters. For this, she is both feared and respected. She is said to possess a magical hammer that allows her to control the weather and even shape landscapes. Like nature itself, she is formidable but neutral – neither good nor evil in her capacity to create and destroy.

Shapeshifter

It is rumored that the Cailleach has the ability to transform into an owl – all the better to oversee her wild domain. In Gaelic, owls are even called "cailleach-oidhche," meaning "night hag." When you see a giant white owl swooping overhead, be wary – the Cailleach is watching you, ensuring you commit no sin on her land.

Primordial age

According to various legends, the Cailleach mothered many children and adopted many more; she is potentially the foremother of every Irish tribe. She eventually outlived all her children, and even her husband, Bodach, making her an entity of profound ancient age. This is a factor that I am keen to explore in my portrayal.

LOCATION

Through the snowy winter landscapes of Scotland, Ireland, and the Isle of Man roams the Cailleach, "the veiled one." Every once in a while, you may hear of sightings of an old crone roaming the shore, or of a giant owl soaring over the land – these are two of her guises. She has wandered these lands for hundreds of years or more, shaping the weather and the earth. However, an immortal life is a harsh reality, even for a goddess. Perhaps she is no longer the force she once was, but just a shell of herself, no longer remembering her role or purpose.

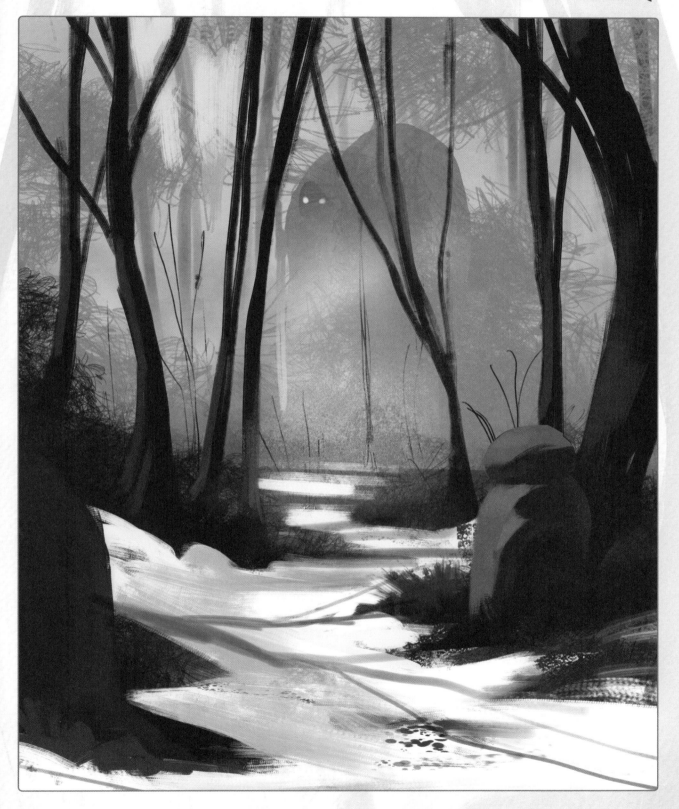

Important Notes

The hag's hammer

The Cailleach is said to wield a magical hammer, which either possesses or grants her the ability to control the winter and storms. With blows from this hammer, she easily carves ridges and valleys in the landscape. I imagine this hammer having a long handle, made from gnarled, twisted wood, and doubling as a staff for the ancient goddess to lean on.

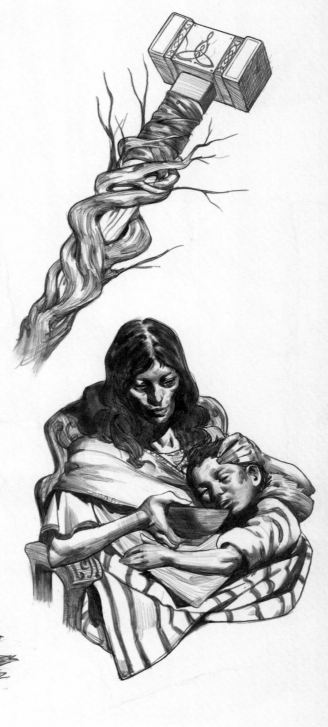

Winter famine

The Cailleach embodies the harshness of winter, therefore controlling the wellbeing of those who inhabit her lands. If she decides the winter will be long and harsh, death and famine will surely follow. If she is appeased by your rituals, you may be lucky and receive a shorter winter.

Rituals

Throughout history, people have created rituals to appease the Cailleach. Some are simple offerings, such as grain from the last harvest. Sometimes the hag has been described as wearing clothes decorated with skulls – perhaps these were the remnants of other, darker offerings.

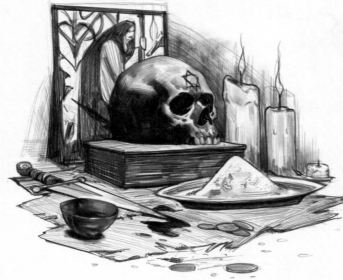

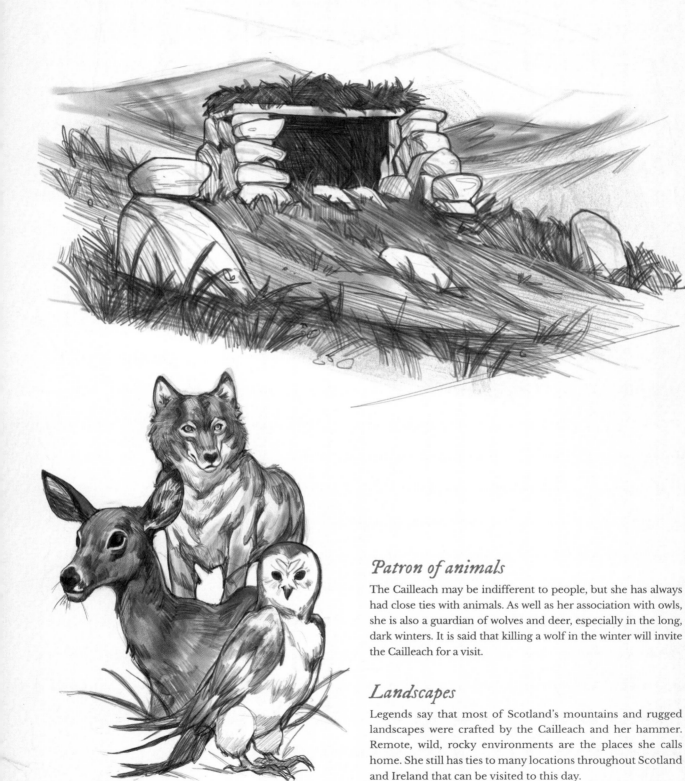

Patron of animals

The Cailleach may be indifferent to people, but she has always had close ties with animals. As well as her association with owls, she is also a guardian of wolves and deer, especially in the long, dark winters. It is said that killing a wolf in the winter will invite the Cailleach for a visit.

Landscapes

Legends say that most of Scotland's mountains and rugged landscapes were crafted by the Cailleach and her hammer. Remote, wild, rocky environments are the places she calls home. She still has ties to many locations throughout Scotland and Ireland that can be visited to this day.

Studying the Witch

IDEATION

Perhaps, over time, the Cailleach's shapeshifting abilities have weakened until she has difficulty conjuring her owl form. This would cause strange, chimeric qualities to appear, such as the great, crooked wings on her back. I really like thumbnail **3**, but she looks more like a wise sage than the design I am looking for (though I may keep her smile). Sketch **4** is a bit too reserved, but there is a lot of it that I can still use.

I go for an exaggerated look in sketch **6**, with a hunched back to show off the leftover wing from her owl form – it's a strong direction that feels wild and ancient. I push that idea further with **7**, emphasizing the chimera- and crone-like features, but the result is slightly *too* wild and less like a goddess. However, there are still plenty of elements I will take forward.

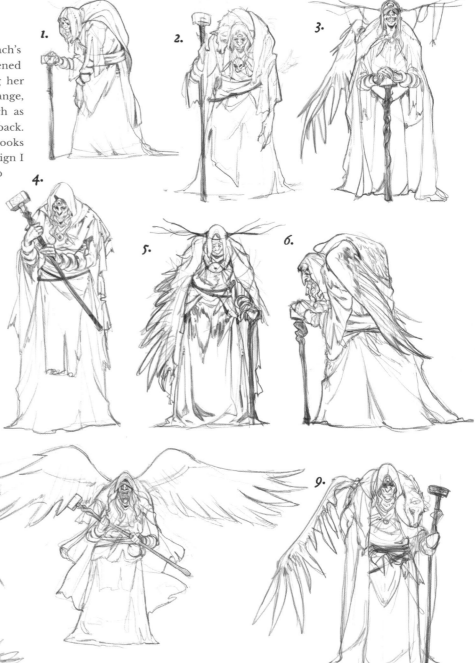

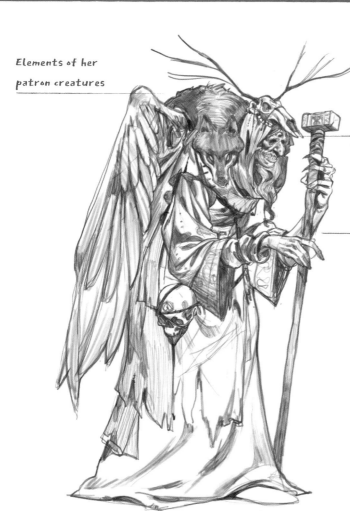

Elements of her
patron creatures

One eye remaining in forehead

Weathered and ancient appearance

Hammer for shaping land and weather

Leftover wing from owl transformation

OVERVIEW

My design integrates the animals with which the Cailleach is associated, making her truly seem like a wild, primordial goddess of nature. She feels ancient, even somewhat lost and declining, as her immortal lifespan brings her into the present day where her influence begins to wane. She has likely suffered many injuries in her long life, and is often described as one-eyed – I imagine that she has been partially blinded and relies on the last remaining eye in her forehead.

She wears deer or wolf fur around her waist and a wolf pelt on her hunched shoulders – perhaps the found remnants of fallen wild creatures, or a darker sign of the Cailleach's gradual deterioration, sometimes turning against her favored animals. Her deer-skull headpiece and long-handled hammer give her a striking silhouette.

 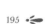

EXPLORATIONS

The Cailleach's weather powers, closeness to nature, and shapeshifting abilities offer many intriguing poses and possibilities. She is a guardian deity and an unpredictable weather witch, made even more volatile by the passage of countless centuries, which I am interested in exploring here.

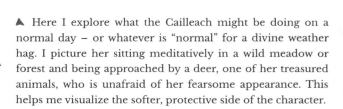

▲ Here I explore what the Cailleach might be doing on a normal day – or whatever is "normal" for a divine weather hag. I picture her sitting meditatively in a wild meadow or forest and being approached by a deer, one of her treasured animals, who is unafraid of her fearsome appearance. This helps me visualize the softer, protective side of the character.

◄ The key aspect of the Cailleach's power is her ability to control the weather. Here she has temporarily cast off her headpiece and heavy furs for ease of brandishing her hammer, casting a weather spell to summon the cold winds of winter.

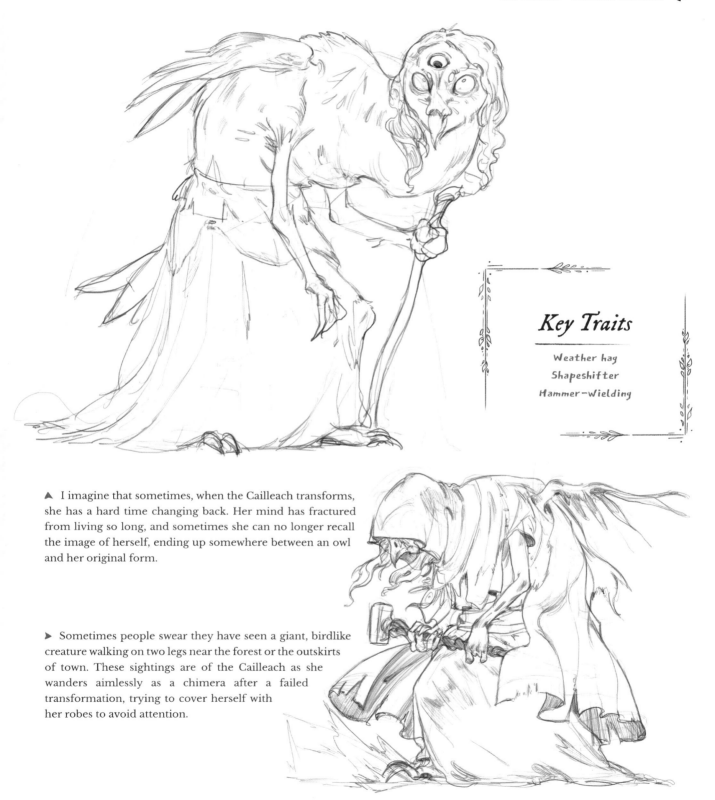

Key Traits

Weather hag
Shapeshifter
Hammer-Wielding

▲ I imagine that sometimes, when the Cailleach transforms, she has a hard time changing back. Her mind has fractured from living so long, and sometimes she can no longer recall the image of herself, ending up somewhere between an owl and her original form.

▶ Sometimes people swear they have seen a giant, birdlike creature walking on two legs near the forest or the outskirts of town. These sightings are of the Cailleach as she wanders aimlessly as a chimera after a failed transformation, trying to cover herself with her robes to avoid attention.

Meeting the Witch

My goal with this design was to capture an aged, powerful crone who has lived for a very long time in isolation, from ancient history to the present day. Living so long has made her slowly lose herself, making her even more fearsome and erratic than she was at the height of her powers. She wears the skins and skulls of wolves and deer – animals with which she has, or had, a positive association. Perhaps, in her twisted state, she no longer recognizes the harm she does to the land she cares for, or the frightfulness of wearing her favorite creatures. She is blue-skinned and wields a great hammer, as the legends say. Her two humanlike eyes are blind, leaving one magical eye in her forehead; which, along with her menacing smile, creates the unsettling feeling I wanted to achieve.

"Living so long has made her slowly lose herself, making her even more fearsome and erratic than she was at the height of her powers"

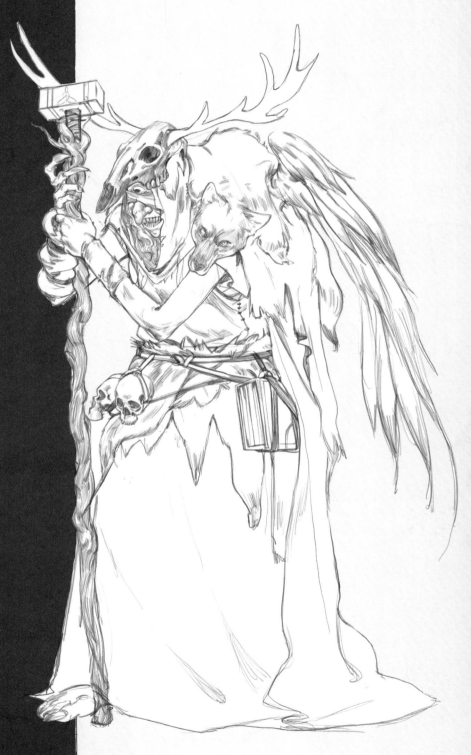

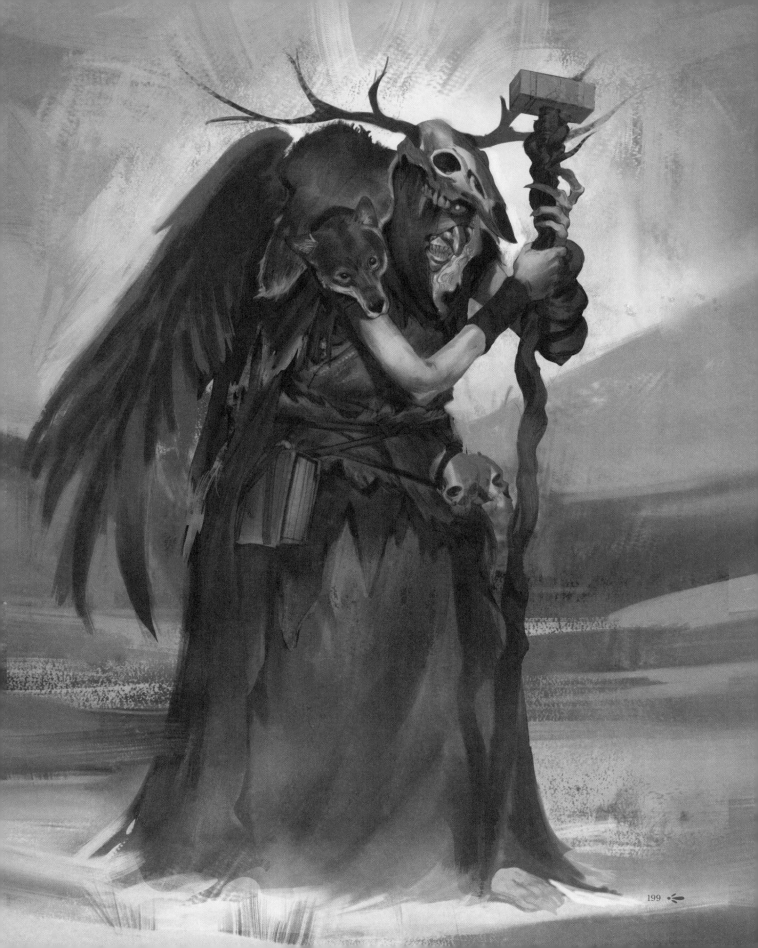

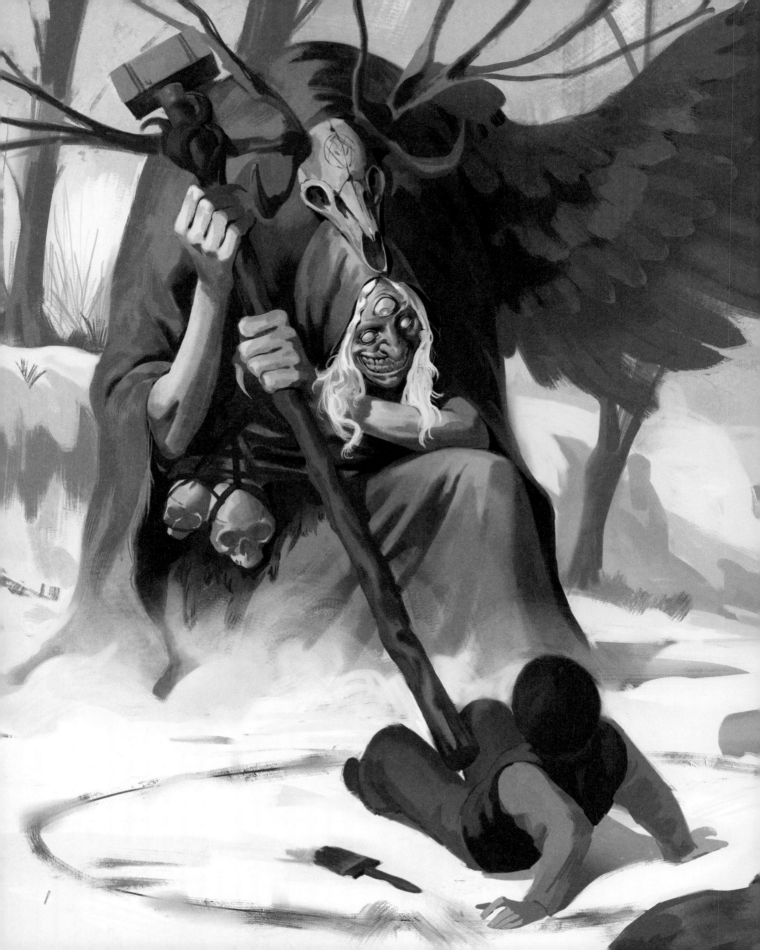

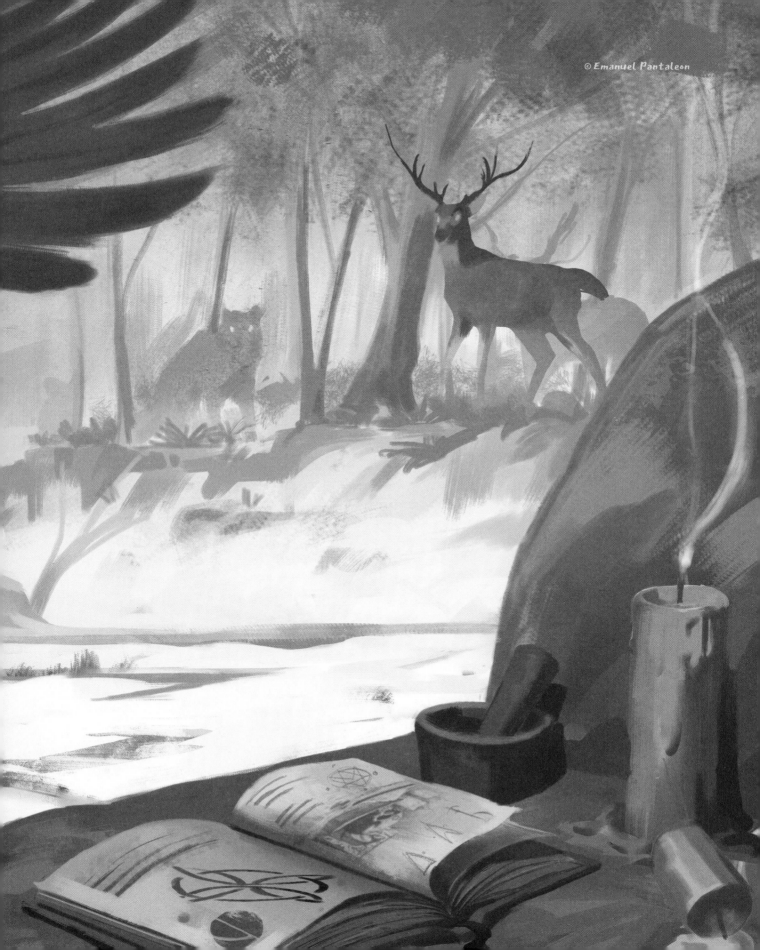

© Emanuel Pantaleon

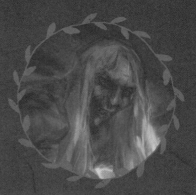

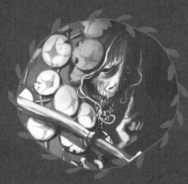

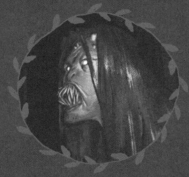

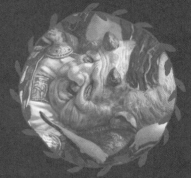

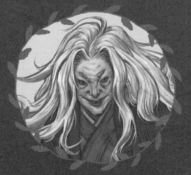

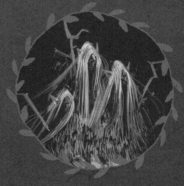

Hags, Crones & Monsters

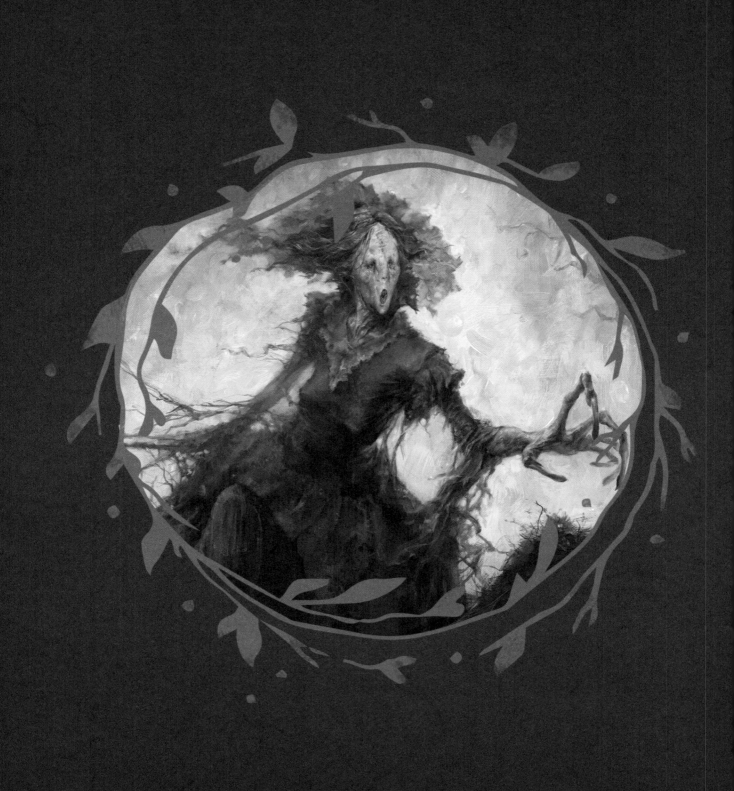

Black Annis

Black Annis is an infamous figure in English folklore: a blue-faced, iron-clawed hag who prowls the countryside at night, looking for windows through which to snatch a victim with her long, powerful arms. Like many traditional bogeymen, she is a cannibal with a voracious appetite for children. Illustrator Eldar Zakirov uses Annis' rich lore to piece together his own eerie interpretation.

Eldar Zakirov | eldarzakirov.com

Research & Rumors

The iron-clawed hag

Most researchers and eyewitnesses describe Black Annis as a tall hag with deathly pale skin, predatory sharp teeth, and long, possibly iron, nails. Some records speak of her as one-eyed. She wears dark clothes, like a cassock, partially woven from the skins of her victims. According to frightening rumors, she decorates her home and the surrounding area with her victims' uneaten remains, hanging them from tree branches.

A nocturnal hunter

Black Annis lives in a cave at the base of a giant oak tree, going deep into the rock. She leaves her home at night or dusk, terrifying the locals, who fear her inhuman strength and cannibalistic disposition. She is known to kill lone adults and abduct children, thrusting her incredibly long arms through even the narrowest windows. Hanging a bunch of protective herbs above your windows and doors may save you from being snatched by Annis.

Annis' different forms

Several researchers and local historians claim that Black Annis sometimes appears as a large, terrifying black cat. There are descriptions of her as a half-old, half-young woman with a "blank" face. In most accounts, her skin is pale, with a blue tint. It is unclear whether she is closer to a person, a phantom, or a feral predator. Rumors of similar accounts echo through the legends of Great Britain and the whole of northern Europe.

LOCATION

Black Annis is said to live in rural Leicestershire, in the Dane Hills, a large area to the west of the English city of Leicester. Her lair is named Black Annis' Bower: a cave in the sandstone rock with a great oak tree at the entrance. This place was once an ancient forest, but this mysterious, old oak is almost all that remains. It is often foggy, rainy, and gloomy here. The villagers try not to pass near the witch's cave, looking cautiously in its direction as they do their farm work, and making sure to securely lock their homes at night...

Important Notes

Iron claws

Black Annis' long, ugly fingers end in dangerous nails, or even claws, which are often described as being made of iron. Annis uses them to tear apart her victims, and perhaps even used them to dig her cave in the sandstone rock, so they are strong, dirty, and stained.

Sandstone cave

Annis drags her victims into her cave to suck their blood and eat their flesh. She hangs their skins out to dry on the branches of her oak tree. According to eyewitnesses who dare to venture close, the cave appears long and narrow – quite a cramped home for a very tall witch. Some rumors even connect the cave with Leicester Castle by means of an underground tunnel.

Pale, blue face

Black Annis is described as a blue-faced or pale-faced hag of terrible appearance. Her face has sometimes been described as half young and half old, or half beautiful and half ugly. Many accounts describe her as very tall, with long, white teeth, or yellow teeth and only one eye. Such varied descriptions suggest that Annis can appear in several guises. All the evidence agrees that her face is terrible and bluish.

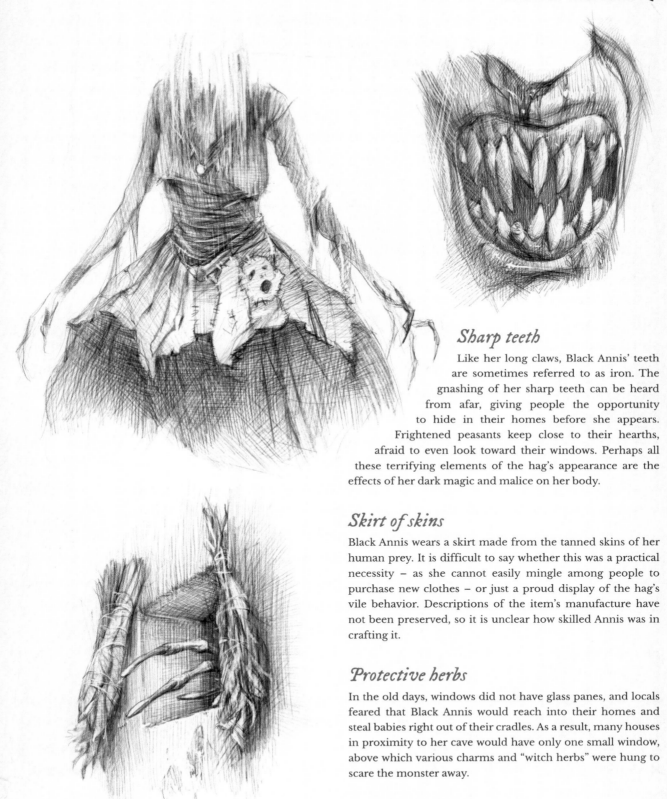

Sharp teeth

Like her long claws, Black Annis' teeth are sometimes referred to as iron. The gnashing of her sharp teeth can be heard from afar, giving people the opportunity to hide in their homes before she appears. Frightened peasants keep close to their hearths, afraid to even look toward their windows. Perhaps all these terrifying elements of the hag's appearance are the effects of her dark magic and malice on her body.

Skirt of skins

Black Annis wears a skirt made from the tanned skins of her human prey. It is difficult to say whether this was a practical necessity – as she cannot easily mingle among people to purchase new clothes – or just a proud display of the hag's vile behavior. Descriptions of the item's manufacture have not been preserved, so it is unclear how skilled Annis was in crafting it.

Protective herbs

In the old days, windows did not have glass panes, and locals feared that Black Annis would reach into their homes and steal babies right out of their cradles. As a result, many houses in proximity to her cave would have only one small window, above which various charms and "witch herbs" were hung to scare the monster away.

Studying the Witch

IDEATION

From the different accounts of her appearance – even appearing as a large cat – we can speculate that Black Annis often resorts to shapeshifting and has more than one guise. Perhaps she was once an ordinary woman who excelled in black magic and dark witchcraft, which ultimately swallowed her up, turning her into a monster. The remnants of her human intelligence might still manifest in her penchant for craft and embellishment, decorating and arranging her cave, stitching her clothes, and perhaps even using sophisticated hunting methods.

Here are my surreptitious sketches of the witch, showing moments of resting, transforming, hunting, eating supper, and even some ritual dances where she moves around on all fours. I have tried to capture her strange, dangerous nature.

I am also interested in Annis' unusual transformations, when the guises of a hag and a tall, demonic, faceless young woman might coexist for a while (**8** and **10**). Are these two entities different and able to act separately? I ask myself this question while studying the witch and her behavior.

Wild, ragged hair

Elderly appearance

Long, sharp iron claws

Robes patched together with skin

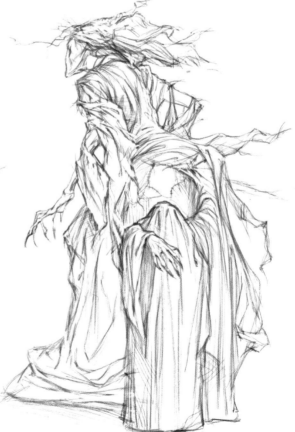

Possible alternate manifestation

OVERVIEW

Here is an overview of the witch's design, incorporating as much of our research as possible. She wears tattered robes like an elderly peasant woman, but on top of those she wears her skirt of dried skins, showing her bloodthirsty, cannibalistic nature. Her arms are unnaturally long, for abducting children from their cradles at night, and her hands are tipped with her infamously long, sharp iron claws.

She has been witnessed both in the form of a terrible old woman, with dangerously long, sharp teeth, but also as a tall, thin woman with an inhuman, featureless face. This second version sounds more like a supernatural, spectral entity to me, though it's certainly the same witch. I imagine it here as a magical manifestation cast by Annis in her elderly form.

EXPLORATIONS

In these sketches we can explore Black Annis' shifting forms and speculate as to her behavior when she is undisturbed and resting in the darkness of her sandstone cave.

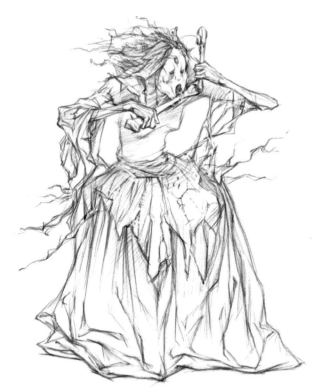

▶ Here the witch can be seen satisfying her appetite, having ambushed a victim from the branches of her oak or grabbed someone from a house at night. The gnashing of her teeth can be heard from afar, and hardly anyone would dare to interrupt her meal. One can only guess how farmers and locals could stay in such an unfortunate area and not try to leave with their families.

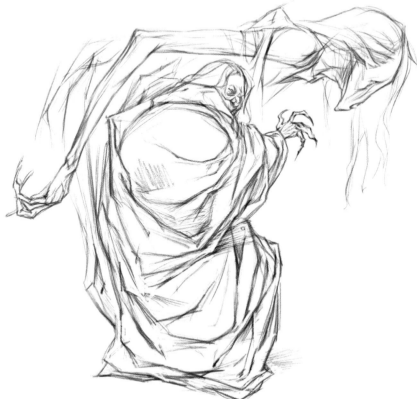

◀ As Annis' transformation takes place, an observer might briefly glimpse both monsters' guises at once. The two forms might appear as if an alternate figure is growing or flowing from the body of one to the other, the first one shrinking as if drying out, until it is fully drawn into the new disguise.

Key Traits

Sharp iron claws
Terrifying face
Cannibalistic

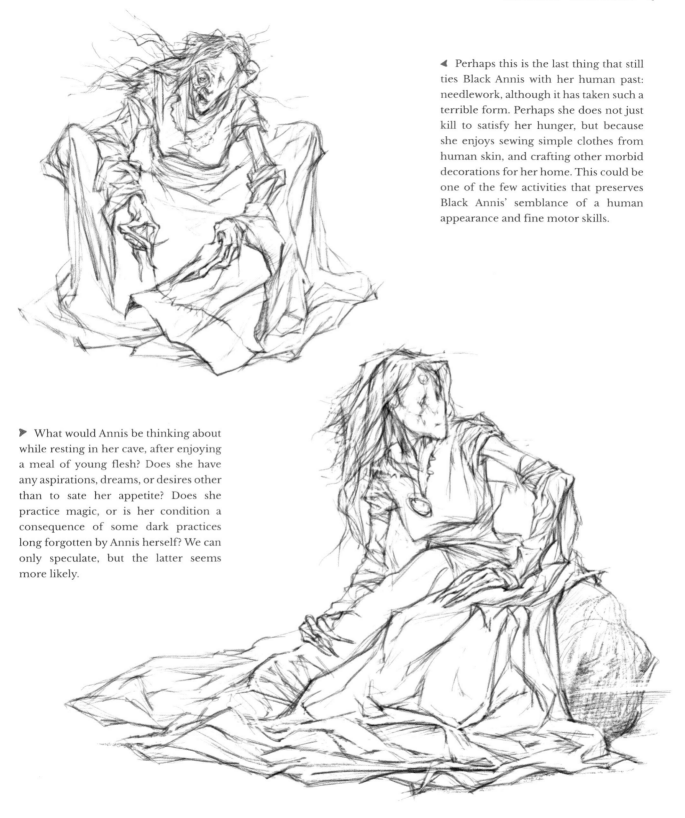

◀ Perhaps this is the last thing that still ties Black Annis with her human past: needlework, although it has taken such a terrible form. Perhaps she does not just kill to satisfy her hunger, but because she enjoys sewing simple clothes from human skin, and crafting other morbid decorations for her home. This could be one of the few activities that preserves Black Annis' semblance of a human appearance and fine motor skills.

▶ What would Annis be thinking about while resting in her cave, after enjoying a meal of young flesh? Does she have any aspirations, dreams, or desires other than to sate her appetite? Does she practice magic, or is her condition a consequence of some dark practices long forgotten by Annis herself? We can only speculate, but the latter seems more likely.

Meeting the Witch

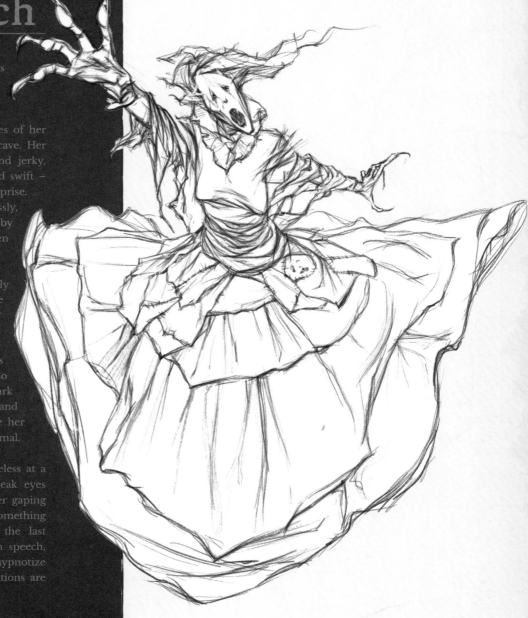

This fearful sight is perhaps the last thing an unlucky traveler would experience. Black Annis has been waiting, hungry, either on the branches of her oak or in the mouth of her cave. Her rapid movements – sharp and jerky, but somehow also smooth and swift – have caught her victim by surprise. She moves almost noiselessly, betraying her presence only by gnashing her sharp teeth when she is hungry.

I imagine her gait is gently swaying from side to side, like that of a praying mantis or some species of spider, as if in a meditative dance. When she sees an opportunity, she makes a sudden dart for her victim, who is then dragged away to her dark dwelling. Her long, thin arms and clawed hands further enhance her resemblance to a predatory animal.

Her face might appear featureless at a quick glimpse, with small, weak eyes barely visible compared to her gaping mouth. She may mutter something as she approaches, perhaps the last remnants of degraded human speech, her swaying gait seeming to hypnotize her victim. And then her reactions are lightning fast.

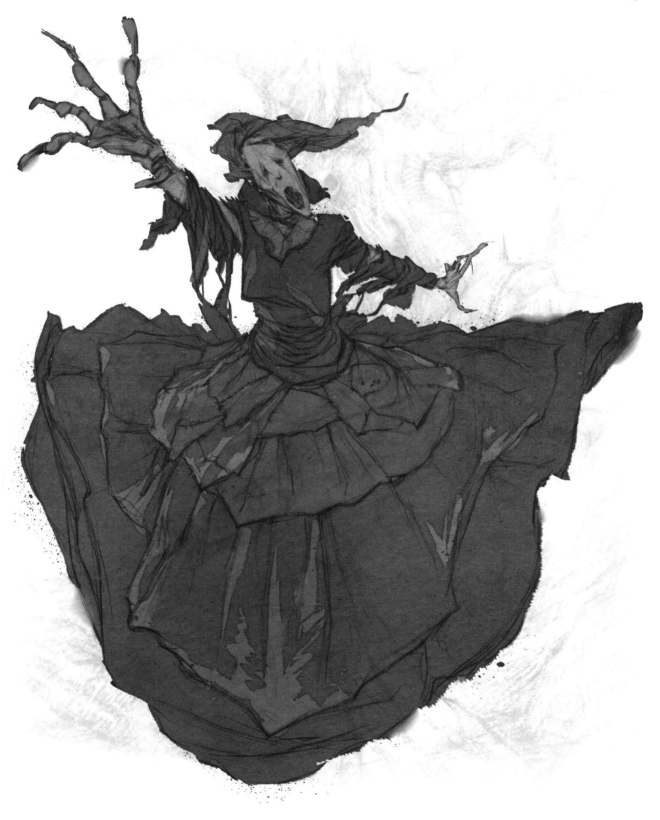

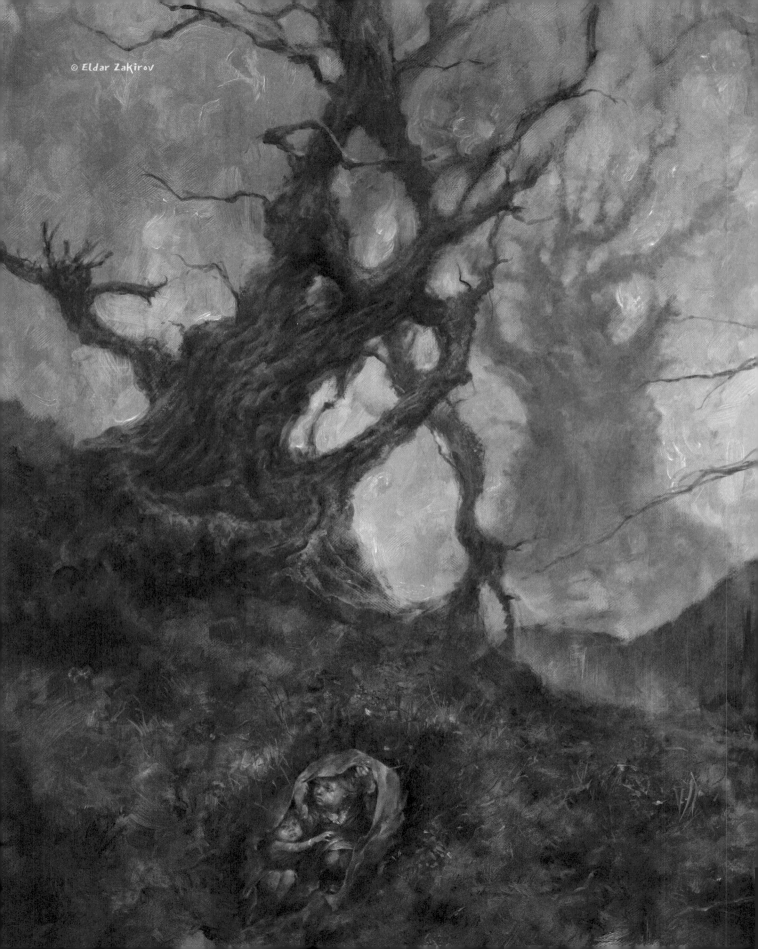

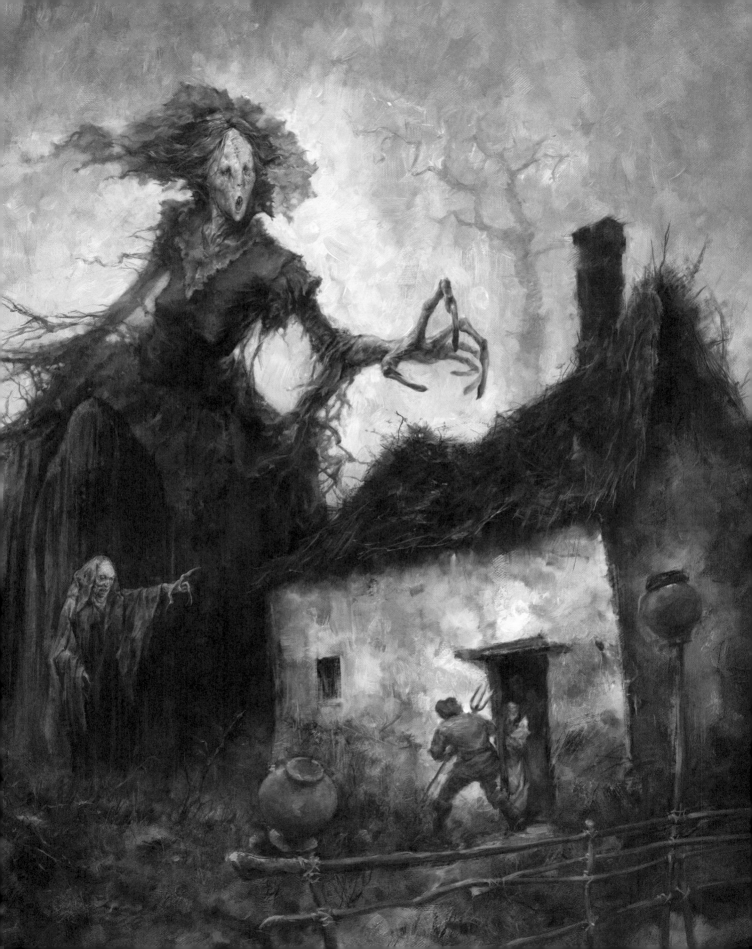

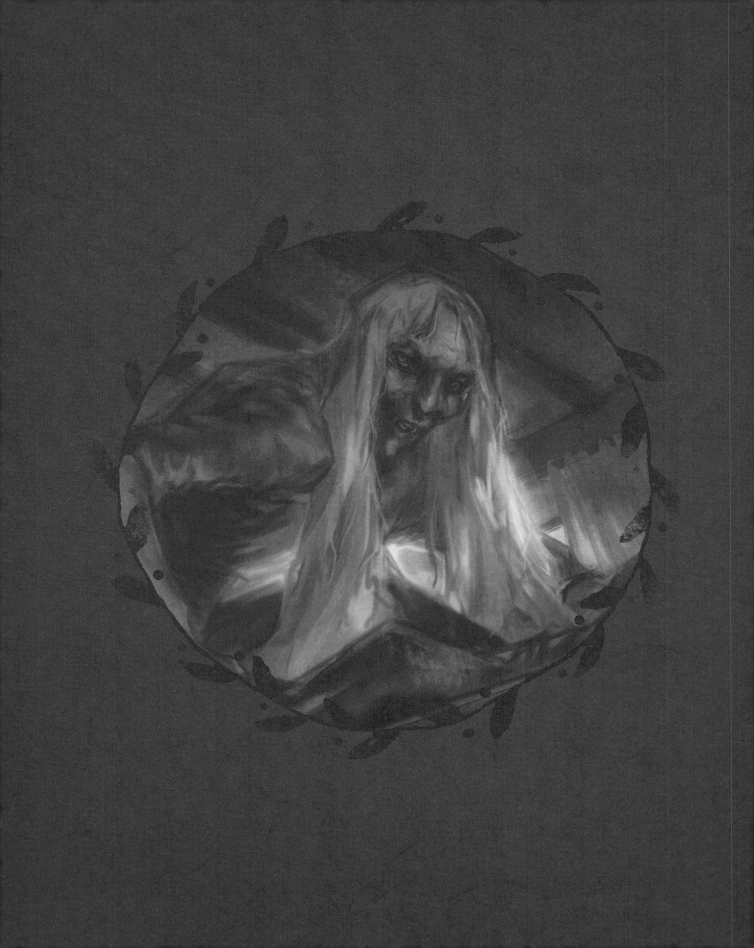

The Bruxa

The Bruxa of Iberian folklore is a vampiric menace born
of witchcraft. She typically preys on children in the night, using
powerful shapeshifting magic to enter the homes of her victims.
Like most supernatural threats, she can be deterred if you know
how – in this case, with garlic and scissors. In this chapter,
illustrator and concept artist Inkognit shares his interpretation
of this mysterious and dangerous folklore figure.

Inkognit | inkognit.com

Research & Rumors

Vampiric powers

The Bruxa has more in common with a vampire than a witch. Yet, as a woman who turned to dark magic, she possesses quite extraordinary powers, including the ability to change her shape.

Human victims

The Bruxa's bloodsucking nature is most often targeted toward baby animals or small children, although there are more accounts of the latter. No place is safe. She will enter your house and you won't even find footprints – at least, not the ones you would expect!

Travelers beware!

When she is not busy feeding, she likes to torment travelers. There are a few tales of some men brave enough to face the Bruxa's mockery, whose attempted heroics rarely end as they would have hoped. They just regain their senses much later, covered in dried blood and in terrible pain.

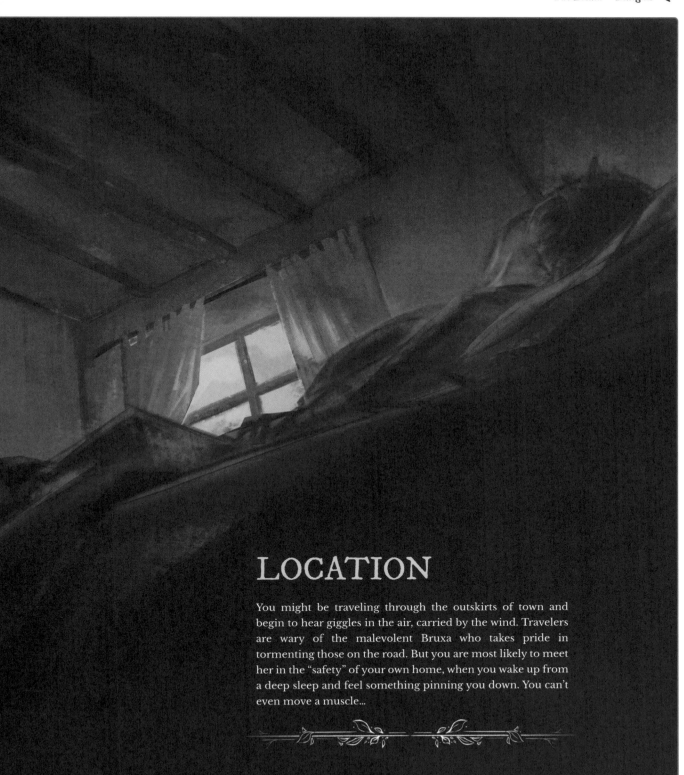

LOCATION

You might be traveling through the outskirts of town and begin to hear giggles in the air, carried by the wind. Travelers are wary of the malevolent Bruxa who takes pride in tormenting those on the road. But you are most likely to meet her in the "safety" of your own home, when you wake up from a deep sleep and feel something pinning you down. You can't even move a muscle...

Important Notes

Vampiric features

The difference between the Bruxa and a typical witch is that the former turned herself into a vampiric creature through dark, demonic magic. With that, she has earned all the key features of a vampire: fangs, elongated features, white hair, and pale skin.

Shapeshifting

There will always be animals that are omens of death and witchery, but these examples are more than that. The Bruxa can shapeshift into all kinds of creatures: bats, mice, and even ants.

Young victims

No one is safe from the Bruxa's thirst, especially if they are children. She will find you, even if you are behind a closed door, in the safety of your room, tightly covered in your blankets and fast asleep. She will come.

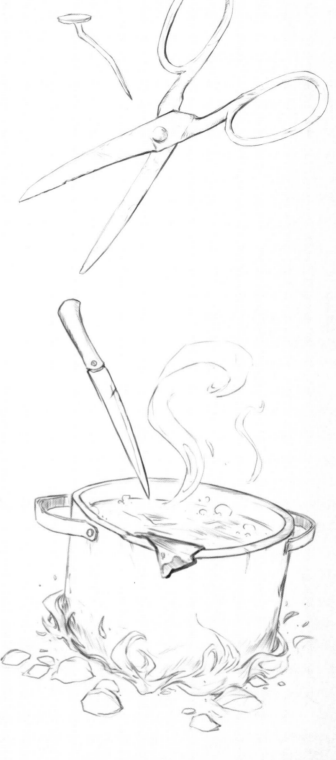

Garlic heads

Fortunately, there are some trinkets that can protect you and even save your life from the Bruxa. One of the most common defenses, known to all mothers, is to sew multiple garlic heads into their children's clothes. These will keep her away.

Protective items

The more trinkets and amulets you have to keep the witch away, the better. Another commonplace method is placing a steel nail in the ground and a pair of scissors under the child's pillow. If those still fail, there are also some incantations that can be spoken to ward off the Bruxa.

A parent's revenge

Yet sometimes all the amulets and incantations in the world cannot save a mother from the grief of losing her child. When that happens, she still has a chance to take revenge on the Bruxa. For that, she needs to place the blood-soaked clothes in a pan and boil them while stabbing them with a sharp object. The vampire will supposedly feel the jabs in her own body.

Studying the Witch

IDEATION

The idea in my mind was already quite formed when I began to think about a witch and a vampire fused together. What was left to explore was how creepy I should make the design, as well as the clothing. I decided to focus on traditional clothing, such as a long, high-waisted skirt (**2**), with some kind of cloak to keep her features hidden as she walks through the village during the day (**1**). In her daytime guise, I imagine the Bruxa appears quite affectionate toward children, so I explore those interactions in **4** and **7**. There are a few thumbnails that stand out, but I feel the one where she is holding the child close to her chest (**3**) has the most potential in terms of storytelling.

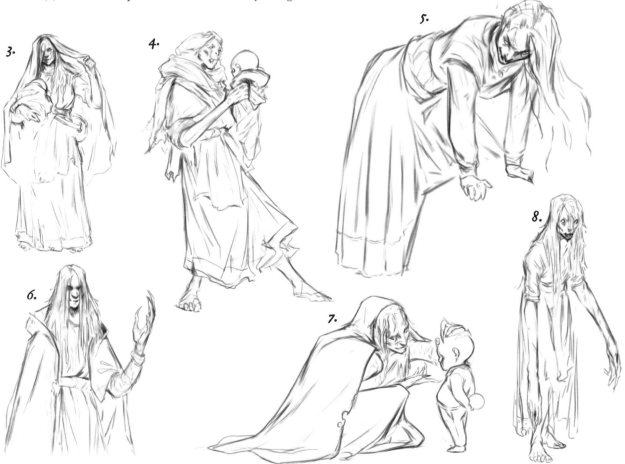

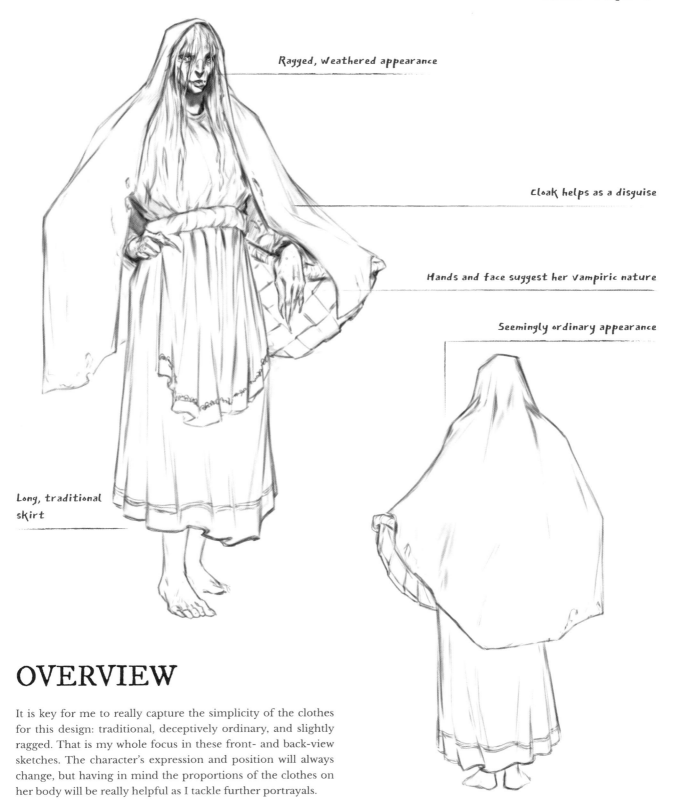

Ragged, weathered appearance

Cloak helps as a disguise

Hands and face suggest her vampiric nature

Seemingly ordinary appearance

Long, traditional skirt

OVERVIEW

It is key for me to really capture the simplicity of the clothes for this design: traditional, deceptively ordinary, and slightly ragged. That is my whole focus in these front- and back-view sketches. The character's expression and position will always change, but having in mind the proportions of the clothes on her body will be really helpful as I tackle further portrayals.

EXPLORATIONS

In these sketches, we can see the various degrees of vampiric influence visible in the Bruxa's appearance and behavior, from her almost fully human guise to an unleashed predator.

▼ In her human form, the Bruxa is tall, lean, and malevolent. Her whole body emits an eerie feeling of discomfort if you stand near her. You will often see her around town, just standing there, watching while caressing her hands.

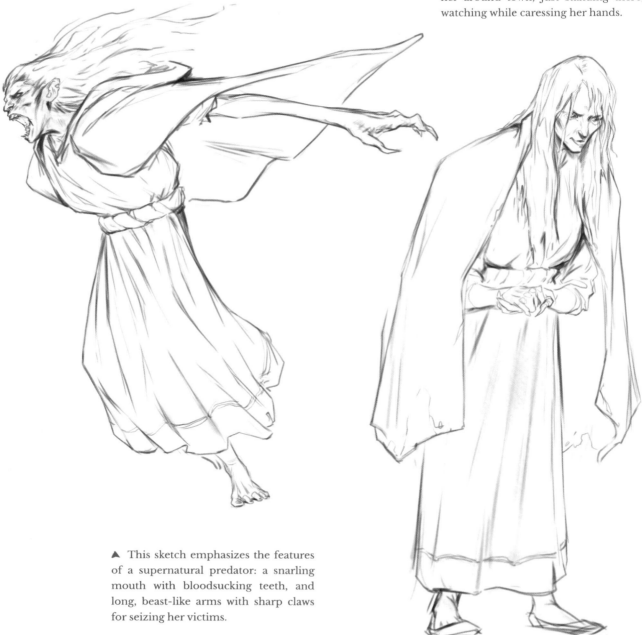

▲ This sketch emphasizes the features of a supernatural predator: a snarling mouth with bloodsucking teeth, and long, beast-like arms with sharp claws for seizing her victims.

Key Traits

Vampire meets Witch

Cunning and dangerous

Changes form with ease

▼ Although she is well versed in magic and spells, the Bruxa is an extraordinary shapeshifter. I can imagine her suddenly materializing in her humanoid form, ready to strike.

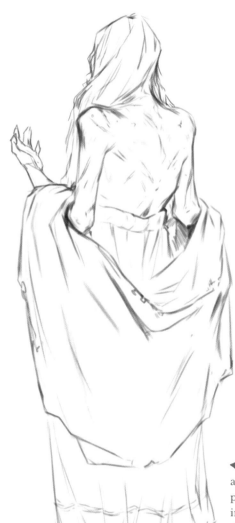

◀ No one actually knows this Bruxa's age. But even if she can evade the passage of time and seem to be immortal, her body will always carry the markings of the tortures inflicted on herself and others.

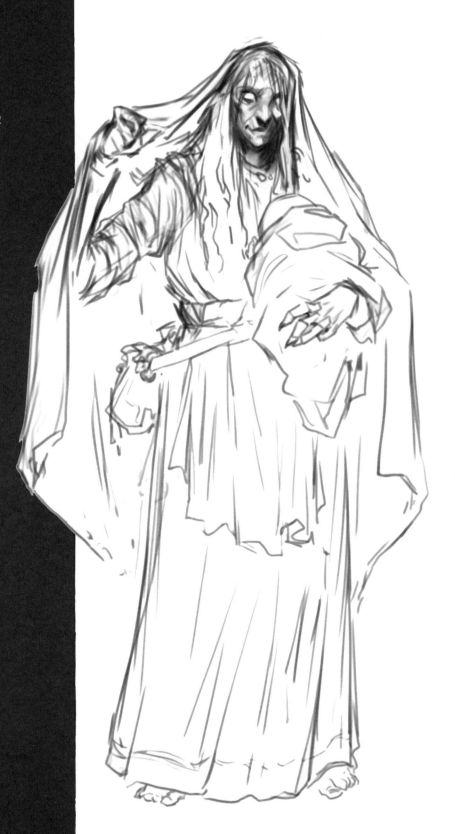

"I like how her mouth and eyes have a reddish tint – it makes the design so much creepier"

Meeting the Witch

Gathering all my notes on the clothes from the front and the back view, I refined the thumbnail that had the strongest storytelling. I checked it against all the parts from my research: the clothing, the children, the feeling of mystery, and the eerie features. I kept the rendering "rough," as I think this style adds to her concept, creating a worn, rustic look. In the colored version, we can clearly see her grayish skin and ghostly white hair. I like how her mouth and eyes have a reddish tint – it makes the design so much creepier!

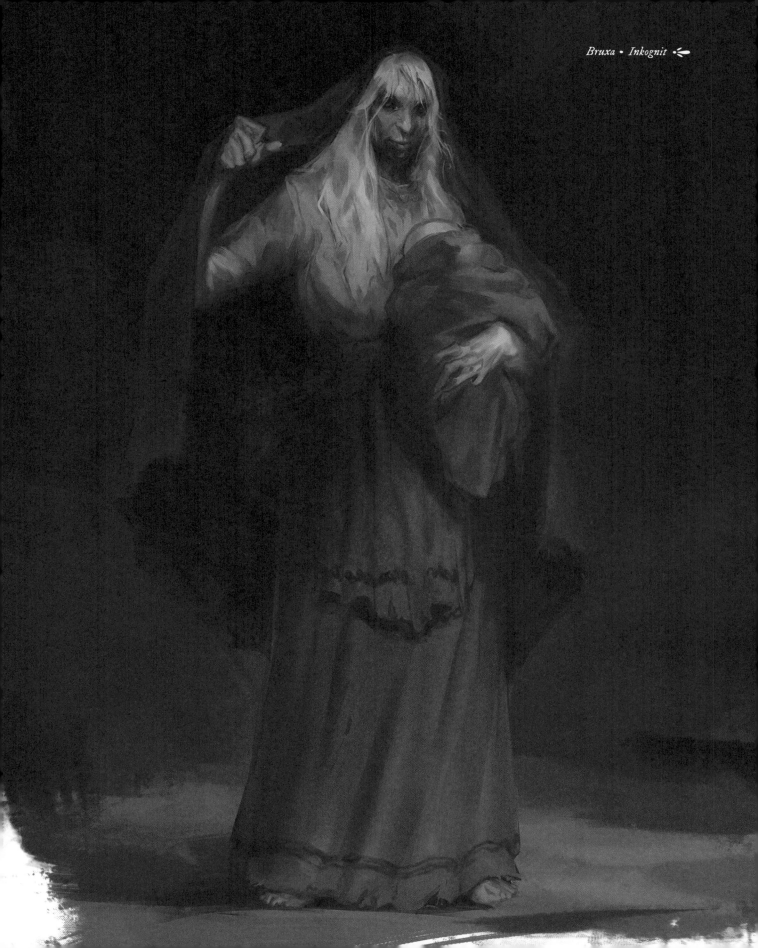

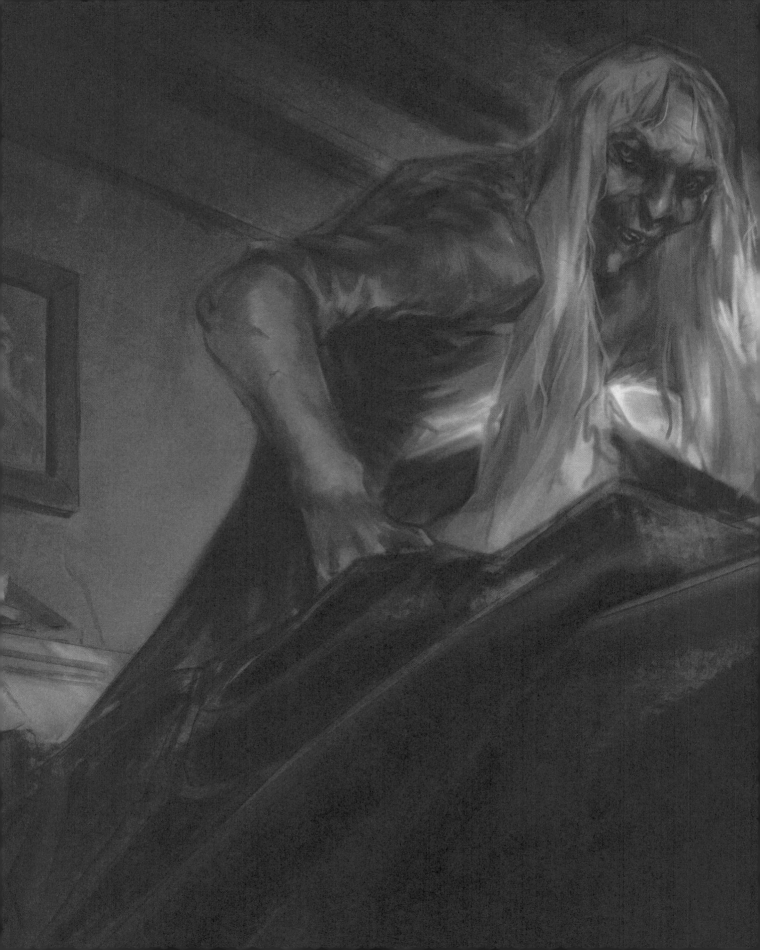

The Cuca

The Cuca is an infamous figure in Iberian and Brazilian folklore – a variation on the classic cautionary theme of a bogeyman who snatches naughty children away. This supernatural being – some kind of ghostly hag or even reptilian beast – has haunted folk stories and lullabies for centuries. In this chapter, concept artist Carol Azevedo delves into traditional tales and her own childhood memories to portray the eerie Cuca.

Carol Azevedo | carolazevedo.myportfolio.com

Research & Rumors

A cautionary witch

The Cuca is a type of bugbear found in Lusophone (Portuguese-speaking) and Hispanophone (Spanish-speaking) regions. She is often used by parents to discipline their unruly children, usually invoked to frighten children who resist bedtime or are too loud. Folklore typically describes the Cuca as a horrendous-looking witch who comes to disobedient children's houses at night and either abducts them or gobbles them up on the spot.

Creatures of night

In her earliest known lore, she is associated with nighttime animals and predators, such as the owl and the moth. In some regions of Brazil, a certain species of large moth is still popularly called "bruxa" (literally a "witch") by older generations.

The shapeshifting Cuca

In some versions of her lore, most likely from Lusophone countries, the Cuca is also a powerful shapeshifter who can turn into various animals – most notably a dragon. This association with sorcery was later adopted by the influential Brazilian author Monteiro Lobato for his own version of the Cuca.

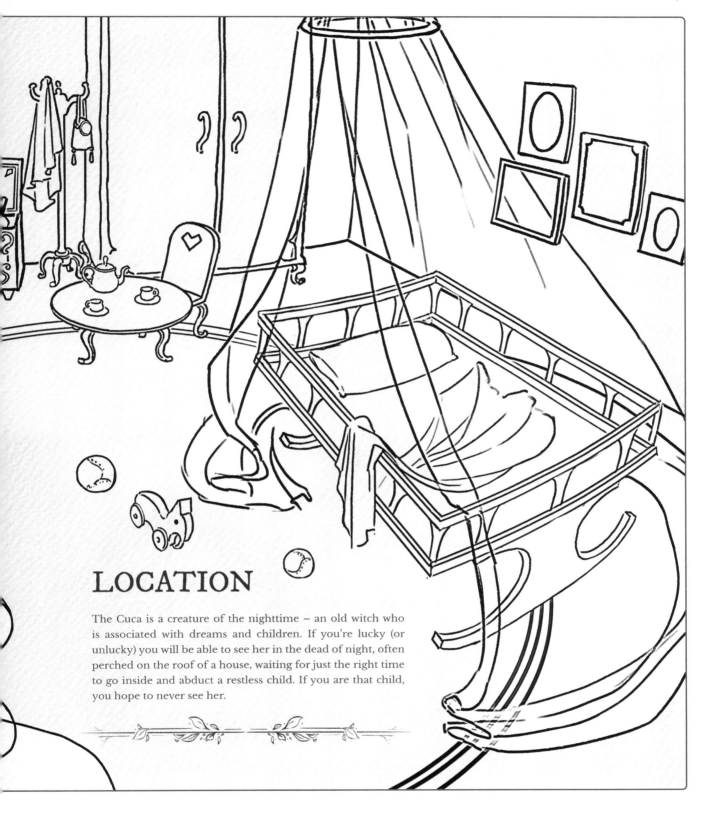

LOCATION

The Cuca is a creature of the nighttime – an old witch who is associated with dreams and children. If you're lucky (or unlucky) you will be able to see her in the dead of night, often perched on the roof of a house, waiting for just the right time to go inside and abduct a restless child. If you are that child, you hope to never see her.

Important Notes

Cultural influences

Although the Cuca is a folkloric character whose origins lie outside Brazil – mainly in Portugal and Spain – Brazil has made her its own. When her story began to spread in Brazil, it went through a transformation. Being the multicultural country that it is, Brazil mixed the Cuca with concepts from Europe, Africa, and indigenous cultures, all of which are integrated through similarities in word meanings and customs. For example, in the indigenous Tupi language, "cuca" is a word for a nocturnal animal that swallows its prey whole (like an owl). In the African dialect Mbunda, the same word means "old" or "decrepit."

Portuguese traditions

"Cuca" or "coco" is a word that means "head" in the popular vernacular. In Portuguese tradition, the bugbear is represented with a gourd or pumpkin with a cutout face, similar to Halloween's jack-o'-lanterns. Because of that, the Cuca (or Coca) started to be associated with the human head and consequently everything in it: our minds, our memories, and our dreams.

An alligator witch

Her most well-known appearance in Brazil today is as a witch with an alligator's head (and sometimes an anthropomorphic alligator's body), thanks to a popular children's book from the 1920s and its many television adaptations. However, this idea may actually have older origins: in both Galician and Portuguese festivities, the Cuca is sometimes described as a shapeshifter, often being depicted as a dragon.

Hard to please

Contrary to most Brazilian folkloric characters, the Cuca is not appeased by gifts such as tobacco, honey, and other foods typically offered. This may well be because of her strong ties to her original lore, and it makes her scarier than all the others. How does one deal with a powerful and insidious creature that cannot be bribed?

The Sack Man

A similar figure in Brazil, and in other Lusophone and Hispanophone countries, is the "Homem do Saco" (the "Sack Man" or "Bag Man" in other parts of Europe). He is described in different ways in these countries – either as an imposing vagrant man or a skinny, ugly, old man. He always carries a bag in which he collects naughty children to take them away. This theme is so widespread that every continent seems to have its own version of a scary man or creature who takes away misbehaving children.

Nursery rhyme

The Cuca has her own nursery rhyme. Although sung with a gentle tone, its lyrics are threatening. One version goes:

Dorme neném
Que a Cuca vem pegar
Papai foi pra roça
Mamãe foi trabalhar

This translates to:

Sleep, little baby
That Cuca comes to get you
Daddy went to the farm
Mommy went to work

This nursery rhyme is so famous that it would be difficult to find a child in Brazil who has not heard at least a version of it growing up.

Studying the Witch

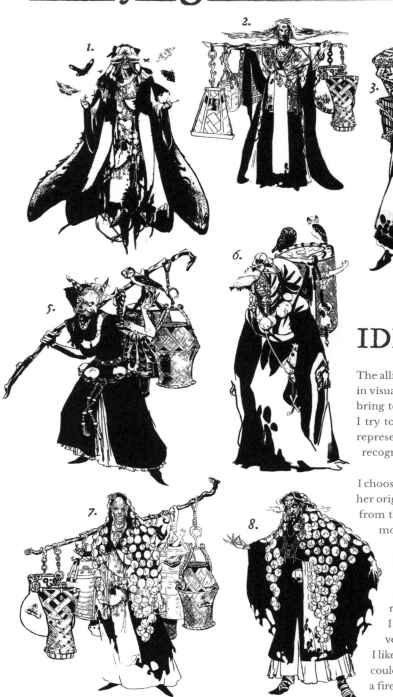

IDEATION

The alligator-headed Cuca has been exhaustingly reproduced in visual and literary arts. So, for this version of her, I want to bring to life her earlier, lesser-known representations. Here I try to explore the many ways in which I can successfully represent the Cuca without losing the qualities that make her recognizable in the modern day.

I choose a rather medieval silhouette for this design, although her origins could be even older than that, and bring in details from the popular imagination for a touch of fantasy. She is more than just a mysterious elderly woman, after all.

I mix and match elements from my research to find the best combination that speaks true to the Cuca: the owl, moth, and alligator motifs, and plenty of skulls and round cranial pieces to create a visual play on her name. I especially enjoy the designs that use many different vessels for transporting abducted children (**2**, **5**, and **7**). I like to think she collects child-sized boxes and pots that she could put to use. If a child is already in a pot, you only need a fire to get dinner going!

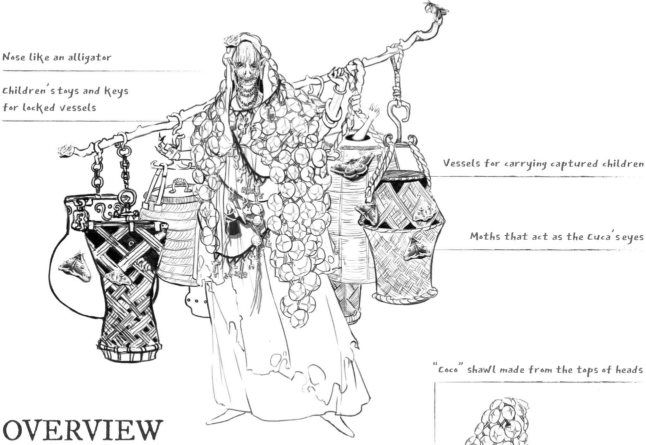

Nose like an alligator

Children's toys and Keys
for locked vessels

Vessels for carrying captured children

Moths that act as the Cuca's eyes

"Coco" shawl made from the tops of heads

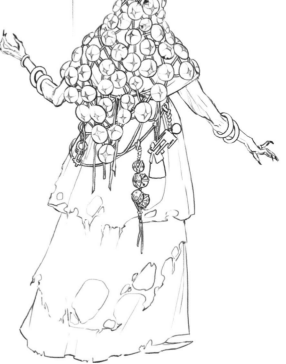

OVERVIEW

I am interested in the idea that the Cuca could be blind and instead sees through her "mariposa" – the great brown moths that keep her company. She sees so easily into a person's mind and dreams that perhaps, in exchange, she needs the aid of a familiar to see in the real world. These particular moths have eyespots on their wings – markings that mimic the eyes of an owl or other predator. The Cuca's association with moths and owls is something I did not know until I began researching for this design, which goes to show that folklore, being mainly an oral tradition, can be remarkably rich and extensive.

Beyond adding these characteristics, I want the witch to be as scary as possible. She is a powerful being with a hunger for young flesh and the power to inject herself into both your nightmares and waking mind. I give her intense wrinkles and alligator-like nostrils as a nod to the modern Cuca, plus various vessels for transporting children away. I think my favorite elements of this design are the children's toys hanging in the same manner as their owners. The repeating pattern of the hanging cages and hanging toys reinforces what this character is all about.

EXPLORATIONS

These sketches explore a few different forms of this formidable witch: the gaping-mouthed child-eater, the reptilian shapeshifter, the wandering hag, and the invader of the subconscious.

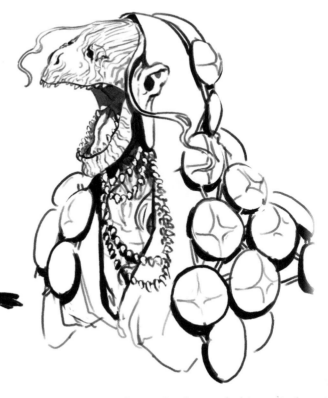

▲ As previously stated, this particular witch is often associated with nocturnal predators that eat their prey whole, such as the owl. I imagine the Cuca having to hide a mouth big enough to swallow a small child in one go.

◄ The Cuca is so tied to the realm of the head – dreams, memories, and thoughts – that all her powers of sight are focused on that other dimension. In the physical world, she needs help from her little creatures in order to see. This small detail ties her in with the local tradition of calling moths "witches". The use of animal familiars also ties her to witchdom itself.

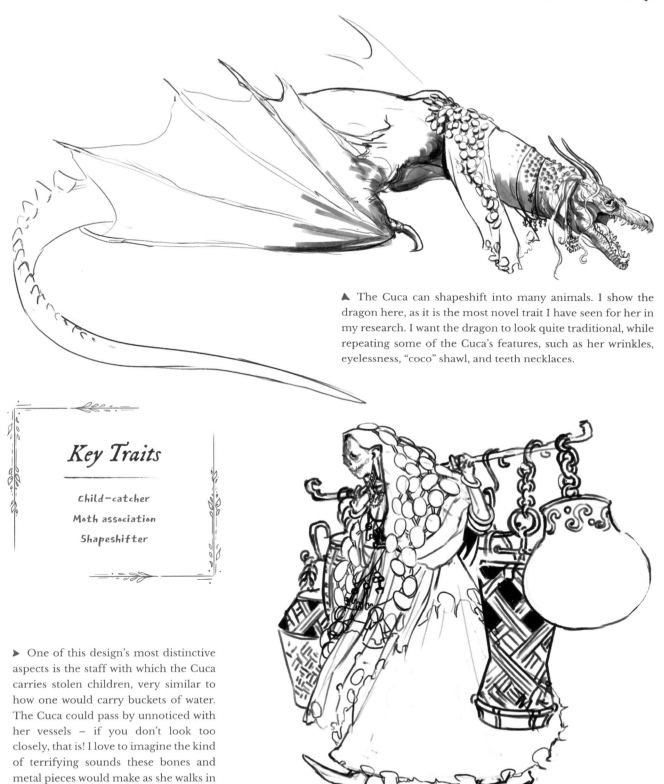

▲ The Cuca can shapeshift into many animals. I show the dragon here, as it is the most novel trait I have seen for her in my research. I want the dragon to look quite traditional, while repeating some of the Cuca's features, such as her wrinkles, eyelessness, "coco" shawl, and teeth necklaces.

Key Traits

Child-catcher

Moth association

Shapeshifter

▶ One of this design's most distinctive aspects is the staff with which the Cuca carries stolen children, very similar to how one would carry buckets of water. The Cuca could pass by unnoticed with her vessels – if you don't look too closely, that is! I love to imagine the kind of terrifying sounds these bones and metal pieces would make as she walks in the night.

Meeting the Witch

The Cuca is not at all a nice witch or even an ambivalent one. She is a creature created for possibly the sole purpose of harshly educating and striking fear into children, so there are fewer nuances to be found in her straightforward, largely unchanged essence. I have the immense luck of having known her folklore all my life; learning that there were myriad incarnations and interpretations of her, from the Middle Ages until now, helped me bring so much depth to her lore and choose which traits to bring back to light.

As a child growing up in the nineties, my perception of the Cuca was not of something to be scared of at all. Even if I did listen to the lullaby countless times, I was much more afraid of the Sack Man! Perhaps that is due to Monteiro Lobato essentially rewriting this folkloric character with a softer, sometimes even comical portrayal. I am very thankful to have the opportunity to investigate the Cuca's origins and create a scarier representation of her.

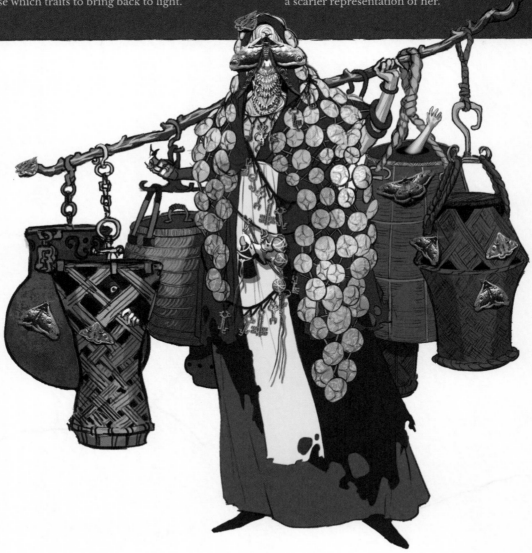

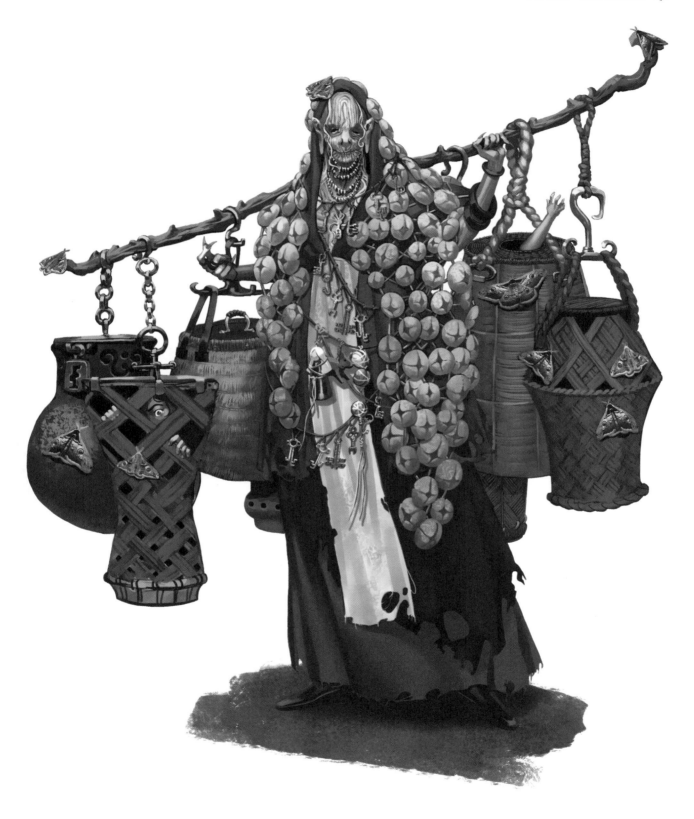

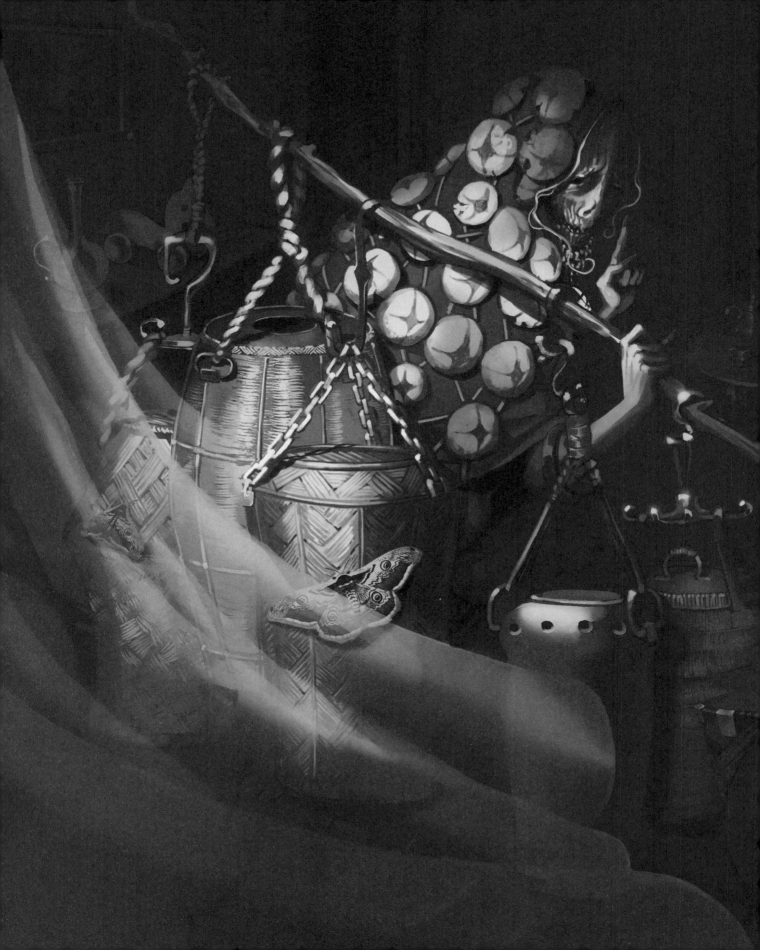

Jenny Greenteeth

Jenny Greenteeth is a particularly distinctive example of the fearsome water hag found in the cautionary tales of many cultures around the world. Hailing from the countrysides of northern England, this hungry hag lurks in deep water, waiting to snatch unsuspecting children from the waterside. In this chapter, concept artist Franco Gonzalez imagines what lies beneath the surface of Jenny Greenteeth's stagnant pool.

Franco Gonzalez | instagram.com/franco_galz

Research & Rumors

Duckweed

It is thought that these little floating plants could have been an important part of Jenny's origins. When something falls into a pool covered with duckweed, the plants quickly close over it. This creates the illusion of the little green leaves working to drown whatever falls in, just like a hag holding someone underwater. In fact, to some, Jenny Greenteeth is simply a name for duckweed itself.

Bogeyman

Tales of Jenny Greenteeth were and are still told with the purpose of keeping children away from rivers and ponds when their parents are not around. What better way to keep a curious child away from these places than by frightening them with a creepy hag that will drown you and eat you if you get too close?

A hag with many faces

Similar water-dwelling monsters are common occurrences across many cultures, from the Japanese kappa to the Slavic rusalka. It is very possible that these similar myths have developed independently in different parts of the world because dark, treacherous waters are something humans have had to contend with since antiquity.

LOCATION

Just under the surface of any river or pond, Jenny Greenteeth might be lurking, hidden by the algae and obscured by the cloudy waters. There she patiently waits for anyone careless enough to wander close by or miss a step and fall within her reach. Mothers use stories of Jenny Greenteeth to keep their children away from dark waters, which can be very dangerous on their own, even with no hag haunting them.

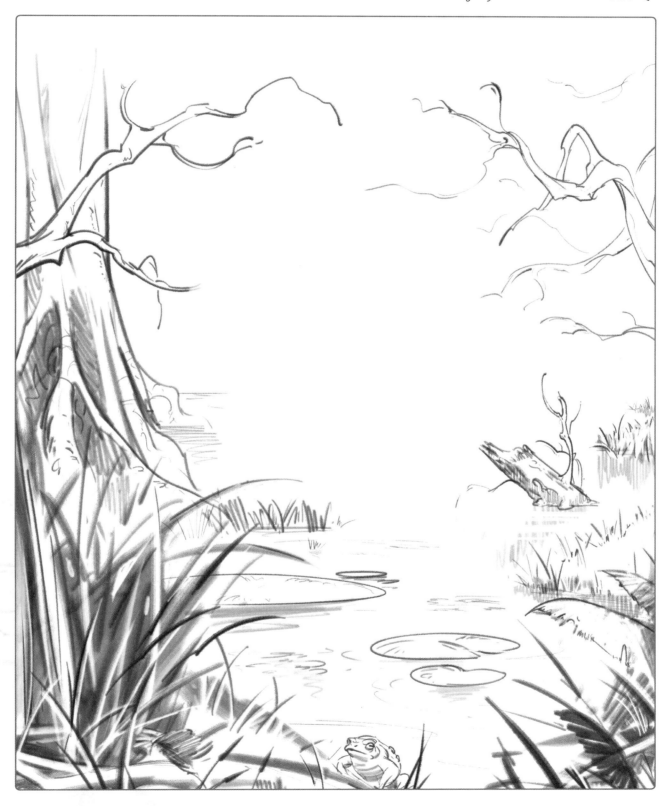

Important Notes

Slimy hair

Long, wild hair will perhaps be the most defining factor of the hag's silhouette. When it is dry, it puffs up and twists around in distinct lumps, appearing like dry foliage if one is not paying enough attention. When wet, the hair droops down, forming a slimy coat that wraps around her figure, like seaweed woven with moss. When she remains still, her hair manages to blend in seamlessly with the surrounding flora, providing the perfect camouflage for her ambushes.

Long arms

Jenny Greenteeth has long, bony arms that twist in an unnatural way, as if there are more joints than a normal person would have. Her fingers are also long and bony, and her hands are disproportionately large, even relative to her already lengthy limbs. On the tip of each finger grows a sharp, black nail, jagged and uncut. With these unsettling extremities, she manages to reach far out of the water when she grabs her prey.

Sharp teeth

Jenny Greenteeth has an enormous mouth resembling that of a carnivorous fish, such as a piranha or barracuda, with a prominent underbite. The skin on her lips is thin and dry, peeling back over her gnarly maw. She sports multiple rows of jagged, sharp teeth protruding from exposed gums. All sorts of putrid remains are stuck among her fangs, including rotting fish and algae, which give Jenny her characteristic green teeth.

Green skin

Jenny Greenteeth's skin is a more subtle element that not many get to see – if they were to get close enough to examine it, they probably wouldn't live to tell the tale! It is riddled with cuts and gashes that never seem to heal properly, with an abundance of warts throughout. On top of all of this, a sizable number of parasitic barnacles infest her flesh. These sharp, rocky protrusions contrast starkly with her otherwise slimy, toad-like, green dermis.

Hunting tactics

Much like an alligator, Jenny waits just under the surface of the water, unmoving, until she is in perfect range to lunge for her target. She uses her surroundings to her advantage, always staying in the darkest, densest part of the pond or river she happens to be haunting. On particularly dark nights, she might even leave one of her arms out of the water, crooked fingers motionless in order to resemble a fallen branch.

Hiding in trees

Some claim to have heard a horrible screeching, like a young woman in agony, coming from the treetops during long winter nights. This is none other than Jenny, although no one seems to know the cause of her screams. When not lurking in water, she uses her long limbs to climb and hang from trees with surprising agility. Her slimy hair is notably unruffled by the wind, making her static silhouette stand out in tempestuous night, even in the dark.

Studying the Witch

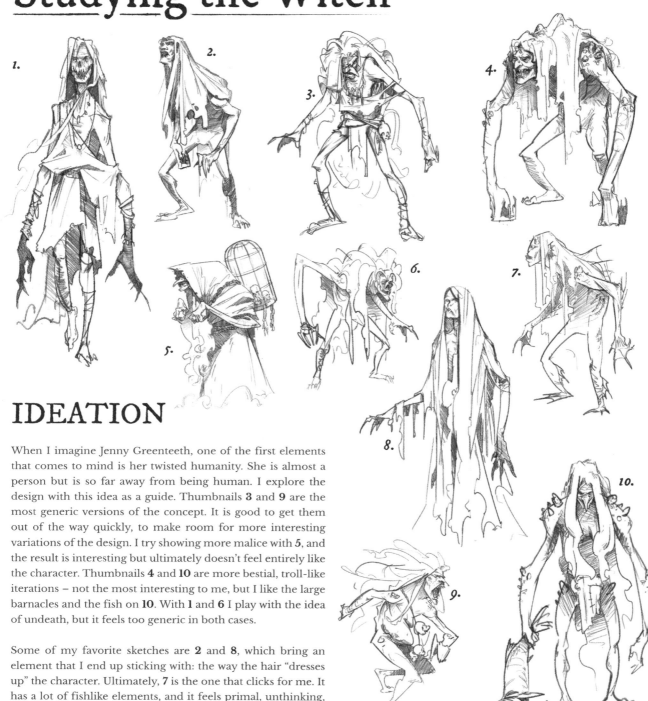

IDEATION

When I imagine Jenny Greenteeth, one of the first elements that comes to mind is her twisted humanity. She is almost a person but is so far away from being human. I explore the design with this idea as a guide. Thumbnails **3** and **9** are the most generic versions of the concept. It is good to get them out of the way quickly, to make room for more interesting variations of the design. I try showing more malice with **5**, and the result is interesting but ultimately doesn't feel entirely like the character. Thumbnails **4** and **10** are more bestial, troll-like iterations – not the most interesting to me, but I like the large barnacles and the fish on **10**. With **1** and **6** I play with the idea of undeath, but it feels too generic in both cases.

Some of my favorite sketches are **2** and **8**, which bring an element that I end up sticking with: the way the hair "dresses up" the character. Ultimately, **7** is the one that clicks for me. It has a lot of fishlike elements, and it feels primal, unthinking, and potentially cursed, so I go with it as my base.

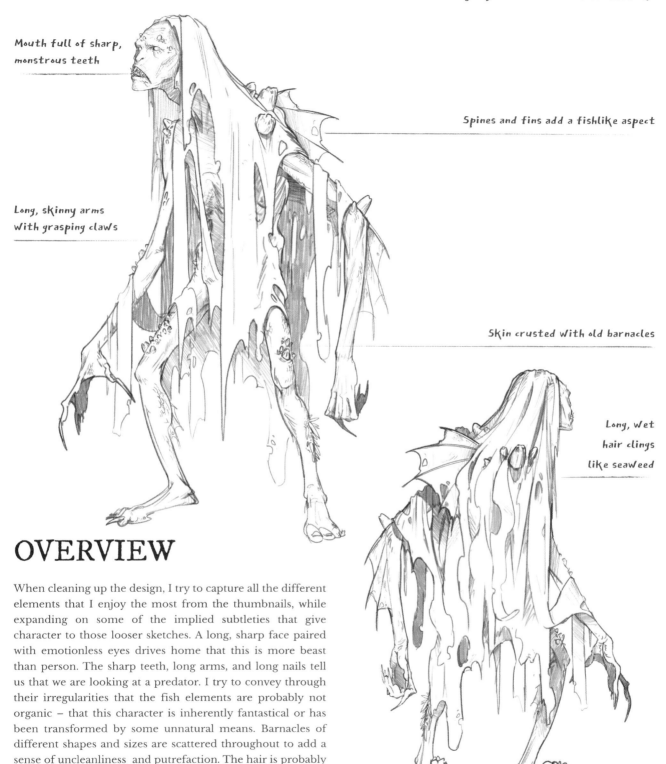

Mouth full of sharp, monstrous teeth

Spines and fins add a fishlike aspect

Long, skinny arms with grasping claws

Skin crusted with old barnacles

Long, wet hair clings like seaweed

OVERVIEW

When cleaning up the design, I try to capture all the different elements that I enjoy the most from the thumbnails, while expanding on some of the implied subtleties that give character to those looser sketches. A long, sharp face paired with emotionless eyes drives home that this is more beast than person. The sharp teeth, long arms, and long nails tell us that we are looking at a predator. I try to convey through their irregularities that the fish elements are probably not organic – that this character is inherently fantastical or has been transformed by some unnatural means. Barnacles of different shapes and sizes are scattered throughout to add a sense of uncleanliness and putrefaction. The hair is probably my favorite element – it really tells a big part of the story of who this character is.

EXPLORATIONS

These sketches explore the behavior of the animalistic hunter behind Jenny Greenteeth's humanoid appearance. As well as lurking in deep pools, waiting for the occasional unlucky child to approach, she would also need to exist and hunt above water.

▶ With this pose I show the character displaying a burst of energy. Seeing the rigid design in action adds a lot to making the character more believable. This pose works especially well with the themes of inhumanity and animal-mindedness. I include some indication of environmental elements in motion, to suggest that the character was calmly lurking mere moments ago.

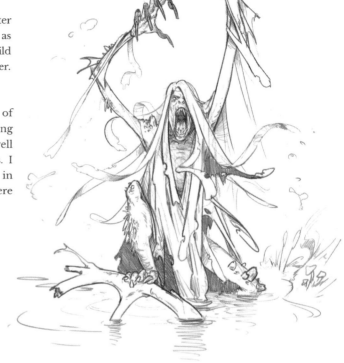

◀ Here I push a little again in the direction of a more troll-inspired character. The pronounced hunch, heavy step, decorative bones of her victims, and exaggerated face shape emphasize this creature's primitive nature and cruel disdain for life. I thought that making the hair more stringy could potentially be fun, so I pair that idea with this pose.

Key Traits

Primal, animalistic nature
Lank, weed-like hair
Long, sharp teeth and claws

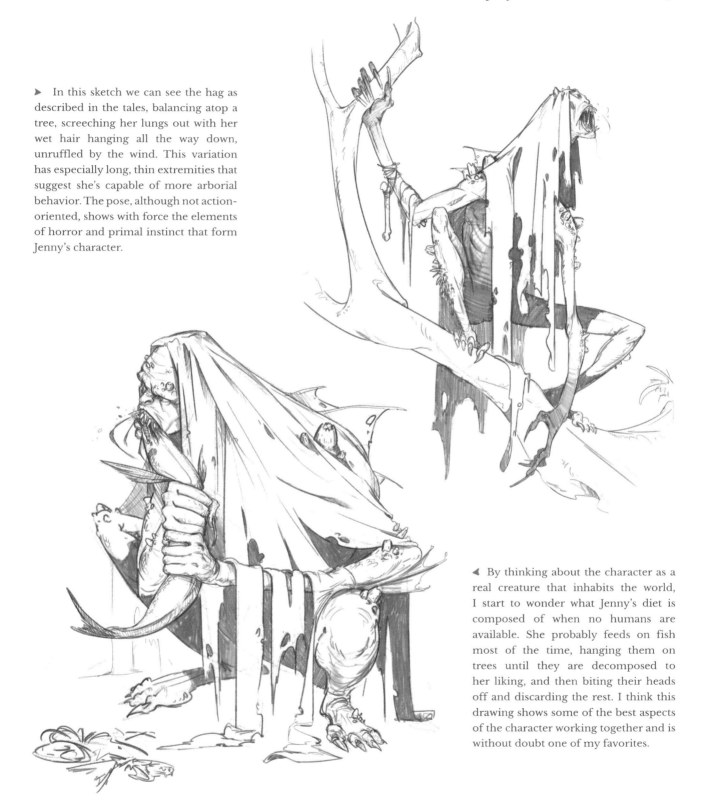

▶ In this sketch we can see the hag as described in the tales, balancing atop a tree, screeching her lungs out with her wet hair hanging all the way down, unruffled by the wind. This variation has especially long, thin extremities that suggest she's capable of more arborial behavior. The pose, although not action-oriented, shows with force the elements of horror and primal instinct that form Jenny's character.

◀ By thinking about the character as a real creature that inhabits the world, I start to wonder what Jenny's diet is composed of when no humans are available. She probably feeds on fish most of the time, hanging them on trees until they are decomposed to her liking, and then biting their heads off and discarding the rest. I think this drawing shows some of the best aspects of the character working together and is without doubt one of my favorites.

Meeting the Witch

Once again I try to combine the best of all the drawings done up to this point. In this particular case, I take the opportunity to render out more of Jenny's decayed flesh and show the texture of her hair in greater detail. These details are harder to capture with only lines, but once values come into play, the wet lumps of seaweed-like hair that I had in mind finally come to light.

I want to place special emphasis on the facial structure and features, so I spend some extra time detailing those parts of the design. The result really shows what you would be facing if you were to encounter this monster in the wild: a rapid turn of the head, a mouth full to the brim with glistening spikes, a blank stare, and a fish hanging from her mouth, exactly where you will be in only a matter of moments. I make use of direct bottom-up lighting to really emphasize the horror theme, which in turn ends up inspiring the final painting.

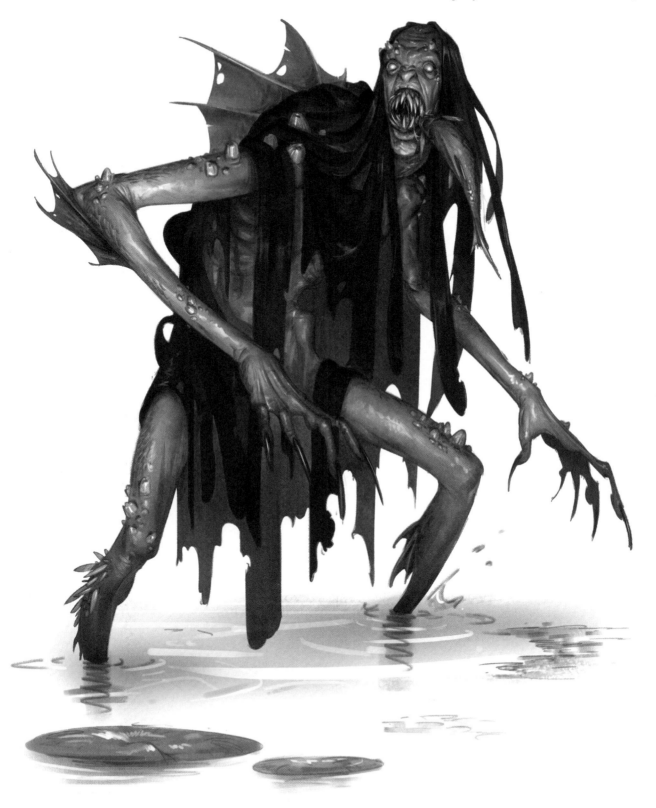

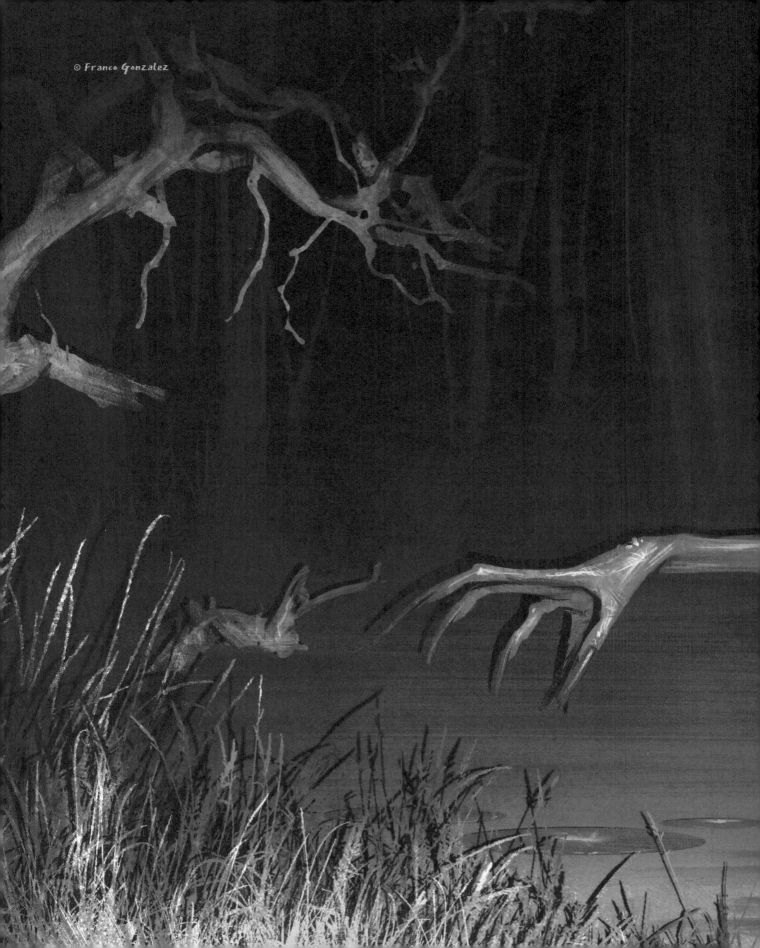
© Franco Gonzalez

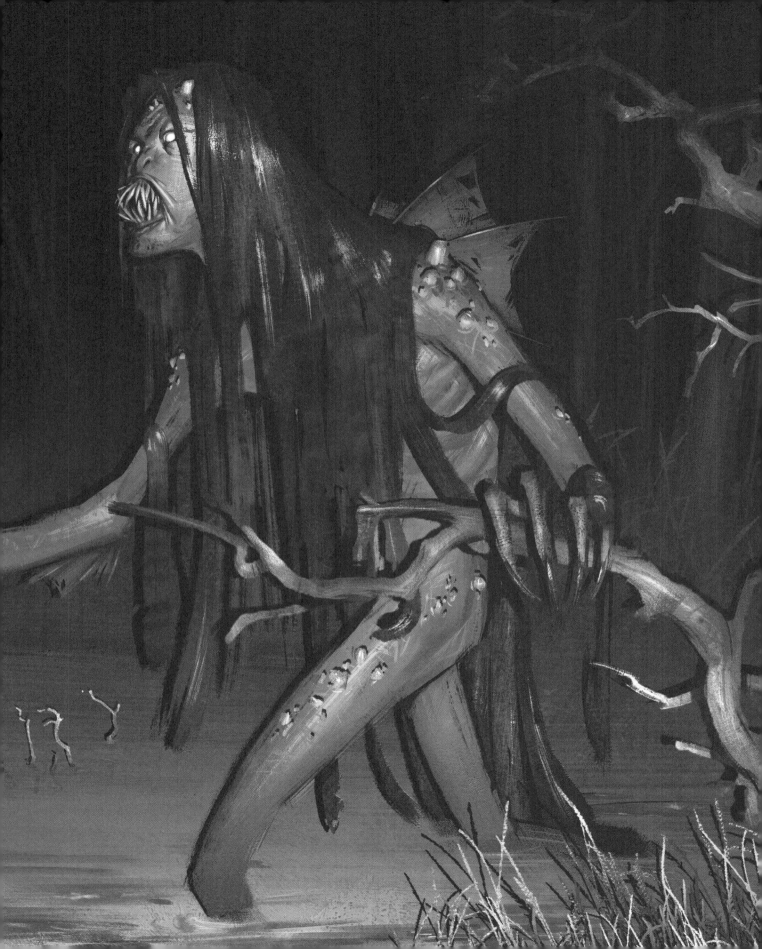

Elli

Elli is a little-known but powerful crone from Norse legend. She is a jötunn, one of the supernatural jötnar – a race of beings sometimes translated as "giants." When the god Thor challenges the jötunn Utgard-Loki to a wrestling match, he is mockingly invited to fight a frail, elderly woman instead. She is unmoved by Thor's strength and he eventually falls to one knee. Later, Utgard-Loki reveals that Elli is Old Age itself, and cannot be defeated. In this chapter, concept artist and illustrator Matteo Spirito ventures into Viking myth to present his own take on this mysterious but memorable character.

Matteo Spirito | artstation.com/matteospirito

Research & Rumors

A king's nurse

Elli is said to have been the nurse of Utgard-Loki, the jötunn (singular for jötnar) king of Utgard. Despite her shrunken, petite appearance, she is extremely powerful. It is said that during his journey to the lands of the giants, Thor challenged Elli to a wrestling match and lost. In truth, no one can fight against her and win, for she is the personification of Old Age.

Deterioration

Though her true appearance was concealed from Thor by the magical arts of Utgard-Loki, Elli symbolizes one of the most powerful forces in the universe, to which all will sooner or later succumb: decay. It pervades all nine of the Norse mythological realms like the strangling roots of a tree, slowly draining everything it touches.

Parasitic powers

I interpret Elli as a parasite of space-time – a world-eater. Everything she devours slowly vanishes into nothingness – such is her irresistible, relentless power. Perhaps it was this power that enabled her to wear down Thor's strength with such ease, despite her frail appearance.

LOCATION

Elli is found in Jötunheim, the world of the ice and rock giants. Her abode is said to be perched high in the mountains, atop a winding staircase covered with icy roots, near the capital Utgard, home of King Utgard-Loki. Jötunheim is a cold, ice-covered, windswept world, a place ruled by primordial forces of chaos, from where the jötnar threaten to destroy our world, Midgard, and even the kingdom of the gods, Asgard.

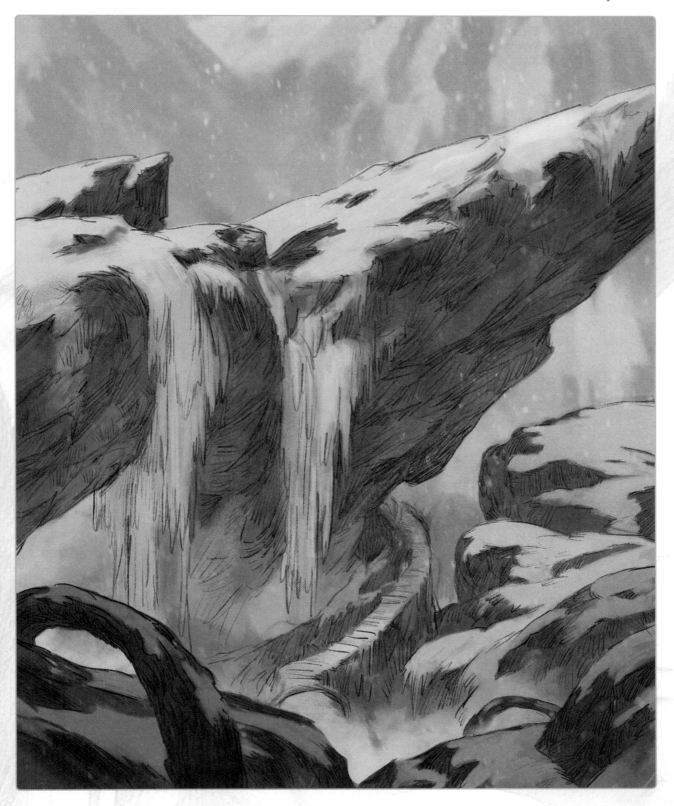

Important Notes

Elli's hangerok

Elli wears a typical Viking woman's dress consisting of a petticoat and a surcoat called a "hangerok," or "apron-skirt," which consists of two strips of cloth with braces held by two brooches. The brooches are the characteristic feature of this garment, and were also used to hold cords onto which beads, colored stones, jewelry, or even useful objects such as keys or knives could be threaded. The decorations feature intertwining snakes symbolizing Ragnarök, the great apocalypse of Norse mythology.

A wooden throne

Being a respected elder figure in Utgard-Loki's hall, I imagine Elli has a special seat of her own, made to fit her small stature. This throne is an old, carved piece of wood; the object is practically part of her. Old Elli cannot move with her legs, so she never leaves it. The throne is decorated with carvings of wolves' heads and the colossal serpent Jörmungandr. The wolf heads might represent Sköll and Hati, the two wolves that will devour the sun and moon during Ragnarök.

Twisted horns

I imagine Elli with twisted root-like horns, with which she drains her enemies. They wrap around her throne like tentacles and penetrate the earth. They can even lift up the throne, allowing the witch to move, transforming into a myriad of gnarled limbs that enable her to grasp things and fight or defend herself. Perhaps they are the only things that make us realize that Elli's gnarled old figure is alive.

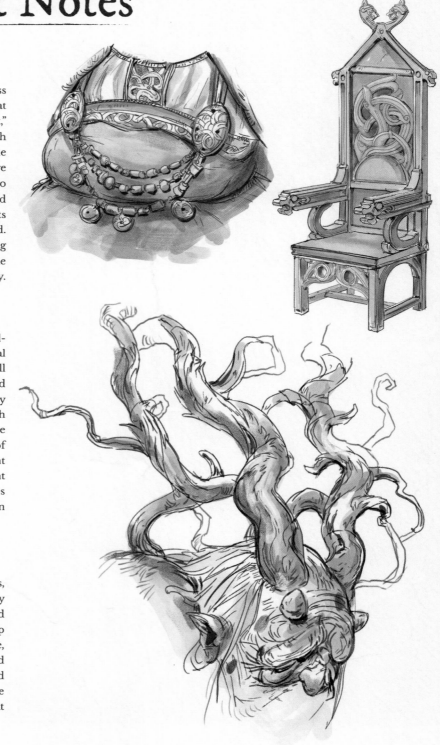

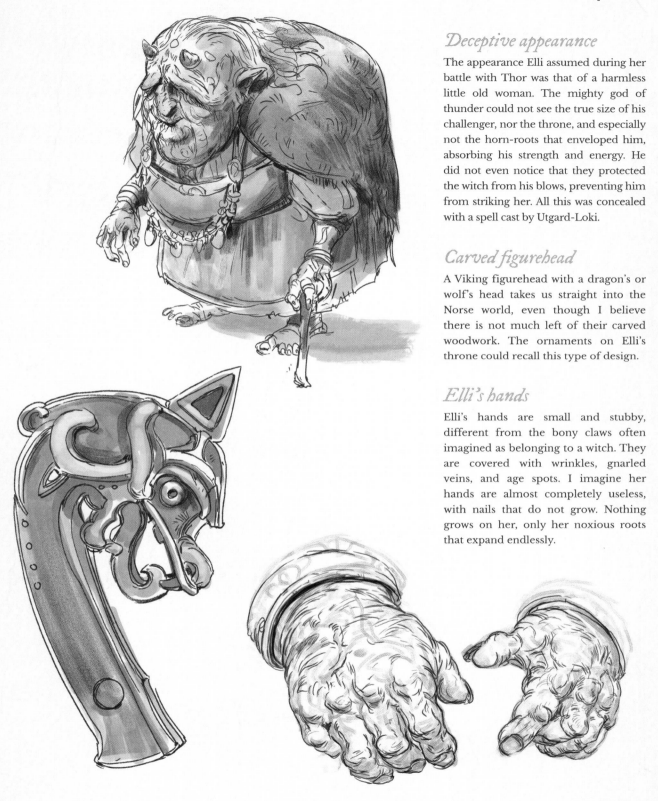

Deceptive appearance

The appearance Elli assumed during her battle with Thor was that of a harmless little old woman. The mighty god of thunder could not see the true size of his challenger, nor the throne, and especially not the horn-roots that enveloped him, absorbing his strength and energy. He did not even notice that they protected the witch from his blows, preventing him from striking her. All this was concealed with a spell cast by Utgard-Loki.

Carved figurehead

A Viking figurehead with a dragon's or wolf's head takes us straight into the Norse world, even though I believe there is not much left of their carved woodwork. The ornaments on Elli's throne could recall this type of design.

Elli's hands

Elli's hands are small and stubby, different from the bony claws often imagined as belonging to a witch. They are covered with wrinkles, gnarled veins, and age spots. I imagine her hands are almost completely useless, with nails that do not grow. Nothing grows on her, only her noxious roots that expand endlessly.

Studying the Witch

IDEATION

There are no traditional descriptions of Elli, so there is no precise iconography to go on when creating her appearance. All we know is that she is a jötunn woman who appears ancient and frail. As Elli is essentially a force of nature, my research starts with the idea of a tree woman. I like the idea of a chaotic shape, so I focus on developing that theme. Though "jötunn" is often translated as "giant," the jötnar are not necessarily huge – Elli could be very small and squat.

I feel that sketches **2**, **3**, and **6** have something more to say, so I really push the idea of the root horns. To make her seem frail and small, perhaps even senile, she could be both hindered by and completely reliant on the roots for movement, as if they have taken over her body. This leads me to decide on sketch **10**, as it best encapsulates the ideas that I want to express: a seemingly harmless, inert figure, shrunken by time, but surrounded by chaotic, threatening roots that seem to have a life of their own.

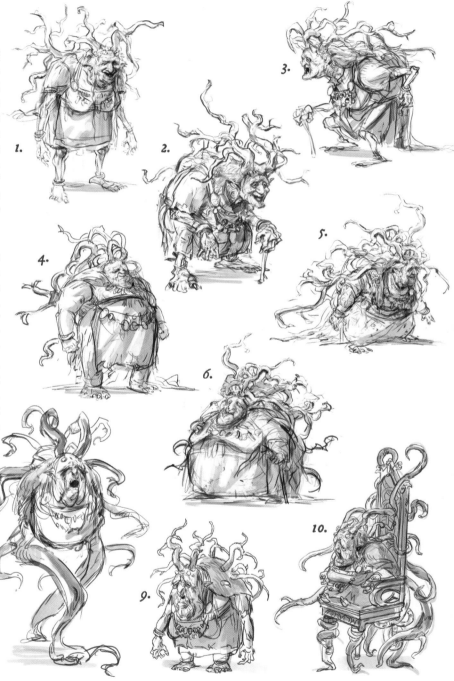

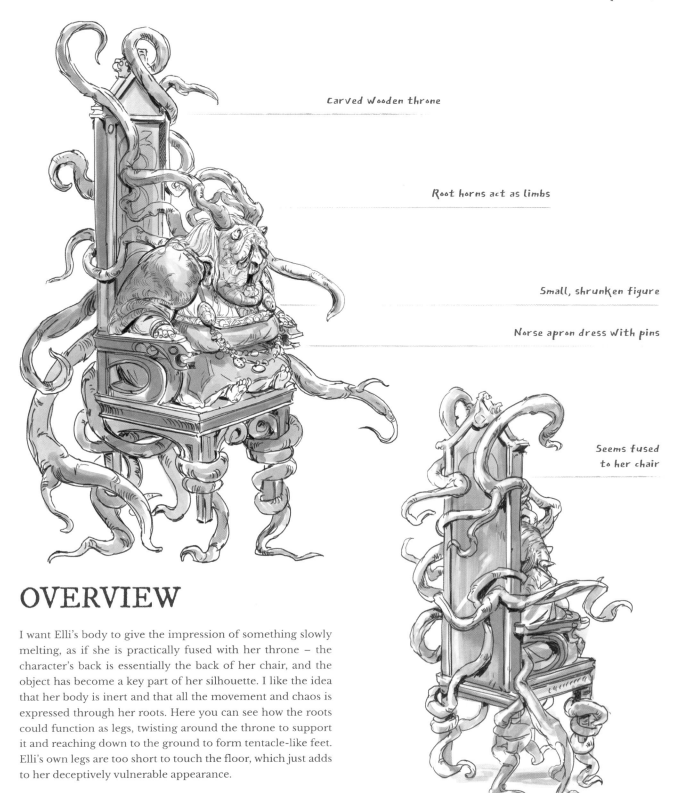

Carved wooden throne

Root horns act as limbs

Small, shrunken figure

Norse apron dress with pins

Seems fused to her chair

OVERVIEW

I want Elli's body to give the impression of something slowly melting, as if she is practically fused with her throne – the character's back is essentially the back of her chair, and the object has become a key part of her silhouette. I like the idea that her body is inert and that all the movement and chaos is expressed through her roots. Here you can see how the roots could function as legs, twisting around the throne to support it and reaching down to the ground to form tentacle-like feet. Elli's own legs are too short to touch the floor, which just adds to her deceptively vulnerable appearance.

EXPLORATIONS

Now that we have established Elli as an ancient, sedentary figure who uses her insidious roots for movement, we can explore a wider range of motion and action that the character might have. How would this small, frail crone use her powers to defeat a god as strong as Thor?

▶ Here we see Elli, enraged, in an attack pose. The roots at the bottom, which support the throne, have risen up like an animal growing larger to threaten its adversary. The topmost roots, meanwhile, converge swiftly like scorpion tails, darting forward to seize their prey. I imagine that Elli does not speak and hardly moves, but her expression has changed as she emits a threatening gasp.

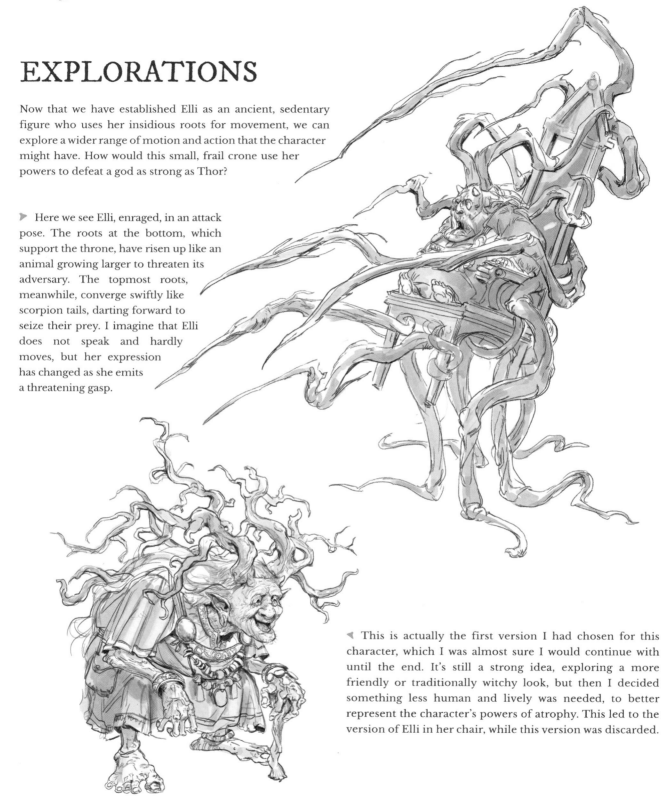

◀ This is actually the first version I had chosen for this character, which I was almost sure I would continue with until the end. It's still a strong idea, exploring a more friendly or traditionally witchy look, but then I decided something less human and lively was needed, to better represent the character's powers of atrophy. This led to the version of Elli in her chair, while this version was discarded.

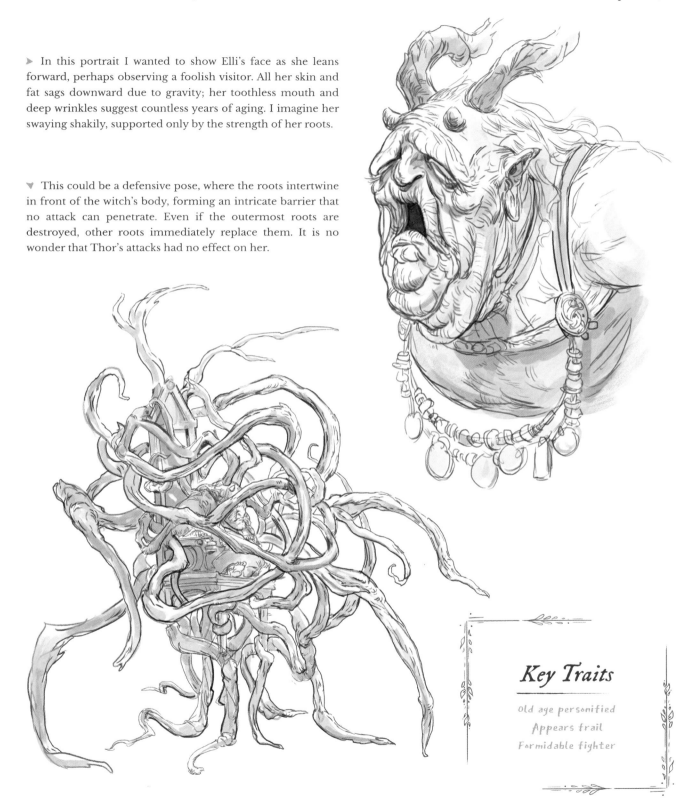

➤ In this portrait I wanted to show Elli's face as she leans forward, perhaps observing a foolish visitor. All her skin and fat sags downward due to gravity; her toothless mouth and deep wrinkles suggest countless years of aging. I imagine her swaying shakily, supported only by the strength of her roots.

▼ This could be a defensive pose, where the roots intertwine in front of the witch's body, forming an intricate barrier that no attack can penetrate. Even if the outermost roots are destroyed, other roots immediately replace them. It is no wonder that Thor's attacks had no effect on her.

Key Traits

Old age personified

Appears frail

Formidable fighter

Meeting the Witch

In this final study, I use a slightly angled overhead shot to help me understand as many of this old witch's details as possible. At this stage, it's important for me to make the different materials feel really concrete. I focus on the textures of the various elements, such as the skin of her face and the snow and ice accumulated on the antler roots.

I give Elli's face an expression that is both mocking and somewhat unconscious and mindless. The final impression is of a tiny, wizened figure that still commands fearsome, primal power. In the final illustration, I will use warm light to contrast with Elli's grayish skin and the cold, icy caverns of her home.

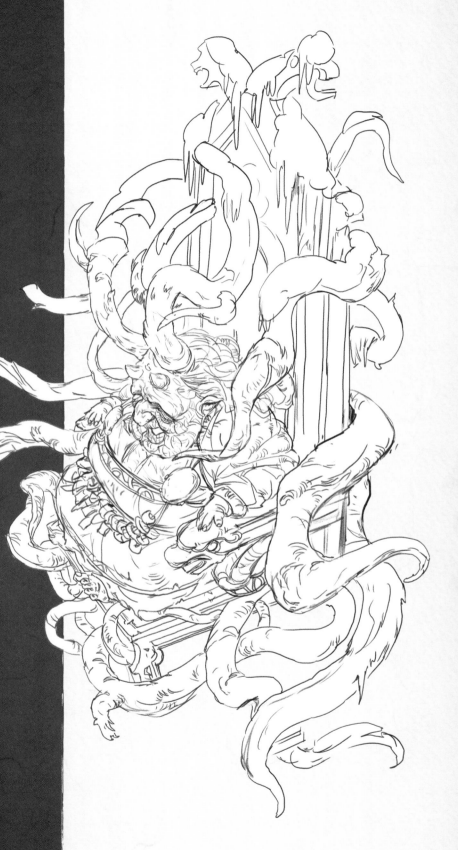

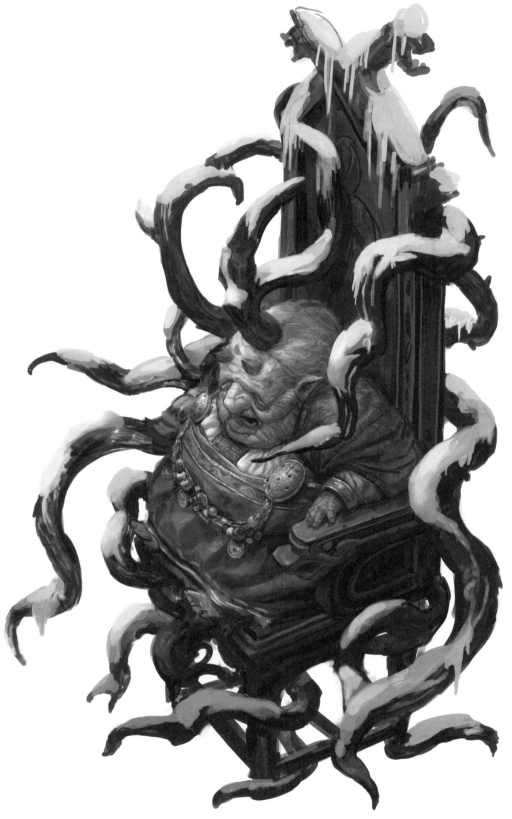

© Matteo Spirito

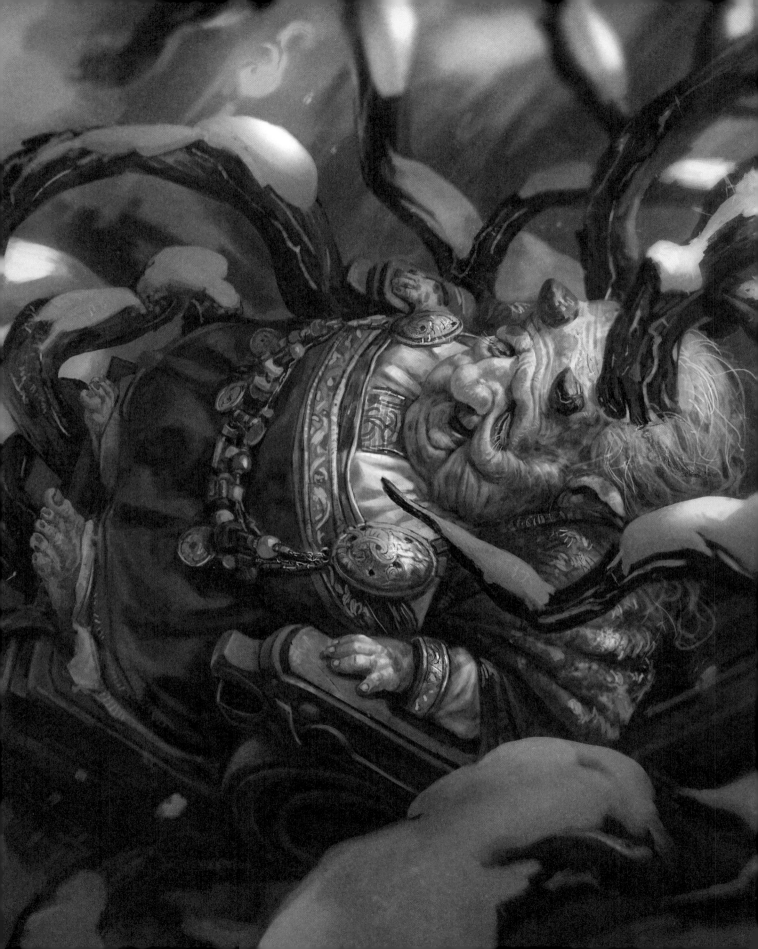

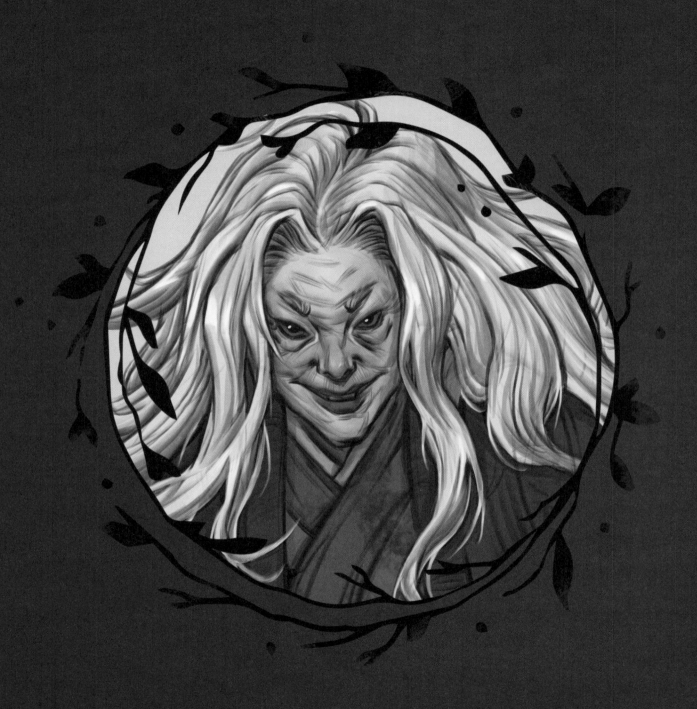

Yama-uba

Yama-uba, the mountain-dwelling hag, is one of the many yōkai that populate Japanese folklore. Mysterious and reclusive, she has been portrayed in several different ways by storytellers and playwrights throughout history, ranging from a frightening, cannibalistic crone to a more protective nature-guardian figure. Illustrator and concept artist Monika Eidintaite investigates the mythology of Yama-uba to create her own take on this supernatural entity.

Research & Rumors

A reclusive hag

Yama-uba is an elderly crone who inhabits the forests of the mountains of Japan. She is said to live alone in a hut by the road, offering shelter and food to weary travelers who have lost their way. She is rumored to be a cannibal who eats those unfortunate enough to accept her offer of help, transforming into her true form once they are helpless inside her home.

Good or evil?

This witch possesses both a benevolent and malevolent side. Some describe her as a terrifying cannibal hag with a particular taste for children, bringing death and misfortune to those who cross her path. Others say she is a kind guardian of nature, nursing children lost in the forests and gifting wealth and prosperity to those she deems worthy.

Historical famine

Yama-uba may once have been human. During a terrible famine in Japan, it is rumored that starving families would take their elders to die in the mountains, so their remaining relatives would have more left to eat. Some say Yama-uba became a hungry hag from this practice, inhabiting the mountain forests to which she was banished.

LOCATION

In the mountainous forests of Japan lies a solitary hut surrounded by old trees. This section of the forest is lonely and remote, with few visitors, except for the occasional lost traveler or merchant. Those who need to venture across the mountain paths for any reason are warned to stay away from this lone hut. If a feeble old lady approaches you, offering food and shelter, you had better decline and be on your way – rumor has it that great misfortune befalls those who accept an offer from this wild-haired woman.

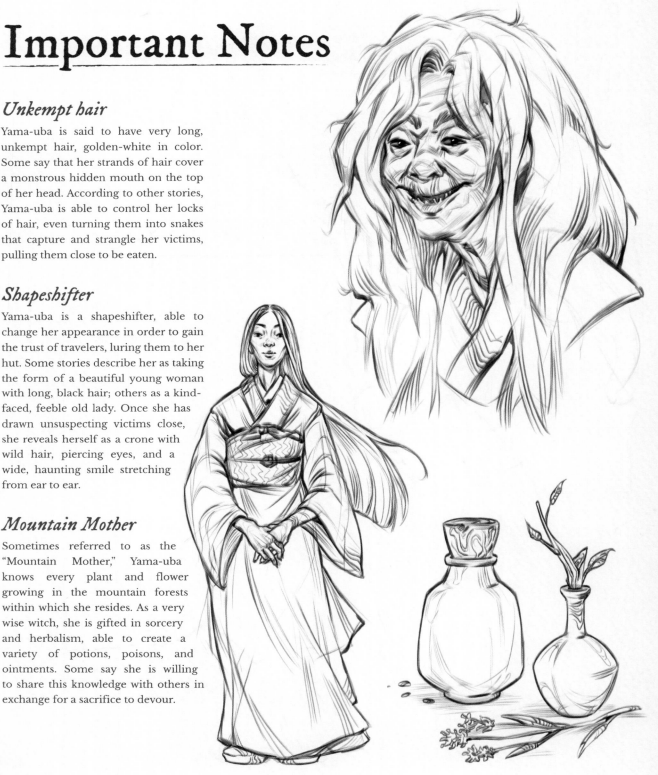

Important Notes

Unkempt hair

Yama-uba is said to have very long, unkempt hair, golden-white in color. Some say that her strands of hair cover a monstrous hidden mouth on the top of her head. According to other stories, Yama-uba is able to control her locks of hair, even turning them into snakes that capture and strangle her victims, pulling them close to be eaten.

Shapeshifter

Yama-uba is a shapeshifter, able to change her appearance in order to gain the trust of travelers, luring them to her hut. Some stories describe her as taking the form of a beautiful young woman with long, black hair; others as a kind-faced, feeble old lady. Once she has drawn unsuspecting victims close, she reveals herself as a crone with wild hair, piercing eyes, and a wide, haunting smile stretching from ear to ear.

Mountain Mother

Sometimes referred to as the "Mountain Mother," Yama-uba knows every plant and flower growing in the mountain forests within which she resides. As a very wise witch, she is gifted in sorcery and herbalism, able to create a variety of potions, poisons, and ointments. Some say she is willing to share this knowledge with others in exchange for a sacrifice to devour.

Weaknesses

Yama-uba is powerful, possessing great strength, and skilled in fooling her victims into trusting her. However, there are stories that tell of her weaknesses. One tale in particular describes her as being unable to walk in sunlight, only leaving her hut in the darkness of the night. Another rumor states that a special type of flower houses the mountain witch's soul, and that the only way to defeat her is by destroying it.

Walking stick

Described as a haggard old woman, Yama-uba is shown in most artistic depictions with a walking stick made of tree bark. Sometimes this makeshift cane has herbs and plants tied around it. This walking stick likely helps her cross the mountains and forests more easily, and has the advantage of making her look a little more helpless, in case she comes across any lost travelers.

Kintarō

Also depicted as a symbol of love and motherhood, Yama-uba is said to have raised Kintarō, a beloved legendary figure in Japanese folklore. One of the tales describes Kintarō's birth mother abandoning him in the mountains, where Yama-uba adopts him and raises him as her own. Kintarō grows up to possess superhuman strength, and makes friends with the animals of the mountain, later embarking on his own adventures and becoming a renowned heroic warrior.

Studying the Witch

IDEATION

My favorite aspect of Yama-uba is her dual nature: the fact that she is not only revered and loved, but also feared. She is not described as a wholly cruel figure, and although she is capable of inflicting great terror, she is often depicted as a guardian and someone with protective qualities. I personally prefer to believe this witch is capable of doing both harm to others, and great kindness to those living with her in harmony with nature. I want these dual qualities to be represented within her design.

One of the main challenges is how to create an ambiguous impression – an individual that looks capable of being both benevolent and malicious. In some thumbnails, such as **1**, **2**, and **10**, I try to create the impression of a friendlier old woman, with a wide smile and a non-intimidating demeanor. In thumbnails **3**, **4**, and **8**, I play with less human shapes and poses to create a more frightening and hostile impression, working off the sometimes terrifying descriptions mentioned in the legends.

Throughout these sketches, I incorporate details such as twigs, leaves, and ropes holding potion bottles together – things that not only create an ornamental impression, but are useful for Yama-uba in her day-to-day life of foraging on mountain paths.

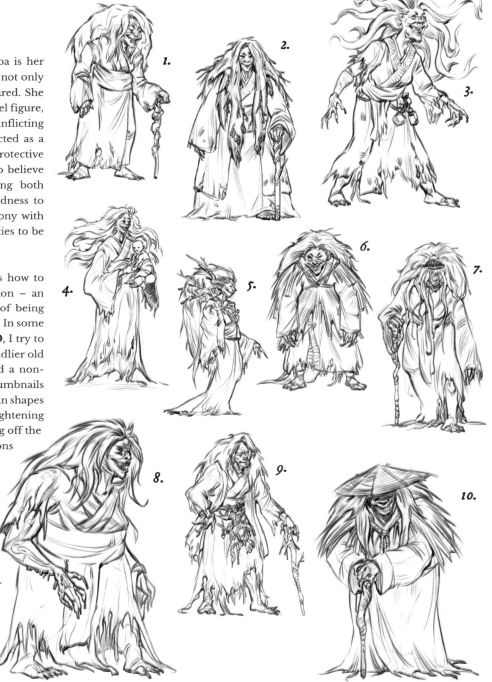

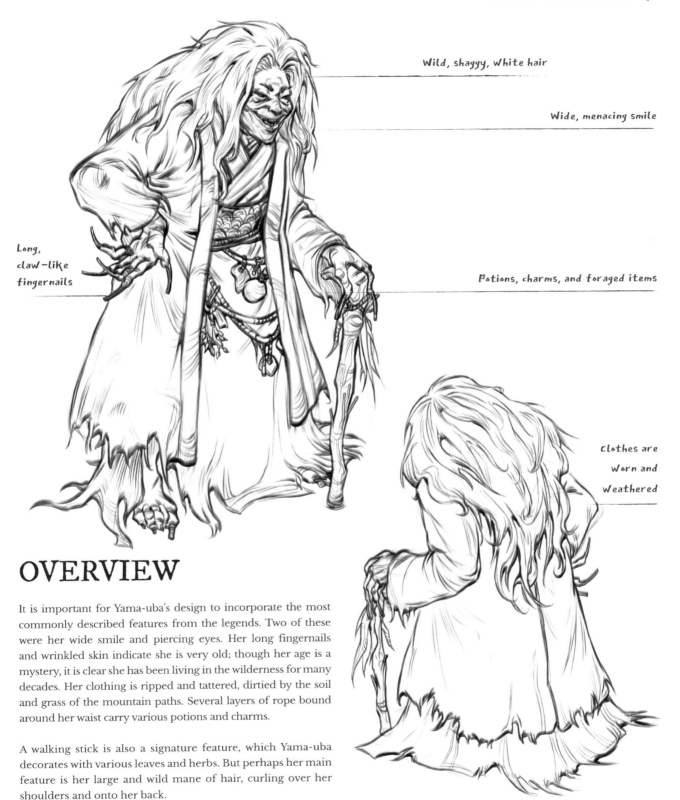

Wild, shaggy, white hair

Wide, menacing smile

Long, claw-like fingernails

Potions, charms, and foraged items

Clothes are worn and weathered

OVERVIEW

It is important for Yama-uba's design to incorporate the most commonly described features from the legends. Two of these were her wide smile and piercing eyes. Her long fingernails and wrinkled skin indicate she is very old; though her age is a mystery, it is clear she has been living in the wilderness for many decades. Her clothing is ripped and tattered, dirtied by the soil and grass of the mountain paths. Several layers of rope bound around her waist carry various potions and charms.

A walking stick is also a signature feature, which Yama-uba decorates with various leaves and herbs. But perhaps her main feature is her large and wild mane of hair, curling over her shoulders and onto her back.

EXPLORATIONS

Yama-uba's behavior needs to reflect her life of solitude, close to nature in the mountains, while taking into account both sides of her character: the fearsome hag and the motherly guardian.

▲ Yama-uba wears a raincoat and hat made of straw and grass, foraging the mountain forests with a container to store various useful herbs and plants. I imagine that Yama-uba later uses these flowers for her various potions and concoctions, as well as for creating small charms and talismans.

◀ Here the witch stands with her hair coiling in all directions – a powerful showcase of her magical and at times frightening nature. When angered, Yama-uba is truly capable of inciting great terror in her foes. Her hair is thick and strong, like venomous snakes, capable of entrapping her enemies.

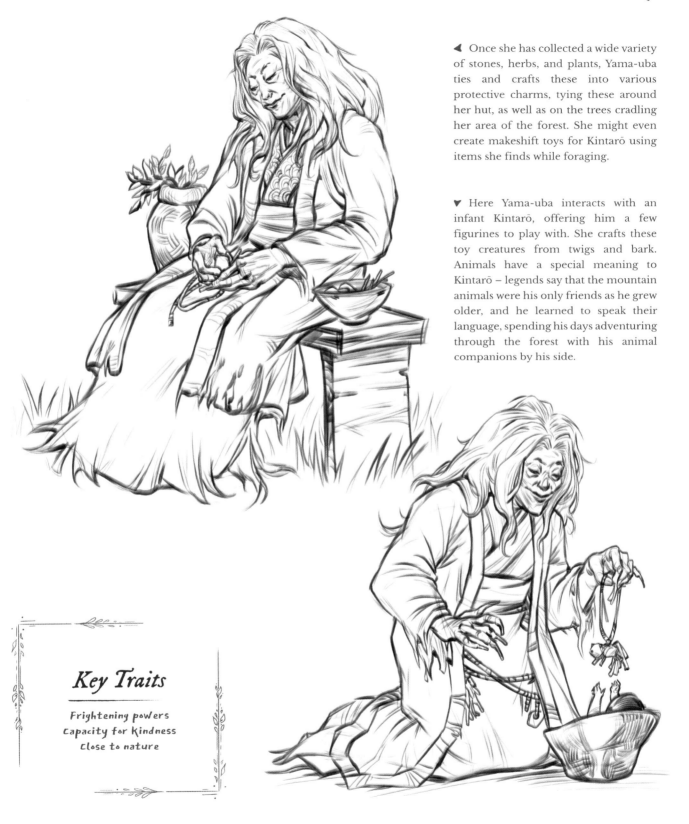

◄ Once she has collected a wide variety of stones, herbs, and plants, Yama-uba ties and crafts these into various protective charms, tying these around her hut, as well as on the trees cradling her area of the forest. She might even create makeshift toys for Kintarō using items she finds while foraging.

▼ Here Yama-uba interacts with an infant Kintarō, offering him a few figurines to play with. She crafts these toy creatures from twigs and bark. Animals have a special meaning to Kintarō – legends say that the mountain animals were his only friends as he grew older, and he learned to speak their language, spending his days adventuring through the forest with his animal companions by his side.

Key Traits

Frightening powers
Capacity for kindness
Close to nature

Meeting the Witch

Yama-uba stands boldly with her cane of warped branches and her signature wide smile. Two important aspects of her personality are her occasionally intimidating and unsettling presence, and slightly frightening powers, so a particular goal within this sketch was to draw her hair like a nest of snakes, coiling unnaturally upward as if in warning. Tied around her waist are ropes with herbs and bottles, highlighting her vast knowledge of herbs and potion-making.

I include Kintarō hugging Yama-uba. Here he is young and inexperienced, wide-eyed and trusting in his guardian completely. Including him beside Yama-uba is important for showing her nurturing, kinder side. She is protective of the child, holding him close and safe from the unknown.

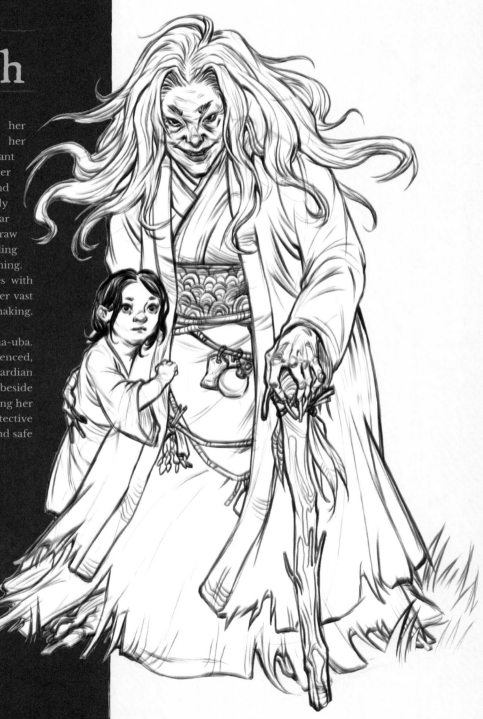

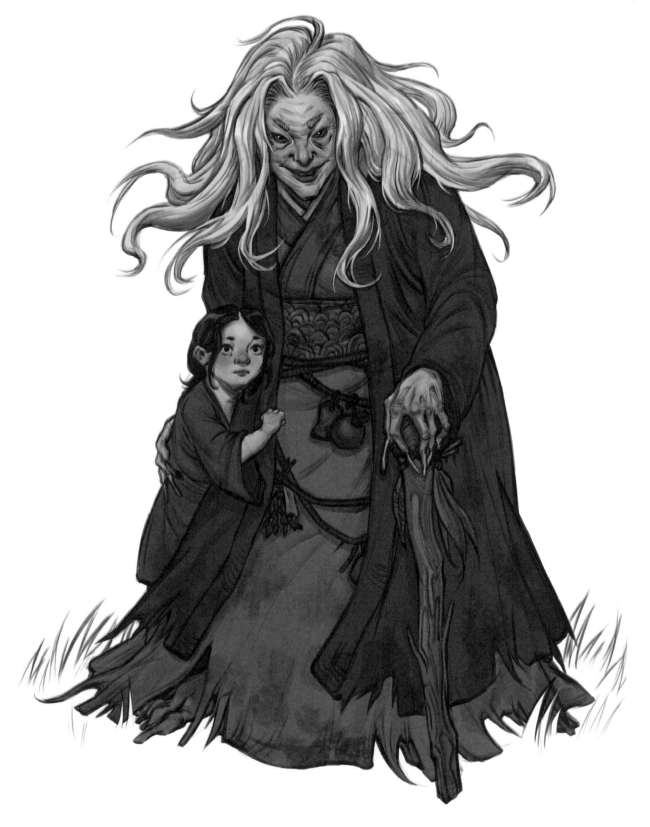

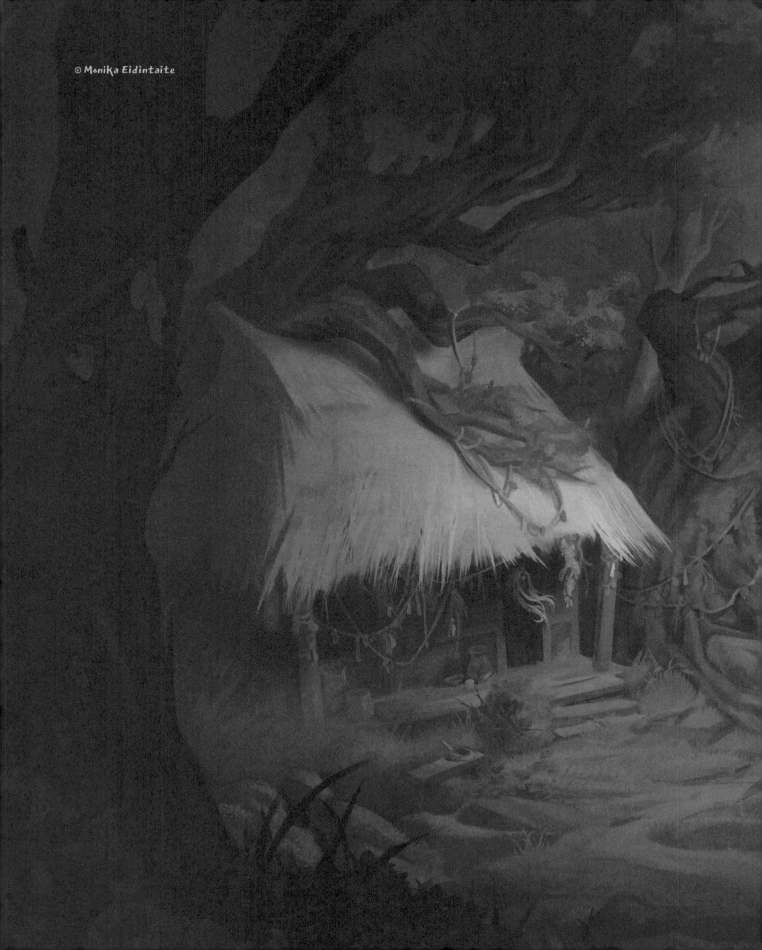

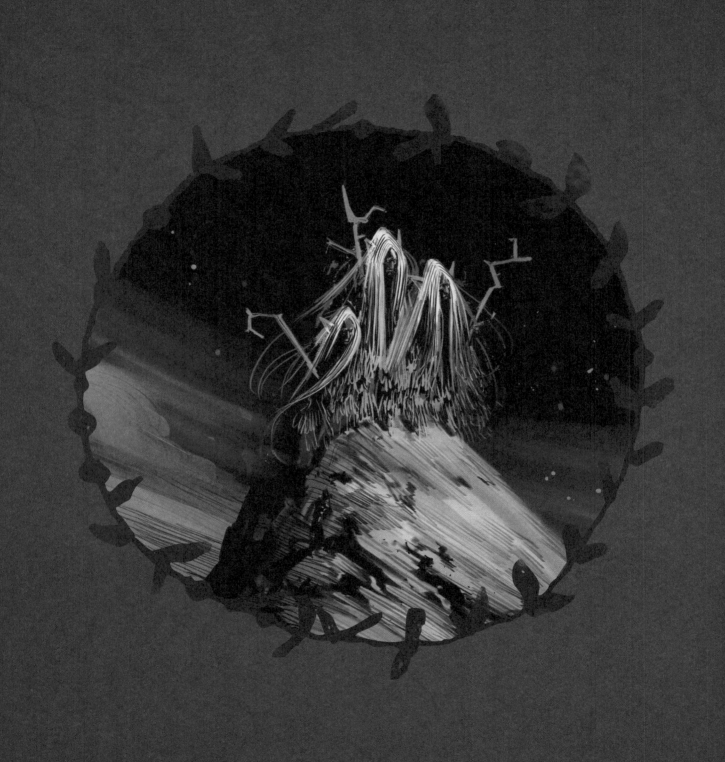

The Weird Sisters

Shakespeare's "Three Witches" or "Weird Sisters" are three strange witches who encounter the Scottish lord Macbeth and prophesize him becoming king, the catalyst for his murderous spiral and eventual downfall. Three is a powerful number in folklore, mythology, and witchcraft; the Moirai and Graeae of Greek myth are two well-known trios, and many magical goddesses have triple or "tripartite" forms. In this chapter, concept artist Jessica Taylor explores this theme to create her interpretation of these three prophetic witches.

Jessica Taylor | instagram.com/jesserintaylor

Research
& Rumors

Greek mythology

Some of the oldest depictions of the "three witches" in folklore and fiction are seen in Greek mythology, such as the Moirai – three ancient goddess-sisters also known as "the Fates" due to their dealings in prophecy and portents – and the Graeae or "Gray Sisters." There are many, sometimes conflicting, depictions of the Graeae, but their most notable appearance in popular stories comes from their encounter with the hero Perseus. In his tale, the Graeae are described as ancient women who share one eye and one tooth between them. The eye gives them knowledge and foresight, for which Perseus seeks them out. Perseus snatches the eye from the sisters as they pass it between them, threatening to throw it into the swamps where they live unless they reveal the whereabouts of the Gorgon Medusa. The sisters have elsewhere been described as beautiful and benevolent, or even as animals, but it's the simpler, classic version of three ancient, wretched crones that appears most often in popular culture.

Shakespeare's Macbeth

Shakespeare borrowed openly from the Graeae for his Three Witches, or Weird or Wayward Sisters, in the play *Macbeth*. Similar to the Greek myth, the sisters deal in prophecy and appear as part of the protagonist's journey – unfortunately for Macbeth, in this case! The witches say, "Fair is foul, and foul is fair / Hover through the fog and filthy air," which describes their attitude well enough for the audience and reader. They deal in darkness, foul play, and cruelty. Their famous verse, "Double, double toil and trouble," shows their malignant intent.

Common depictions

Similar to popular depictions of the Graeae, the witches often appear as ancient hags, huddled together around a bubbling cauldron and speaking in riddles and prophecies. However, the witches in *Macbeth* aren't tricked as the Graeae were by the clever Perseus. Instead, they foresee Macbeth's doom with much more agency than their ancient Greek counterparts.

LOCATION

These three witches roam a desolate, mountainous landscape waiting to encounter someone to give them a prophecy with their all-seeing magical powers. They have been alive for a long time, so they have no need to mingle in a town or a village, but usually venture off on their own into the vast landscape. It would typically look like the Scottish Highlands, with minimal trees or only a few scraggly, dead ones.

Important Notes

Crooked staff

I imagine the three witches would each carry a staff as they trek through the stark, mountainous landscape. The staff would likely be something natural, made from the debris around them – in this case, a large stick or gnarled tree branch would do.

All-seeing eye

A magical eye would be a powerful way to drive home the idea that these witches are all-seeing and prophetic. Their final design could incorporate eyes, or a single eye like the Graeae of Greek myth, to some degree.

Three fingers

It would be interesting to give each witch three fingers to represent the threefold nature of the sisters. Sticking with the number three for as many elements as possible will add a pleasing repetition and harmony to the witches' design. The long nails give their hands an avian appearance, like wild birds of their highland home, and also recall the Greek Graeae, who were sometimes depicted as part bird, part woman.

"It would be interesting to give each witch three fingers to represent the threefold nature of the sisters"

Tattooed arms

In my depiction, I imagine the witches receiving prophecies directly on their arms. These lines may look like scribbles from afar, but are actually small words and sentences from their past prophecies, engraved forever in the form of a kind of tattoo. This could also be a nod to the Weird Sisters' literary origins, as well as enhancing that scaly, birdlike look from a distance.

Cauldron

"Fire burn and cauldron bubble!" The classic cauldron is definitely a key element present in the sisters' representation. It could be a strong idea to show them cooking up their witches' brew while foreseeing prophecies.

Studying the Witch

IDEATION

I make some sketches that visualize the three witches as one unit. Sketch **4** is the most obvious, with them huddled together with their staffs and furry coat, trekking the wilderness far and wide with all-seeing eyes on their foreheads.

Next I take that idea further, attaching the witches to each other with only two long arms, which are stirring something in their cauldron (**5**). In **2** I take that idea even further by combining it with a cauldron head, with the witches' faces on it, and only two arms again.

Thinking way out of the box, I even try a spider with three heads and an all-seeing eye on its back – a witch spider (**3**)! A similar idea combines all three witches, one on top of the other, with an all-seeing eye staff (**1**). All of these ideas are different combinations of the important elements from my research, but I find myself gravitating back to **4** the most.

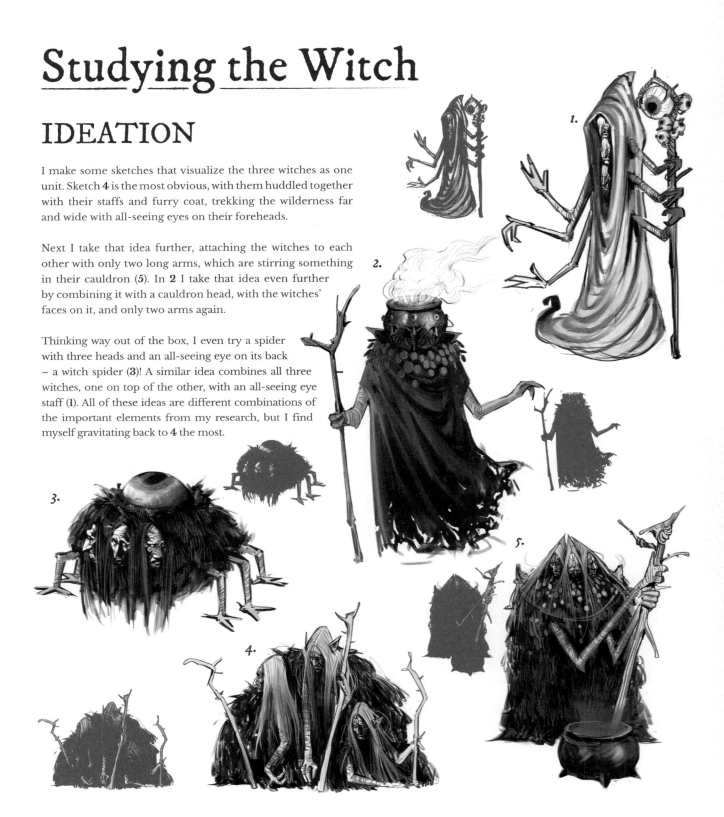

1.

2.

3.

4.

5.

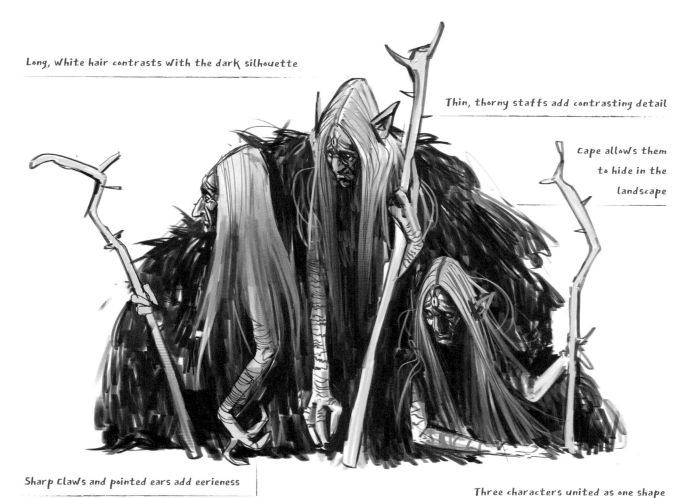

Long, white hair contrasts with the dark silhouette

Thin, thorny staffs add contrasting detail

Cape allows them to hide in the landscape

Sharp claws and pointed ears add eerieness

Three characters united as one shape

OVERVIEW

In my depiction, the three witches are one huddled mass with a hunched, creature-like silhouette. Their ragged cape conceals their bodies completely, except for their pale faces and tattooed, clawed arms, allowing them to hide easily from unwanted visitors on the heath. You won't see these witches unless they want to be seen! The three crooked staffs break out of the silhouette to add a finer detail, like the branches of a thorny bush, as the witches move through the landscape as one being.

EXPLORATIONS

Grouping the three witches together, almost as one character, means their actions and movements are limited in exchange for a strong, united shape. However, there are still some scenarios we can explore in these pose sketches without compromising the witches' silhouette.

▶ Here I wanted to make the all-seeing eye more prominent, so I huddled them around a floating eye as if they are receiving a prophecy. In one thumbnail, the eye hovers above them while they are crouched below, but in my final idea they are gathered around it more secretively to shield it from prying eyes. This pose also evokes the image of the mythological Graeae the most, with three figures "sharing" one eye.

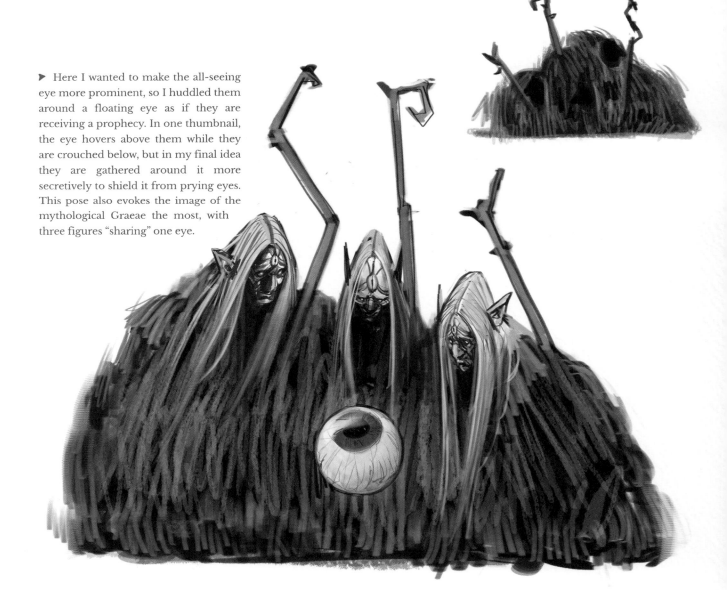

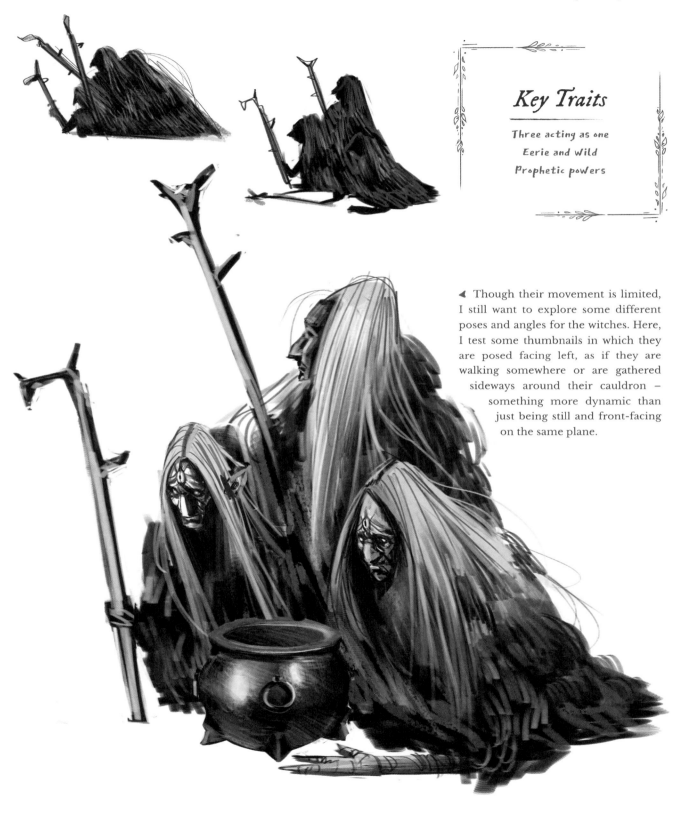

Key Traits

Three acting as one
Eerie and Wild
Prophetic powers

◀ Though their movement is limited, I still want to explore some different poses and angles for the witches. Here, I test some thumbnails in which they are posed facing left, as if they are walking somewhere or are gathered sideways around their cauldron – something more dynamic than just being still and front-facing on the same plane.

Meeting the Witch

I quite liked how I drew these witches in the sketching phase – I barely wanted to change anything about them! I often find that the first thing that comes to mind, and the first thing I draw on the paper, is the best idea and the one that I move forward with, but exploring other options allows me to confirm this. The main thing I change is the pose of the first witch, giving her head a clearer rotation that matches the other witches, inspired by one of the later pose variations I explored. I want the colors to express the witches' dark nature, so I use a limited range of grays, greens, and browns that make them feel part of the ominous highland landscape.

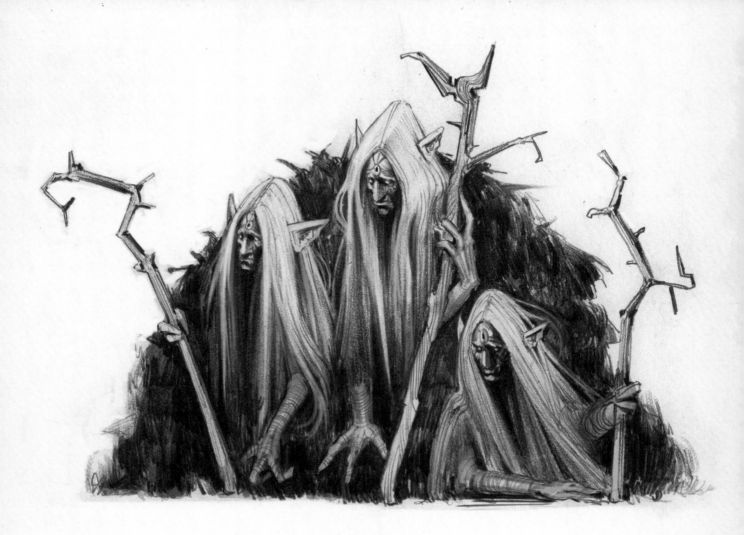

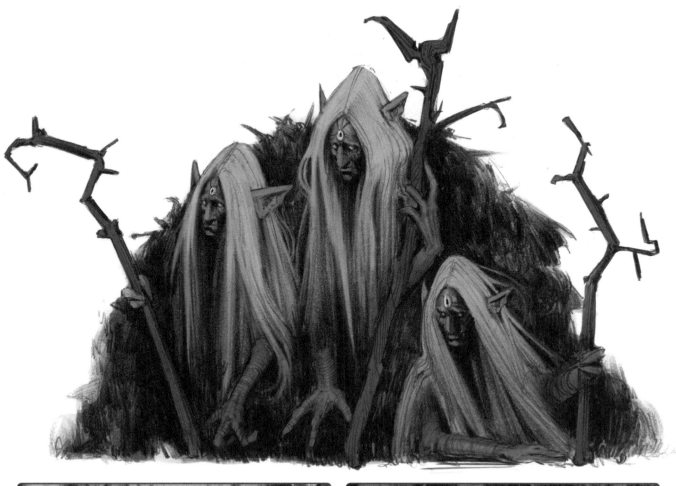

© Jessica Taylor

Downloadable Resources

At the link below, you can find a booklet of line drawings, courtesy of our excellent artists, to download, print, and color.

3DTOTALPUBLISHING.COM/RESOURCES

Contributors

Amagoia Agirre

lacont.artstation.com

Amagoia Agirre is a freelance illustrator and comic artist based in Spain, currently working on various illustrated books and comics as well as some personal projects.

Hazem Ameen

instagram.com/caninebrush

Hazem Ameen is a freelance artist based in Kerala, India, specialized in character design and narrative illustration. He has worked for clients and projects such as Paizo's *Pathfinder*, Creative Assembly, Petersen Games, and more. When he is not working for clients, he is usually working on his own personal projects.

Olga "AsuRocks" Andriyenko

asurocks.art

Born in Ukraine and raised on Slavic fairy tales, Olga Andriyenko currently lives in her own little indoor jungle in Hamburg, Germany. She is a freelance art witch of many passions: she creates illustrations, designs characters, writes and draws comics, animates, storyboards, pets her two black cats, and watches seeds grow.

Carol Azevedo

carolazevedo.myportfolio.com

Carol Azevedo is a character concept artist based in Brazil, who tries to bring her love of history and mythology to her designs.

Kacey Lynn Brown

instagram.com/untroubledheart

Kacey Lynn Brown is freelance illustrator with a fondness for all things fairy-tale and fantastical. When not drawing, she is usually found writing, reading, or exploring antique shops.

Karolina Derecka

artstation.com/clouv

Karolina Derecka is a freelance illustrator based in Poland. She enjoys drawing anything fantasy-related, especially human characters and dragons.

Monika Eidintaite

artstation.com/monikaeidintaite

Monika Eidintaite is an illustrator and concept artist currently based in the United Kingdom, with experience of working for the games industry and a particular passion for character design.

Franco Gonzalez

instagram.com/franco_galz

Franco Gonzalez is an artist who loves characters, creatures, and when the magical and otherworldly seem real. He is inspired by nature and classic fantasy, with the goal of evoking a sense of discovery that is grounded in reality – and, most of all, to simply make cool pictures!

Madi Harper

madisonharper.myportfolio.com

Madi Harper is a freelance illustrator working in children's books, cover art, and commercial illustration. Her inspiration comes from the joy of creating art combined with the art around her: in nature, in hiking, in the people she meets, and in the illustrators that came before her. Her work holds an element of early- to mid-1900s illustration with a modern twist in the color palette and medium.

Jana Heidersdorf

janaheidersdorf.com

Jana Heidersdorf is a fantasy and horror illustrator located in Berlin, Germany. Her ethereal, nature-inspired compositions can be primarily found on and in books, comics, and the internet, but really she can be hired for anything that needs a gentle haunting. Her clients include Little Brown Young Readers, Penguin Random House, Sourcebooks, and DC Comics.

Inkognit

inkognit.com

João Fiuza, also known as Inkognit, is an illustrator and concept artist specializing in creature and character design. He is also the creator of the project Silver Giant, where there are monsters, spirits, soldiers, and even gods – a place where the imagination runs loose.

Abigail Larson

abigaillarson.com

Hugo Award winner Abigail Larson specializes in dark fantasy illustration using a unique mix of traditional and digital media. Her clients include Netflix Animation, Disney Publishing, Sideshow Collectibles, Syfy, Universal, Titan Comics, Llewellyn Worldwide, DC Comics, and Dark Horse. Abigail has illustrated three tarot decks: *The Dark Wood Tarot*, *The Nightmare Before Christmas Tarot*, and *The Horror Tarot*.

Jodie Muir

jodiemuir.squarespace.com

Jodie Muir is a freelance fantasy illustrator from the United Kingdom, specializing in dark, gothic doom and gloom, and currently working as an artist on *Magic: The Gathering*.

Emanuel Pantaleon

artstation.com/emanuelpantaleon

Emanuel Pantaleon likes to draw and is currently working on building his skill set with the aim of making art his career. When he is not drawing, sports and the outdoors are his favorite pastimes.

Entei Ryu

artstation.com/badzr

Entei Ryu is a concept artist and digital sculptor based in Tokyo, currently working in the entertainment industry. She graduated from the University of Tokyo with a degree in architecture, but now mainly works on character and creature designs for video games and movies, as well as creating sculptures and jewelry designs as a freelance artist.

Janna Sophia

jannasophia.art

Janna Sophia is a freelance illustrator from Salzburg, Austria. She grew up near the mountains, listening to tales of old kings, evil stepmothers, girls lost in the woods, and creatures lurking in the forests. She has always been captivated by mythology and folklore, especially the witches and powerful women they often describe, and is fascinated with learning about them – no matter how ancient the myth.

Matteo Spirito

artstation.com/matteospirito

Matteo Spirito was born in Sezze, a small town near Rome, and was inspired to become an artist by his father's cluttered studio of canvases and paints. Matteo has worked as an illustrator and concept artist for around a decade, with his heart set on the path of designing creatures for video games.

Leroy Steinmann

leroysteinmann.com | instagram.com/leroy_steinmann

Leroy Steinmann is a freelance artist from Zürich, Switzerland. He enjoys being open to different kinds of work, with past projects ranging from concept and character design to storyboards and advertising.

Jessica Taylor

artstation.com/jesserintaylor | instagram.com/jesserintaylor

Currently working as a concept artist, Jessica Taylor started her artistic journey young, always painting and drawing. She decided to pursue a career in architecture, gaining an undergraduate degree in architectural science in Toronto, but that developed into a career in concept art. Her personal art consists of a lot of traditional pencil work while her professional output is mostly digital.

Eldar Zakirov

eldarzakirov.com

For almost twenty years, Eldar Zakirov has worked on numerous books and magazines, and with agencies from Europe, the USA, and Australia. Not remaining within a single genre, he's equally willing to illustrate scientific, technical, and journalistic publications and articles, fiction, prose, and children's books.

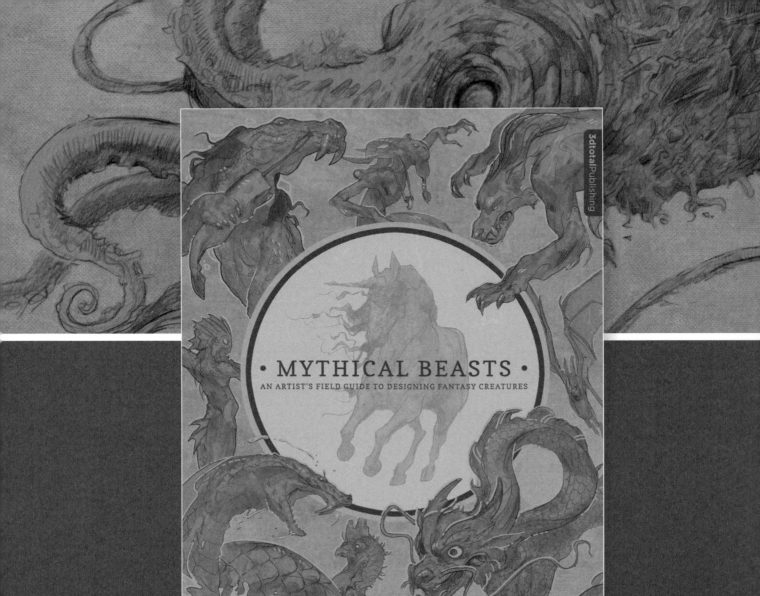

MYTHICAL BEASTS

AN ARTIST'S FIELD GUIDE TO DESIGNING FANTASY CREATURES

3dtotalPublishing

THE ART OF
feefal

The Art of Feefal is the first published collection of work by Swedish artist Linnea Kikuchi, known as Feefal to her fans and fellow artists. Feefal guides you through this fascinating book as she explores her extraordinary world of playful characters in settings infused with curious dream-like and macabre qualities. She reveals personal thoughts around her creative process alongside the techniques she uses to bring these ideas to life.

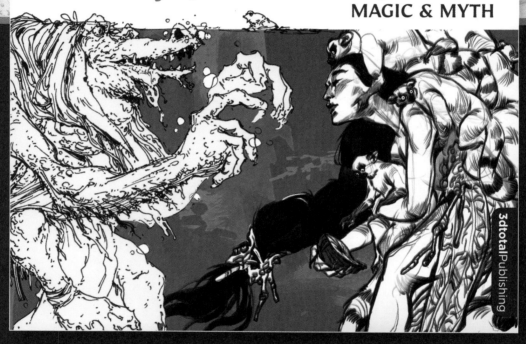

Sketching from the Imagination

Check out what else is on offer in
the Sketching from the Imagination collection...

3dtotalPublishing

3dtotal Publishing is a trailblazing, creative publisher specializing in inspirational and educational resources for artists.

Our titles feature top industry professionals from around the globe who share their experience in skillfully written step-by-step tutorials and fascinating, detailed guides. Illustrated throughout with stunning artwork, these best-selling publications offer creative insight, expert advice, and essential motivation. Fans of digital art will enjoy our comprehensive volumes covering Adobe Photoshop, Procreate, and Blender, as well as our superb titles based around character design, including *Fundamentals of Character Design* and *Creating Characters for the Entertainment Industry*. The dedicated, high-quality blend of instruction and inspiration also extends to traditional art. Titles covering a range of techniques, genres, and abilities allow your creativity to flourish while building essential skills.

Well-established within the industry, we now offer over 100 titles and counting, many of which have been translated into multiple languages around the world. With something for every artist, we are proud to say that our books offer the 3dtotal package:

LEARN | CREATE | SHARE

Visit us at 3dtotalpublishing.com

3dtotal Publishing is part of 3dtotal.com, a leading website for CG artists founded by Tom Greenway in 1999.